THE ROMAN WORLD

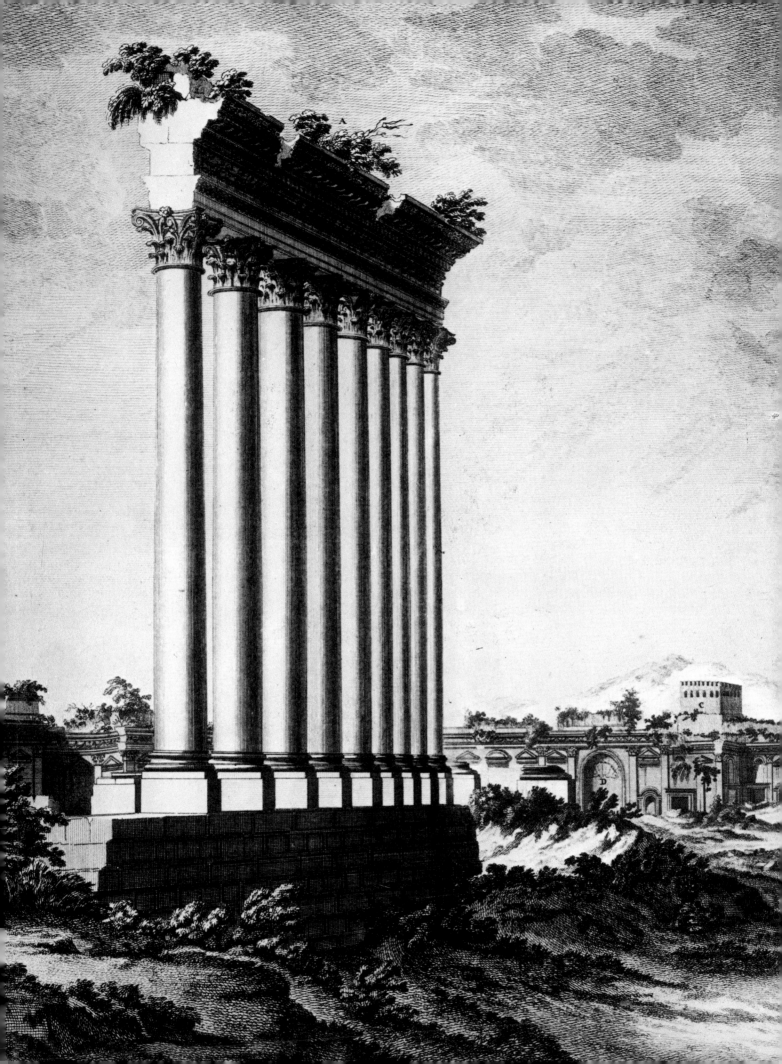

The Making of the Past

The Roman World

Michael Vickers

Peter Bedrick Books
New York

Advisory Board for The Making of the Past

Frontispiece: the Temple of Jupiter at Baalbek, from Wood and Dawkins'
The Ruins of Baalbec (1757).

 AN EQUINOX BOOK
First American edition published in 1989 by
Peter Bedrick Books
2112 Broadway
New York NY 10023

First edition © 1977 Elsevier Publishing Projects SA, Lausanne
Second edition © 1989 Equinox (Oxford) Ltd

Library of Congress Cataloging-in-Publication Data
Vickers, Michael J.
 The Roman world/by Michael Vickers. — 1st American ed.
 p. cm. — (The Making of the past)
 Includes index.
 ISBN 0-87226-302-9
 0-87226-212-X (pbk.)
 1. Rome—Civilization. I. Title. II. Series: Making of the
past (New York, N.Y.)
DG77.V53 1989
937—dc20

 89-32103
 CIP

Printed in Yugoslavia

5 4 3 2 1

Contents

Preface to the series

This book is a volume in the Making of the Past, a series describing the early history of the world as revealed by archaeology and related disciplines. The series is written by experts under the guidance of a distinguished panel of advisers and is designed for the layman, for young people, the student, the armchair traveler and the tourist. Its subject is a new history – the making of a new past, uncovered and reconstructed in recent years by skilled specialists. Since many of the authors of these volumes are themselves practicing archaeologists, leaders in a rapidly changing field, the series is completely authoritative and up-to-date. Each volume covers a specific period and region of the world and combines a detailed survey of the modern archaeology and sites of the area with an account of the early explorers, travelers, and archaeologists concerned with it. Later chapters of each book are devoted to a reconstruction in text and pictures of the newly revealed cultures and civilizations that make up the new history of the area.

Preface

The achievement of Rome, from its modest beginnings on the bank of the Tiber around 800 BC to the domination of the Mediterranean and western Europe during the first centuries of the Christian era, is one of the most impressive success stories in history. (Although the main outlines of the story are well enough known from ancient writers, archaeology can help to fill in the gaps and give us invaluable information about the material culture of, for example, the earliest inhabitants of the city of Rome or their Etruscan neighbors. It can illustrate the transition of Rome from provincial status to the political and artistic hegemony of the Mediterranean and it can show how Rome served as a conductor of the mainly Greek culture of the eastern Mediterranean to the west. Archaeology can also give us an insight into how the peoples of the Roman Empire with their different local traditions assimilated the Greco-Roman message. Thus the remains of primitive Iron Age huts on the Palatine serve to remind us of Rome's humble origins; the restrained pomp of the reliefs of the Ara Pacis, carved by immigrant Greek sculptors in the closing years of the 1st century BC, reveals how Roman political ideas could be expressed in visual terms that had been developed in Athens five centuries earlier; and the neatly demolished legionary fortress at Inchtuthil in Perthshire, Scotland, impresses us with the organizational skill of the Roman military machine even in retreat.)

The means employed by archaeologists to extract information concerning Roman civilization are varied, but the common factor is always an interest in the material remains, whether the research be conducted in the field or in a museum, in the library or in the laboratory. One archaeologist may be interested in Roman antiquity from the point of view of an art historian; another from the standpoint of the environmental historian. The one may perhaps prepare a catalog of Roman emperor portraits; the other produce dramatic evidence of our rude forefathers' uncomfortable environment with the discovery of a Roman bedbug from Warwick. Most of the raw material on which archaeologists work comes from out of the ground – either carefully (or sometimes carelessly) excavated, or found by chance. The undertaking of an archaeological excavation is an attempt to satisfy curiosity about the past; to answer questions about man's history.

The same spirit moved Cardinal Prospero Colonna when he investigated the sunken Roman ships in Lake Nemi in the 15th century as spurred on General Pitt Rivers when he explored the remains of Cranbourne Chase in the 19th. Techniques of excavation have developed and improved over the centuries, especially in the 20th, and scientific aids abound (too much, perhaps, for the curse of metal detectors has led to the destruction by vandals of several important sites).

We shall be concerned as much as anything in this book with tracing the history of medieval, Renaissance and modern man's interest in the Roman past and the various ways it has been studied and interpreted. The history of archaeology reflects very closely the history of ideas. We shall also consider some of the ways in which an awareness of antiquity affected the arts at different periods; how an artist like Andrea Mantegna in 15th-century Mantua might obtain sketches of rather pedestrian Classical reliefs from Rome and translate them into some of the finest products of Renaissance art; and how the discovery of ornate frescoes at Pompeii has influenced interior decoration in Europe and America from the 18th century to the present day.

Roman antiquity is extremely accessible to the tourist. Practically anywhere within the frontiers of what was the Roman Empire Roman remains are plentiful, though sometimes they may be hard to detect: tracing the course of a Roman road can make for an interesting country walk in Britain. And many sites in Britain, once excavated, are entrusted to the Department of the Environment who conceal them again with lovingly tended lawns. More spectacular ruins can be seen in the Rhineland (e.g. Trier), the south of France (Arles, Nîmes, Orange), Spain (Mérida, Segovia, Italica), Yugoslavia (Pola, Split), and of course Italy. Most ancient sites in Greece have more Roman buildings than anything else, and Turkey, the Near East and North Africa have some of the best-preserved Roman antiquities of all: Ephesus in Turkey, Baalbek in Lebanon, Masada in Israel, Salamis and Paphos in Cyprus, Lepcis Magna and Sabratha in Libya, Dougga and Sbeitla in Tunisia, Djemila and Timgad in Algeria, and Volubilis in Morocco. But go and see for yourself, dear reader.

Chronological Table

Politics and Society			Architecture and Culture
	BC		
753 Legendary founding of Rome by Romulus	700		
	600		
c. 616–509 Rome is ruled by Etruscan kings			
509 The Republic is established, following expulsion of the last Etruscan monarch	500	509	The Temple of Jupiter, on the Capitol, is dedicated
494 The office of tribune is created to protect the rights of plebeians	400	498	The Temple of Saturn is built
493 Rome joins the Latin League formed by its neighbors for mutual defense			
449 Publication is begun of the Law of the Twelve Tables, codifying existing Roman law			
396 Rome violates its agreements with the Latin League by annexing new territory	300	312	Rome's first highway, the Via Appia, is built
390 The Gauls sack Rome but soon withdraw		312	Rome's first aqueduct
340–338 Rome defeats and dissolves the Latin League			
c. 290 Victory over the Samnites completes Rome's domination of central Italy		264	Earliest record of gladiatorial combats
287 The Hortensian Law shifts legislative power from aristocrats to plebeians		240	Latin tragedy and comedy are inaugurated with the plays of Livius Andronicus
275 Rome is undisputed ruler of southern Italy		221	The Circus Flaminius is built
264–241 The First Punic War with Carthage sees Romans ultimately victorious		220	The Via Flaminia is constructed
		c. 205	Plautus' comedy *Braggart Soldier* is performed
218–201 The Second Punic War ends in Roman triumph despite Hannibal's remarkable invasion across the Alps		205	Cult worship from Asia Minor influences Rome
		204	The poet Ennius comes to Rome
c. 211 The first silver denarius			
197 Rome defeats Philip V of Macedon at Cynoscephalae	200	166	The playwright Terence's *Andria* is produced
149–146 The Third Punic War; Rome besieges, then destroys Carthage		c. 160	Cato composes his major treatise on agriculture
146 Destruction of Corinth		131	Satires by Lucilius are published
133–122 Land reforms of Gracchus brothers			
121 Rome conquers southern Gaul			
112–106 War with the North African king Jugurtha			
87 Violence erupts between partisans of the aristocrats and the populace	100	81	Cicero delivers his first oration
		c. 62	The lyric poet Catullus arrives in Rome
81 The aristocratic general Sulla becomes dictator; he restores the power of the Senate and improves the judicial system		c. 55	Pompey's Theater, the first stone theater in Rome, is constructed
73–71 Spartacus leads a slave revolt that ends with bloody reprisals against the rebels		c. 55	Death of Lucretius, author of the great philosophical poem *On the Nature of Things*
63 Cicero becomes consul		51	Caesar publishes his *Commentaries* on the Gallic Wars
60 The First Triumvirate is formed: Pompey, Caesar and Crassus		c. 50–40	Murals at the Villa of Mysteries at Pompeii are painted
58–51 Caesar conducts a series of great campaigns in Gaul		48	The Library of Alexandria is destroyed by fire
49–48 The civil wars begin; Caesar defeats Pompey		46	Caesar's Forum Julium is dedicated
48 Caesar meets Cleopatra in Egypt		44	Cicero's *Philippics*, attacking Mark Antony, are delivered
46 Caesar appointed dictator for 10 years		c. 41	The historian Sallust publishes his history of the war with Jugurtha
44 Caesar is assassinated; Mark Antony takes command in Rome		39	The first public library is founded
43 Octavian, Caesar's heir, is elected consul; he then forms the Second Triumvirate with Antony and Lepidus		c. 37–30	The poet Virgil's *Georgics* are written
42 The Second Triumvirate defeats Caesar's assassins at Philippi		c. 35–30	The poet Horace's *Satires* appear
41 Mark Antony meets Cleopatra in Egypt		c. 33–16	The poet Propertius composes his *Elegies*
31 Antony and Cleopatra are defeated at Actium by Octavian		28	82 Roman temples are restored
27 Octavian becomes emperor and assumes the title of Augustus		19	Virgil dies; his *Aeneid* is published posthumously
c. 4 The birth of Christ		13	The Theater of Marcellus is dedicated
		2	Augustus dedicates the forum named after him
14 Augustus dies; Tiberius becomes emperor	**AD**	8	The poet Ovid is exiled from Rome
37 Caligula becomes emperor		77	Pliny the Elder's 102-volume *Natural History* appears
43 Conquest of Britain begun		79	The Colosseum is dedicated
54 Nero is emperor		c. 82	The Arch of Titus commemorating Titus' victory over the Jews is built
64 Rome burns, giving Nero an excuse for the first persecution of Christians		86	The first books of the poet Martial's *Epigrams* are published
79 Mount Vesuvius erupts, burying Pompeii and Herculaneum		98	The historian Tacitus' *Germania* appears
135 Hadrian suppresses the revolt of the Jews and denies them access to Jerusalem	100	c. 100	The first extant satires of Juvenal are published
		112	Trajan's Forum is dedicated
161 Marcus Aurelius is emperor		118–28	Hadrian rebuilds the Pantheon in Rome
193 Septimius Severus is emperor		c. 121	Suetonius publishes his *Lives of the Caesars*
212 Roman citizenship is granted to all free inhabitants of Roman provinces by Caracalla		130–38	Hadrian constructs an elaborate villa at Tivoli
		c. 176	The column of Marcus Aurelius is built
		197	Tertullian's *Apology* refutes the charges made against the Christians
	200	212–16	The Baths of Caracalla are constructed

Introduction

"On the Ides of September, dear sister, please come and attend my birthday party": this is the earliest known example of writing in Latin by a woman. Claudia Severa's letter was found in 1985 at Vindolanda near Hadrian's Wall in Northumbria where her husband was a unit commander. It is but one of the new and exciting discoveries which have been made in the dozen or so years since this book first appeared. Much scholarly attention has been devoted of late to the material remains of the Roman world. We have seen the publication of field surveys, excavation reports and exhibition catalogs which have thrown much new light on areas about which we once knew little. There has been an encouraging willingness on the part of younger scholars to weld together the findings of archaeology and ancient history to give a broader picture of ancient Roman society. An indication of the interest generated by the subject is the recent foundation of a dedicated periodical, the *Journal of Roman Archaeology*. What follows is a brief and necessarily selective overview of a many-faceted topic.

The reason why there has been a renewed interest in the Roman world is an interesting subject in itself. In part, it is due to the existence of a large educated public curious to know more about an age whose physical remains figure large in the Mediterranean area and throughout much of Europe. In part, the imperial echoes of the Holy Roman Empire, of Napoleon or of the mercifully short-lived Thousand-Year Reich have ceased to be urgent issues of the day; the Treaty of Rome is a gentler instrument of European unity, and the new and

An inscription discovered in 1977 in excavations in the Temple of Mater Matuta at Satricum, 50 km south of Rome. It reads: "The comrades of Publius Valerius dedicated this to Mars." It is possible, but by no means certain, that the P. Valerius in question was the Publius Valerius Publicola who was one of the first consuls of the Roman Republic.

welcome tendency for Europe East and West to come together inevitably generates interest in a period when much of Europe was united for centuries. While modern economic development has led to the destruction of much of what had survived, whether as a result of new building in old civic centers, of road building or deep plowing due to farm mechanization, a general awareness of the importance of the Roman past has encouraged "rescue" excavation in advance of new construction.

The results of rescue archaeology, however, are inevitably piecemeal and haphazard. One way around this problem is to conduct research excavations with a view to answering specific questions. There have been several of these, the most remarkable perhaps being the research programs conducted by Italian, British and American archaeologists in the vicinity of Cosa in Etruria, of which more below. Another is to write works of synthesis of a kind best represented by a series currently being edited by Timothy Potter of the British Museum. His own recent study of *Roman Italy* has set very high standards, and more volumes are in the pipeline.

The city of Rome. The capital of the Roman Empire is now the capital of Italy. A city of four million inhabitants, most of whom travel by automobile, Rome is inevitably beset by problems of atmospheric pollution. Although motorists have been excluded from large parts of the old city to the advantage of pedestrians and tourists, little has been, or indeed can be, done to tackle the underlying problem. Many Roman monuments have been under wraps since a program of cleaning and conservation began in 1982. The columns of Trajan and Marcus Aurelius have recently emerged clean and fresh, but the question now arises, for how long will they remain in such a state before their surfaces turn into powder? There have been projects on paper to build

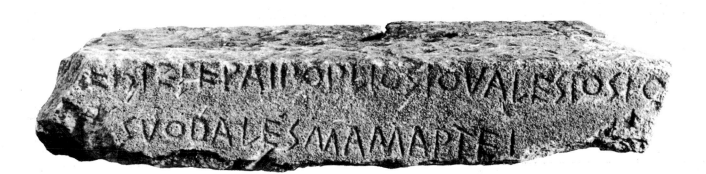

protective glass shelters, but nothing has come of them; there have been suggestions that the monuments be dismantled and placed in purpose-built museums, as was once done for the Ara Pacis. No solution, however, has struck the right balance between practicality and expense. Similar considerations apply to other monuments whose restoration is approaching completion: see them soon, or not at all.

Several of these monuments are situated in the Roman Forum, which has been the scene of much archaeological activity in recent years. Excavators from the University of Pisa have found what they believe to be the stone walls of the original *pomerium*, the "bounds" of the city of Rome traditionally founded by Romulus on the slopes of the Palatine Hill. The walls are believed to have been built in the 8th century BC, and their existence has brought about a reassessment of the status of early Rome. It no longer seems to have been a village of huts of wattle and daub, but a civic center of some pretensions.

The Forum is the object of much international attention at present. British archaeologists are at work in the area of the Basilica Aemilia; Danish beneath the Temple of Castor and Pollux; American in front of the Temple of Vesta; French on the upper part of the Palatine; and Swiss near the foundations of the "House of Tiberius." A few years ago the municipal authorities announced a project to excavate the whole of the area occupied by the Roman Forum and the Fora built by the emperors, in order to create a vast archaeological park, but there was such an outcry that this is no longer a serious proposition. Not since the Norman adventurer Robert Guiscard sacked Rome some 900 years ago, it was objected, has the city been threatened with such destruction.

Gold, silver, metrology and mining. Precious metals are rarely found in controlled excavations; most are found by chance or by treasure hunters (the metal detector has been a mixed blessing in this respect). People in antiquity did not regularly bury caches of gold and silver and, if some emergency did cause them to do so, it was usually the case that hoards were subsequently recovered by their owners. The circumstances in which a hoard might not be recovered in antiquity were presumably exceptional; hoards thus indicate particularly disturbed times. Although we hear in inventories of Romans possessing collections of both gold and silver plate, it is unusual for gold vessels actually to be found in hoards. It seems likely that in most cases cumbersome silver vessels were hidden and any gold carried off for immediate purposes. The Thetford Treasure, found in Norfolk in 1979, presents various problems in that it did contain a substantial amount of mostly unused gold jewelry – rings, buckles and bracelets for the most part. Three silver strainers and 33 silver spoons, most of which are inscribed, appear to have belonged to the authorities

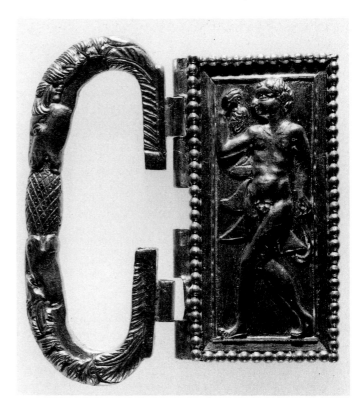

A gold buckle from the Thetford Treasure, found in Norfolk, England, in 1979. The bow is decorated with stylized horses' heads and the rectangular plate bears a relief of a satyr.

of a sanctuary of the pagan god Faunus. The hoard was most probably deposited towards the end of the 4th century, at a time when Christianity was rapidly replacing paganism as the religion of the Roman Empire. The Thetford Treasure was published with impressive speed and, although many questions remain open, it was clear when the weights of the silver objects were analyzed that there was an underlying pattern to their metrology. The spoons in one series were apparently intended to weigh one Roman ounce (27 grams) each, and the total weight of the other group was approximately one and a half Roman pounds (491 grams).

The careful attention paid to metrology in the 1983 publication of the Thetford Treasure marked a new departure in the study of ancient metalwork. The weights of objects made from precious metal are often not given in catalogs, still less analyzed for what they can tell us about ancient economic life. There does in fact appear to be a long tradition in antiquity of making plate according to one precious-metal weight standard or another; gold and silver vessels were every bit as much convertible currency as coinage, and it must have aided calculations of wealth to know that a given object, or a set of objects, might represent a certain amount. To overlook such, literally, rich sources of information is to miss much of what the ancients thought was important.

Gold and silver plate was often exquisitely decorated, and few pieces can have matched the silver amphora found in the sea near Baratti (Populonia) in 1968, but only recently put on exhibition in Florence after a long and painstaking restoration. The amphora weighs more than 7·5 kilograms and is 61 centimeters high. The surface is decorated with 132 different medallions of musicians, dancers, deities and personifications arranged in nine rows on the neck and body. It was probably made in Roman Syria towards the end of the 4th century AD.

Keith Hopkins has estimated that the annual budget available to the central authorities of the Roman Empire in the early 1st century AD amounted to a little over 800 million sesterces (a unit of account approximately equal to a gram of silver). Direct comparisons with the present are bound to be somewhat illusory, but this is equivalent at today's (1989) silver price to about 15 billion dollars. About half this sum was spent on the army. Since taxes were levied at 10 percent, this makes for a total annual audited expenditure of around 150 billion dollars, which does not take account of private individuals' savings in coin and bullion or of the rich holdings in temple treasuries. Hopkins also believes that an average of 250 kilograms of wheat equivalent (covering the cost of food, clothing, heat and housing) per person per year is a low, but reasonable, estimate of an individual's minimum needs in antiquity. Again, a modern comparison must be regarded with caution, but this would have cost 50 dollars per annum at prices current at the time of writing. If this represented the minimum in an empire of some 50 million inhabitants, then there was clearly room for the possession of considerable fortunes further up the social scale.

A major source of silver in the Roman world was Spain, and prominent among Spanish mines was, then as now, the Rio Tinto operation. Modern open-cast mining on the site of the ancient works has revealed houses of the largest Roman mining settlement yet known, as well as a broad and deep cross section through the mine workings of the early Imperial period. The latter was carefully cleaned as part of a research program carried out in the mid-1970s by Barri Jones of Manchester University, and it was possible to see the furnaces, charcoal, clinker and slag left by the Roman miners. Ceramic evidence suggested that large-scale work came to an end towards the end of the 2nd century AD, perhaps as a consequence of the deforestation of the surrounding area (timber was used for making charcoal used in the refining process and for pit props), perhaps as the result of an attested Moorish invasion in the 170s. It may not be wholly coincidental that, with one of the Romans' largest silver sources out of operation, the amount of silver coinage issued in the reign of the emperor Commodus (180–92 AD) appears to have fallen considerably: finds of *denarii* from Britain are down by 50 percent and from Germany by 65 percent.

Roman villas and agriculture. Much Roman wealth was derived from landholding and farming, and a major part of recent research has been directed towards elucidating the questions which arise from this fact. Not so very long ago comparatively little was known from excavation about Roman villas in Italy. Indeed, more was known about farms and country residences in England. It has been in large part thanks to pioneering work done by British archaeologists in Italy that the picture has changed. Much of the credit is due to the late John Ward-Perkins who was for many years Director of the British School at Rome, and who encouraged the excavation of two small villas at Francolise in the Ager Falernus north of Naples. Their anonymous owners appear to have made their living from oil and tile and brick production. Since then many more rural sites have been investigated, but none has attracted as much interest as the villa at Settefinestre near Cosa, recently excavated by an Italo-British team.

The Ager Cosanus had been allotted to colonists in 273 BC. Each settler was probably given six *iugera* (1·5 hectares) of land in an area which had been divided up into square fields by a system known as centuriation. Gradually these allotments coalesced into rather larger holdings, and by the time the villa at Settefinestre was built in the 1st century BC, it was probably the center of a large estate of 500 *iugera* (125 hectares). There were two periods in which the villa flourished. The first was from about 40 BC to 100 AD. The evidence of the initials LS on tiles found on the site as well as the abbreviation SES on wine amphoras suggests that the owner at this time may have been a certain Lucius Sestius, a member of the Roman aristocracy and consul in 23 BC. The second period lasted from about 100 to 200 AD, after which the villa was abandoned. In both periods the estate was worked by slaves in a manner similar to plantations in the American south. That the abandonment in the 3rd century was accompanied by a breakdown in the whole centuriation system is indicated by the presence in the relevant archaeological strata of seeds of plants which had blown in from nearby marshes.

The owner's house was 150 Roman feet (44 meters) square, and was in effect a town house transported into the country. The entrance was on the east side and led into an atrium with a pool in the center. This led to a courtyard surrounded by a colonnade with dining rooms and bedrooms leading off it. This in turn led to a loggia which looked over a terraced garden surrounded by a turreted wall. The standard of decoration employed in the house was high, with polychrome mosaics on the floors of many of the rooms, and stuccoed and frescoed walls. Along the north side of the house were a grain mill and olive and wine presses. The latter were probably the most important part of the economy of the earlier phase of the villa. It has been estimated that the Settefinestre

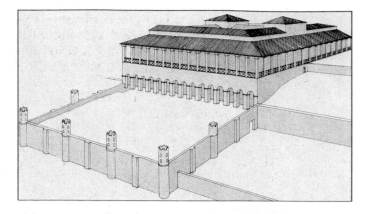

A reconstruction of the newly excavated villa at Settefinestre near Cosa. Investigations by an Anglo-Italian team of archaeologists have shown that it was the center of a large estate worked by slaves between the 1st century BC and the 2nd century AD. The principal garden was surrounded by a wall adorned with miniature towers which recall those of a town.

estate produced more than a million liters of wine per annum, earning the equivalent of 60 kilograms of silver, at a period when fortunes were being made in supplying wine to the rapidly growing city of Rome 140 kilometers away down the coast.

There were quarters for the staff, probably slaves, and accommodation for animals, horses, cattle, sheep and pigs in and around the main dwelling, as well as a large granary built separately as a precaution against fire. The arrangements were changed during the second period of occupation. The most conspicuous addition was a new bath house built in one of the gardens. The nature of the villa's economy changed too, for wine and oil now ceased to be produced: they could be imported more cheaply from the provinces. Slaves became a commodity in themselves and were bred and sold; pig raising was the other major source of income. Both activities went into a steep decline in the later part of the 2nd century. It is thought that a contributory factor may have been the plague which was brought to Rome in 166 as a consequence of Lucius Verus' military triumphs in Syria. We have learned much about the economy of Settefinestre from the analysis of animal bones and seeds – items which used to be ignored, but which are now, thanks to archaeological scientists, a valuable source of the kind of information which is rarely preserved in the literary record.

"Where the rich hang out." For all its comparative grandeur, Settefinestre was a modest establishment compared with the seaside villa uncovered at Torre Annunziata near Naples during the past couple of decades. About a sixth of the total area of an extremely grand holiday home for some rich Roman has been revealed, and more work is promised in years to come. The site has been associated with Oplontis, a name which occurs only on the Tabula Peutingeriana, a 13th-century copy of a 4th-century Roman itinerary. The villa was overwhelmed with ashes and mud in the same eruption of Vesuvius that destroyed nearby Pompeii and Herculaneum, but it represents a level of size and luxury without equal in those cities. The site is open to the public, but is not much frequented by tourists as yet. A visit is highly recommended.

The villa at Oplontis was built in the 1st century BC and may have suffered some damage in the earthquake of 62 AD. It was undergoing a restoration when disaster struck in 79. No furniture or household goods were found, which indicates that the house was empty at the time.

Some of the state rooms and the servants' quarters have been uncovered, and they present a remarkable contrast in the way they are decorated. The walls of many of the rooms in the western part of the villa still bear frescoes which are among the finest anywhere. Distant architectural vistas are broken by columns and walls carefully painted to look like exotic marbles and onyxes. Here an enormous gold tripod conjures up an image of Delphi, there a basket of figs or fruit in a translucent bowl the pleasures of the table. A bathing establishment had recently been redecorated with scenes from classical mythology framed within the spindly columnar arrangement fashionable in the 70s AD, and a small jewel of a bed chamber still retains stucco moldings on its ceiling.

The slaves' quarters, however, are very plain. The plaster on walls and columns is painted in a very crude imitation of panels of banded marble. There are storerooms around a cloistered courtyard, and a long corridor lined with benches on which visitors to the villa may have waited for an audience with the owner. Archaeologists have been able to reconstruct with plaster the roots of plane trees more than a hundred years old in a corner of what must have been a very large garden. Some have taken a stamped amphora found in the villa as evidence for Oplontis having been the summer residence of Nero's wife Poppaea. But whoever it belonged to, the new villa provides support for an old suggestion that the name Oplontis was a contraction of *ad Opulentos* – "where the rich hang out."

Ceramics and archaeology. There is currently a lively debate going on between archaeologists whose primary concern is with the material remains of an earlier period as to the status of the decorated Athenian pottery which has for the most part been found in tombs in Etruria to the northwest of Rome and which has come down to us in such profusion (p. 85 below). Although it has been known for some time that the prices of such pottery in antiquity were low – some would now say very low indeed – Greek ceramics are still widely thought of as luxury goods, and this outlook has been carried over into

Roman studies, so that Arretine pottery (p. 27 below), for example, is occasionally referred to as "luxury ware." The reasons why high value should be imputed to fine pottery are complex, but they include: the sales talk which accompanied the first big sale of Greek ceramics in the 18th century and which depended in large part upon fraudulent arguments regarding the value of painted pottery in antiquity; and the tendency on the part of archaeologists to privilege what has survived at the expense of what has been lost, coupled with an understandable desire on the part of some scholars to view the objects of their study in the rosiest possible light. The picture that we get of ancient societies, whether Greek, Etruscan or Roman, is that elites ate and drank from gold and silver, and it is becoming increasingly apparent that fine ceramics were infinitely cheaper surrogates to be placed in the tomb in lieu of the family silver, or else objects used in everyday life by those who could not afford plate. A silver vessel might cost a thousand times more than its fineware ceramic equivalent, and a gold one ten thousand times more. Fashions in tableware were created for the rich, and thanks to the operation of the "trickle-down effect" their forms and decoration influenced less expensive materials which have survived owing to their relative indestructibility and complete lack of value until the advent of the art market.

Recent research suggests that ceramics were "parasitic" on other, more valuable trade goods. They might travel as "space fillers" accompanying more important items such as wine, oil, grain, or real luxury goods such as silks, unguents, incense and spices, and as such they are of great value in assisting archaeologists to reconstruct patterns of trade. We know from various kinds of historical evidence – texts and inscriptions – that Campanian Puteoli had a thriving trade with the eastern Mediterranean. Although there is no such evidence relating to the city's trading relations with the western Mediterranean, a complementary picture can be created by an analysis of the findspots of Campanian pottery. It also appears that mass production of ceramics often occurred in centers whose principal *raison d'être* was the marketing and manufacture of other commodities. Puteoli's wealth in the late Republic in large part depended on the import of slaves and grain and the export of oil and wine. The need for suitable containers will have stimulated pottery production.

It has recently been argued that the extant fine pottery was intended to evoke the actual materials from which elite dining vessels were made. In the case of marbled "Samian" ware the dependence on variegated marble vessels is clear. Black Arretine pottery, which appears to echo patinated silver, gives way to the orange-red variety at precisely the point in the 60s BC when Rome was suddenly enriched by the acquisition of great amounts of booty, much of it in gold, from the conquests of Lucullus and Pompey in the east. An earlier change from black to red pottery is observable in the Hellenistic east after Alexander's conquest of the Persian Empire. Kevin Greene has rightly said that "the reason for producing a red rather than a black end-product was presumably determined by taste rather than technology"; it may well have been a reflection of a taste for gold on the part of wealthy Romans supplanting a taste for silver.

The implications of the relatively low status of pottery in antiquity are only just beginning to be felt. In field surveys (where large areas are methodically combed for surface remains) it used to be assumed that the presence of fine pottery was an index of wealth. One of the conclusions of Liverpool University's recent field survey of the Methana peninsula in southern Greece is that the high density of pottery imports belonging to the middle and late Roman periods may not be a sign of wealth but instead an indication of high taxation.

Some scholars, who accept the primacy of precious metal, interpret the fineware pottery found even on the site of a wealthy villa as "second-best" ware, to be used when the family was not entertaining; but this is not altogether in keeping with evidence which suggests that materials used for dining varied according to financial circumstances. Thus the Jewish *Tosephta* (written in the 3rd century AD), in discussing a man wanting to apply for public assistance, states: "If he formerly used golden vessels, he must sell them and use silver vessels; if he used silver vessels, he must sell them and use copper vessels; if he formerly used copper vessels, he must sell them and use glass vessels." Ceramic does not even figure in this list, but it was presumably similar in value to glass.

Tripolitanian oil wealth. Olive oil was a commodity of major importance in the Roman world. Apart from its obvious use in the preparation of food, it was one of the principal means of providing artificial light and also formed the basis of most soaps and unguents. It has been estimated that as much as a billion liters may have been required each year. Although olive trees can grow in most parts of the Mediterranean, some areas specialized in oil production more than did others. David Mattingly's recent work has shown how extremely important was Libyan Lepcis Magna and its hinterland in this respect. The tall stone supports of oil presses (their first student thought that they were "idols") have been found all over the hilly area to the west of Lepcis known as the Gebel Tarhuna. They are often to be found in groups of five or ten or more, and are usually situated close to Roman roads or tracks. Their produce was clearly intended to be taken to market. There were hundreds of presses with a potential productive capacity of millions of liters. The dwellings associated with the presses appear to be farms worked by tenants rather than the luxurious rural retreats of an urban elite.

Lepcis' agricultural hinterland was vast (c. 3000–4000

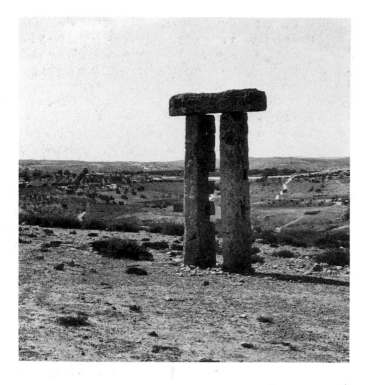

The uprights of a Roman olive-oil press at Gasr Doga in the hinterland of Lepcis Magna in Tripolitania. A modern olive grove can be seen in the distance.

square kilometers) by the standards of most Roman cities, but it seems to have been owned by relatively few landowners. The kinds of amphora used to export Tripolitanian oil – found in the famous Roman rubbish dump, the Monte Testaccio, and increasingly in shipwrecks – have only been recognized for what they are in the past 20 years, but they may have accounted for as much as 10 percent of Rome's annual imports of oil. Many of these amphoras, moreover, bear the names of major families of Lepcis Magna. Their benefactions at Lepcis are well attested, and during the 2nd century some of them had become members of the Senate at Rome (the requirement for which was capital assets of at least 1 million sesterces, the equivalent of 1 tonne of silver). It was a member of one of these families, the emperor Septimius Severus, who not only paid for the erection of the grandest buildings in his native city, but ironically indirectly sowed the seeds of its decline. He bestowed upon the Lepcitans the *Ius Italicum* – the same civic status as the inhabitants of Italy – and in return they made a voluntary donation of oil to the city of Rome, apparently on an annual basis. At the time it seemed to be a good investment in that the Severan dynasty looked as though it was going to endure; as it was, Severus' son Caracalla was the last of the direct male line. Although the oil continued to be produced, it no longer brought wealth back to the city.

It is in large part thanks to the work of underwater archaeologists during the past couple of decades that our understanding of trans-Mediterranean trade has been transformed. The ancient equivalents of the *Mary Rose*, numerous wrecks have been excavated by divers. Their surviving contents are usually amphoras, the baked clay packaging favored for the transportation of wine and oil, and parallels can often be made with amphoras found in excavations on land, thus providing an indication of the origin of a cargo. For example, a ship that sank in the 1st century BC at Madrague de Giens near Toulon contained wine amphoras bearing stamps of Publius Vevius Papus, an individual otherwise known from stamps found in the area of Terracina in southern Italy.

Spectator sports. Carthage possessed the biggest Roman circus in North Africa. During the past few years American excavators have revealed something of its history. It lies in the suburbs of modern Tunis, and its exploration has formed part of the massive international rescue excavation campaign begun under the auspices of UNESCO in the 1970s. Houses were already being built on its site when excavation began, but this was as nothing to the vicissitudes the structure had suffered since serious chariot-racing ceased in about the 5th century. Not only was a huge refuse dump established between the circus and a 5th-century fortification wall constructed to defend the city from the Vandals, but squatters began to live in its neglected ruins. A cemetery developed nearby in the 7th century. The circus building began to be used as a quarry, and deep robber trenches were dug in order to extract masonry for use elsewhere. These trenches gradually filled with rubbish and the whole area lay fallow for centuries. It was a relatively simple procedure for the archaeologists to empty out some of these robber trenches and to reconstruct on paper the way the seating was arranged. This was steeply banked, and included at least 15 rows, with a colonnaded gallery decorated with Corinthian capitals of Pentelic marble running around the top. The actual seats were of limestone and rested directly on a series of concrete vaults constructed at right angles to the track. The capacity of the Carthage circus has been estimated at between 60,000 and 75,000.

The site of the Roman gladiatorial arena has recently been found in London, not far from the Roman fort which once stood at Cripplegate. A team from the Museum of London was investigating the remains of the 15th-century Guildhall Chapel when, just as the excavation was drawing to a close, two Roman walls – one of them curved – were found. It quickly became apparent that they belonged to one of the entrances to the city's Roman amphitheater. Even more interesting was the fact that plans of the city from before the Great Fire of 1666 showed that the streets in the area curved around the Guildhall Yard where medieval jousts, the later counter-

parts of gladiatorial combats, were held. It was also discovered that the Guildhall itself was built on the site of the box which would have accommodated the governor and other dignitaries. The proximity of the arena to the Roman fort is also significant, for amphitheaters often doubled up as places for military training and ceremonial tattoos.

Built in the early 2nd century AD, the amphitheater was demolished late in the 4th. Earlier finds made in the area began to make sense, and it was possible to estimate the dimensions of the Roman building. It seems to have measured 100 by 80 meters externally, with an arena of 60 by 40. Nevertheless, by comparison with many Mediterranean examples, it was small. The amphitheater even at Pompeii (externally 135 by 104 meters) was considerably bigger.

Roman art and its after life. There has been something of a movement away from questions of style and connoisseurship towards an interest in the meaning works of art may have possessed for their original beholders and the context within which they were made. There has been a shift of emphasis from an interest solely in "artistic creativity" to include a consideration of the requirements of a patron. The Laocoon group, Michelangelo's best-known point of contact with antiquity (and also, rather surprisingly, the object of Winckelmann's dictum "Noble simplicity and quiet grandeur") has recently been discussed in this sense. It has been argued that the group was made as a diplomatic gift from a king of Pergamon in Asia Minor to Rome in the 2nd century BC. The subject matter is aptly symbolic of this, for the incident represented was both crucial in the legendary history of Rome and one which took place in Asia, namely the turning point in the Trojan War. If the Trojan priest of Apollo had not been attacked by a pair of serpents, his fellow citizens might have paid heed to his warning not to have anything to do with the Wooden Horse that the apparently departing Greeks had left as an offering to Trojan Athena. If Troy had not been sacked by the Greek army, there would have been no refugees to journey to Latium to found the line from which Romulus and Remus sprang. Against such a background, the Laocoon becomes a gracious gift.

There is a carnelian stone in Oxford made for a member of the court of Tiberius by the gem cutter Felix which bears a related scene, viz. the seizure of the Palladium – an image of the goddess Pallas Athena – from the citadel at Troy. Ulysses remonstrates with his companion Diomedes for having murdered Athena's priestess. Again we have a reference to Rome's earliest legendary history: it had been foretold that without possession of the Palladium, the Greeks could never take Troy; and without Trojan émigrés there would, according to this logic, have been no Rome. Diomedes is supposed to have given the

image of Athena to one of Aeneas' followers and a Palladium was perhaps the most precious object guarded by the Vestal Virgins at Rome. It could be that Ulysses also remonstrates with his companion because he has actually cast unchaste male eyes on the image he has stolen. Neptune in the background turns his back on the scene, and in 241 BC, when the pious Pontifex Maximus Lucius Caecilius Metellus saw the Palladium when he rescued it from a fire, he voluntarily paid for his unintentional sin with his sight.

The Felix gem was once in the collection of Pope Paul II (1464–71), where it was considered to be the most valuable of all his intaglios, being appraised at 1000 gold ducats. At this period it was set in a box adorned with the Annunciation: a Christian parallel not without wit (no Troy, no Rome: no Annunciation, no Holy Mother Church). It is next recorded in a Gonzaga inventory, and was most likely acquired by Cardinal Francesco Gonzaga on the pope's death in 1471. We hear of the cardinal showing his collection of gems to Andrea Mantegna, the Gonzaga artist in residence, in 1472, and we must assume that Mantegna took some impressions, for motifs from the Felix gem occur frequently in his work thereafter. They are present, for example, in the triumphal program which Mantegna composed for Gian Francesco Gonzaga, which included the *Triumph of Caesar* (below, pp. 33–42), and in the *Parnassus* of 1497. One suspects that the gem's subtle Roman allusions appealed to Francesco Gonzaga

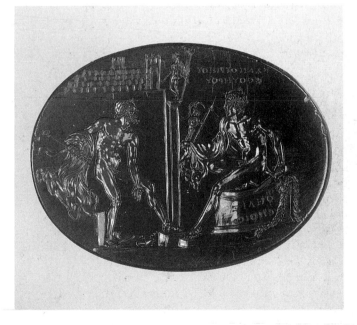

The Felix gem in the Ashmolean Museum, Oxford. Ulysses and Diomedes steal a cult image from the citadel at Troy. Made for a member of the court of Tiberius (emperor 14–37 AD), in the 15th century the gem was in the collections of Pope Paul II and Cardinal Francesco Gonzaga, when it was considered to be the most valuable intaglio of the age.

partly because on becoming cardinal he moved to Rome, and partly because his family were loyal subjects of the Holy Roman Emperor.

It was well known that the Felix gem was next in the collection of Thomas Howard, Earl of Arundel (1585–1646), but until recently it was unclear as to how it got there. David Howarth has discovered the answer in his demonstration that William Petty, Arundel's trusted agent, acquired the Gonzaga gem cabinet in Venice from the dealer Daniel Nys for 10,000 *scudi*. Subsequent owners have been the Dukes of Marlborough, Sir Arthur Evans, Captain E. G. Spencer-Churchill and now the University of Oxford's Ashmolean Museum. This is a particularly happy accident for the Ashmolean also holds the bulk of the remaining sculpture from the Arundel collection, given to Oxford in 1755 by Henrietta Louisa, Dowager Countess of Pomfret, who had become a convert to Horace Walpole's Gothic Revival, and to whom they had consequently become so much old-fashioned rubbish.

Another important development which occurred about the same time was Johann Joachim Winckelmann's rejection of allegory in art. In his *Versuch einer Allegorie*, written between 1759 and 1763, he criticized Cesare Ripa, the author of what had been for 150 years the standard work on classical imagery. "In the whole of the *Iconology* of Cesare Ripa," snorted Winckelmann, "there are two or three passable allegories." Winckelmann's attack was effective in the long term, and an unfortunate by-product has been to cause many students of antiquity to dismiss even the possibility of allegory in ancient art. Recent work by the eminent American scholar William Heckscher has shown how much learning, and how much understanding of the ways of thought of the ancients, went into the composition of Renaissance and Baroque allegories and emblems. In the short term, however, Winckelmann's pique was thoroughly ineffective. Elisabeth Schröter has recently demonstrated that at

the very time Winckelmann was in his employment, his patron Cardinal Albani was busily decorating the rooms of his eponymous villa in Rome with an intricate and learned *Imago Mundi* – a systematic expression of the cardinal's spiritual, humanistic, Roman origin – based principally on Ripa's work. The rule of Apollo the sun is the *leitmotif*, and it is carried through in both the ceiling paintings and the arrangement of the sculpture collection of the Villa Albani.

Many of Albani's statues had been restored by Bartolemeo Cavaceppi, an artist whose work has attracted the scholarly attention in recent years of Seymour Howard and Carlos Picon. Many of his restorations of fragments of antique statues – in reality works of art in their own right – were acquired by English noblemen to adorn their country houses. Born-again Arundels, they hoped to grace their native land with the outward signs of an Italian culture they had acquired on the Grand Tour. Among them was Thomas Coke, later Earl of Leicester, who with the professional aid of William Kent and Matthew Brettingham built a neo-Palladian villa at Holkham in Norfolk between 1731 and 1765. The sculpture gallery at Holkham contains antique statues "by" Cavaceppi, some of which had formerly belonged to Cardinal Albani. It is scarcely surprising, given the spirit of the age, that Apollo occupies pride of place in the central niche.

Signs of the Roman world are all-pervasive. New digs and surveys yield new evidence and new understanding. The increased sophistication of scientific analysis of excavated materials enables us to obtain a picture that was unavailable even ten years ago. Art-historical scholarship is finding new interpretations of the distant past by our more recent ancestors. The revival of interest in Rome ensures that the European community which preceded ours will continue to be interpreted and reinterpreted for decades, if not centuries to come.

Michael Vickers

1. Roman Civilization

Historical background. The time-span covered by this book is fairly wide: from the Italian Iron Age, beginning in the 9th century BC, to the time when the Roman Empire had reached its apogee in the 3rd century AD. These centuries witnessed the emergence of Rome from a cluster of simple villages by the Tiber to the leadership of the Mediterranean and lands beyond. Rome was the chief heir to Greece, and her main achievement was to carry a version of Greek culture, together with a large admixture of her own – in short, Greco-Roman civilization – into parts of the world that were relatively backward and unsophisticated. It would not be an exaggeration to say that if it were not for the Romans the linguistic and administrative face of modern Europe would now be rather different.

We shall see in the following pages how Rome emerged from its obscure origins to become a city. This evolution occurred at a time when, according to legend, Rome was ruled by kings, the last of whom were Etruscan. Under the kings Rome became the leading power in Latium, but when, towards the end of the 6th century BC, Etruscan power was on the wane in central Italy, the kings, so we are told, were expelled and the Roman Republic was set up. It should not be imagined that the early Republic was a democracy; rather it was an oligarchical system established by the local aristocracy – the patricians. They controlled the magistracies, and the state religion, which encouraged a quiet conformity on the part of the people.

By the middle of the 3rd century BC things had changed. The deep respect for religion was still there, but the Roman state now controlled the whole of peninsular Italy, and had in the process become a democracy. The two phenomena were closely linked: external expansion necessitated internal unity, and simultaneously created outlets abroad for problems at home; domestic changes came about as a result of the aristocratic patricians giving way to the plebeians on crucial political points in return for their military support. The chief magistrates were two consuls elected annually from, at first, among the patricians. The Senate was a body of men who theoretically only had advisory powers, but in fact possessed a good deal of moral authority and spoke and acted on behalf of the patricians as a whole. The assembly of the people was divided into 30 wards or *curiae*, and hence was known as the Curiate Assembly. This body had limited powers and was normally controlled by the patricians through their retainers or "clients." The plebeians used the foreign dangers to Rome to their own advantage, even threatening to secede if their political demands were not met. They set up a Tribal Assembly led by annually elected tribunes who ultimately came to have the power of veto over the actions of any magistrate.

Previous page: part of the Forum Romanum, for centuries the center of Roman political and religious life, showing the shrine of Vesta, the Temple of Castor and Pollux and, in the distance, the Arch of Titus and the Colosseum.

The richer plebeians benefited from a reform of the army when recruits were classified into centuries (hundreds) according to wealth. The Centuriate Assembly came to replace the old Curiate Assembly, and position in society came to depend on wealth rather than birth. Plebeians gained access to the higher magistracies and the Senate. The Roman constitution was suited to the management of a city-state and by a system of decentralization it was even possible to make it work in an Italian context, but when, during the period 264–133 BC, Rome stepped outside Italy to become a Mediterranean power, strains were created which led to civil strife during the later Republic and the establishment of an autocratic regime under a series of emperors.

By 200 BC the western part of the Mediterranean was largely under Rome's control, the threat presented by Carthage under Hannibal having been dealt with in a long series of bloody campaigns in Italy, Spain and Africa. The ensuing peace was shortlived, for within a year Roman armies were fighting in the east against the foremost powers of the Hellenistic world, Macedonia and Syria, two of the successor states into which the empire of Alexander the Great (d. 323 BC) had been divided. Victories were won against Philip V of Macedon and Antiochus III of Syria whose own imperial designs were stopped. Not that Rome made any territorial gains herself at this period, but she hoped that the Greeks of the Aegean would voluntarily accept the fact of Roman domination. As it was, the Greek political system was too complex for the Roman Senate to comprehend, and the Greeks failed to understand the real strength of Roman power. A series of wars in the 2nd century BC led to Macedonia becoming a province, with the Greek states dependent on it. When the last ruler of Pergamum bequeathed his kingdom to Rome in 133 BC much of Asia Minor became a Roman province too.

Unfortunately, Rome failed to develop the administrative machinery necessary for ruling the empire she had almost accidentally won. Provinces were ruled by ex-magistrates who were sent from Rome on an annual basis; most of local government remained in the hands of existing cities and tribes. It was very difficult to control a bad governor; even the court set up by the Senate to try malefactors was ineffective, for its senatorial members were reluctant to condemn their colleagues just in order to appease provincials. Another longstanding problem was that military forces continued to be raised on an *ad hoc* basis, at a time, however, when farmers (the traditional source of manpower) were being driven from the land to become the new urban poor. The senatorial aristocracy was putting the wealth won from the provinces into large estates worked by slaves.

Not surprisingly, there was unrest, both at home and abroad: slave revolts and agitation for civil rights on the one hand and dissatisfied and rebellious provinces on the other. In 90 BC, for example, the Italian cities broke out in a

revolt which, however, subsided when they were granted the Roman citizenship they had been seeking for many years. Almost immediately a serious threat was presented to Roman authority in the east when in a single day in 88 BC 80,000 Italian merchants were put to death in Asia Minor. The Greeks had suffered enough from Roman maladministration and extortion. Sulla's military success in the east in the 80s BC was followed by a bloodbath in Rome when his political opponents were put to death – frequently merely on account of their wealth which was needed to pay his veterans (by now professional soldiers) their bonus. Although he chose not to take full advantage of the situation but restored the Senate's position in the state, it was now clear to anyone who cared to take the point that the army was the key to power at Rome.

The lesson was not lost on either Pompey (Cn. Pompeius Magnus, 104–48 BC) or Gaius Julius Caesar (102–44 BC). Both achieved military glory, the one in the east and the other in the west, but it was Caesar who succeeded in seizing sole power after a brilliant campaign in 48 BC. For him the Republic was dead, but not for his opponents who resented his pretensions to kingship and

assassinated him in the Senate in 44 BC. He did, however, succeed in carrying out much-needed reforms that were continued by his eventual successor and adoptive son Augustus, who was careful enough to eschew many of the trappings of power in favor of the appearance of constitutionality. By means of annual grants of tribunician power (the basis of the power of veto traditionally held by the tribunes of the old Tribal Assembly) he was able to avoid Caesar's fate, and to enjoy his autocratic position as head of state. He described himself as *princeps*, the first citizen, but is customarily called the first of the emperors and his regime the Empire. He created an efficient administrative machine and shared the tasks of government with the Senate, whose real authority, however, was now in decline. He encouraged artists and poets – so long as they supported the patriotic ideals of the regime.

Augustus died in 14 AD, and was succeeded by his stepson Tiberius, a member of the Claudii. Down to the death by suicide of Nero in 68 AD the emperors were all members of either the Julian or Claudian families, hence the name Julio-Claudian that is applied to their dynasty. The emperors often set their stamp on their period, and it is convenient to label changing styles and fashions by the name of the emperor or dynasty. Thus, historians and

The Roman world.

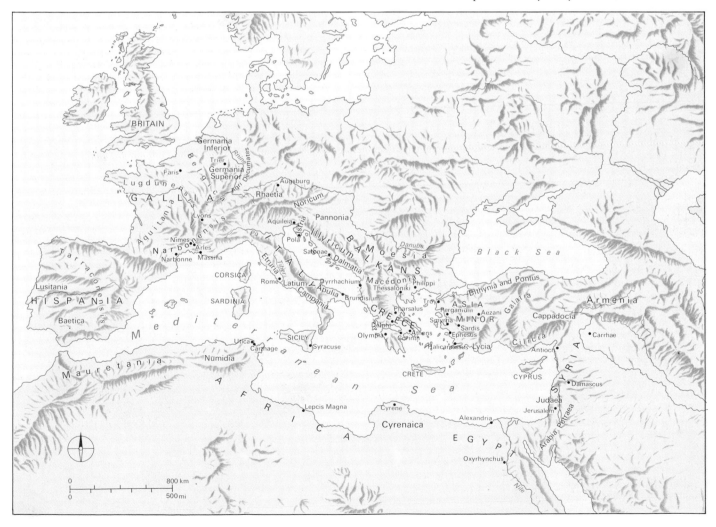

archaeologists speak of the Flavian (69–96 AD), Trajanic (98–117 AD), Hadrianic (117–138 AD), Antonine (138–180 AD) or Severan (193–235 AD) periods.

The fall of the Empire in the west (it continued in the east until 1453) does not concern us in this volume, for it will be treated elsewhere in the series, but we can already see in frontier wars of the 2nd and 3rd centuries AD early signs of the dangers which threatened the Empire from the north. The normal state of affairs during the earlier Empire, however, was peaceful. The Pax Romana, obtained as a result of the reorganization carried out by Augustus and consolidated by his successors, was a remarkable achievement. The peoples of the Empire enjoyed a lasting peace which led to great material prosperity for which, judging by the statues and laudatory inscriptions they erected, they were enthusiastically grateful. The price they paid for stability was the impossibility of any serious political activity and an intellectual climate that did not extend far beyond materialism.

Geographical background. The Italian peninsula lies in the central Mediterranean, something over 600 miles long and between 100 and 150 miles wide. To the east it faces the Adriatic and the Balkans beyond, while to the west it looks across towards Corsica, Sardinia and Sicily. In the north is the rich valley of the River Po which is fed by streams descending from the Alps. This area (known as Cisalpine Gaul) was occupied in our period by Celtic people who were Romanized beyond recognition once Roman authority extended this far. To the south extends the peninsula itself, divided along its length by the Apennines, which skirt the rich lands of Etruria, Latium and Campania on the west before continuing down towards Sicily with the dusty plains of Apulia on their east. The climate and terrain encouraged agriculture and stock raising. Cereal crops would be grown during the mild winter, and be harvested in early summer, and olives and grapes harvested in the fall. Stock raising involved a system of transhumance: the animals were moved from one pasture to another depending on the season of the year. Italy was rich enough to support quite a sizable population, and was host to immigrants from the earliest times.

Directly to the east of Italy lay Illyricum. Istria and Dalmatia on the coast were considered to be Roman lands under the Republic, but the tribes of the interior had inflicted ignoble defeats on Roman armies and only became subject to Rome under Caesar and Augustus. Greece in Republican times was one large province, but in the Empire consisted of two smaller provinces – Macedonia and Achaea. The old cities and shrines of Greece were regarded with great respect during the period of the Empire and were visited by such philhellene emperors as Nero and Hadrian.

Much of Asia Minor was bequeathed to Rome by the last king of Pergamum in 133 BC. The province of Asia

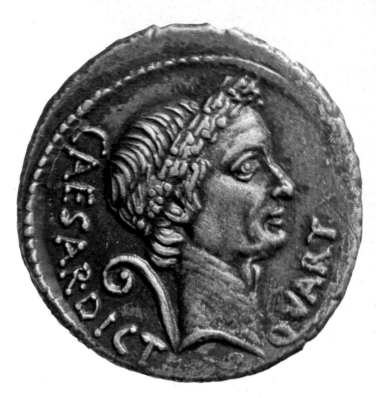

Above: silver denarius of Julius Caesar struck in 44 BC, when he was "dictator for the fourth time." This was the first occasion that a living Roman was shown on coinage. British Museum.

Opposite: statue of Augustus as Pontifex. Late 1st century BC. Museo Nazionale delle Terme, Rome.

included the cities of Ephesus, Sardis, Smyrna and Halicarnassus, but the province of Bithynia and Pontus on the Black Sea to the north was extremely backward by comparison. Galatia, in the center of Asia Minor, was a Celtic kingdom which became a Roman province in 25 BC. Lycia in the south and Cappadocia in the east remained autonomous until the death of Augustus.

Cilicia, which had been a notorious haunt of pirates until Pompey rooted them out in 67 BC, did not become a province until the reign of Vespasian (69–79 AD). Armenia was annexed for a time by Trajan, but its usual role was that of a client state now loyal to Rome, and now favoring the Parthians, Rome's perennial adversaries on the eastern frontier. Syria was an extremely wealthy province, and its capital Antioch, with its fountains and gardens, and even street lighting, was probably the pleasantest city in the Empire. Judaea to the south had a troubled history: a client kingdom under Herod, it became a Roman province in 6 AD and after the final cruel suppression of the Jews in the reign of Hadrian, was known as Syria Palestina. Arabia Petraea became a province in 106 AD and extended from Damascus as far south as the Sinai peninsula and along the east shore of the Arabian Gulf, incorporating the kingdom of the Nabataeans.

Egypt was an anomaly in various ways: it was the last of the Hellenistic kingdoms to give up its independence. Its

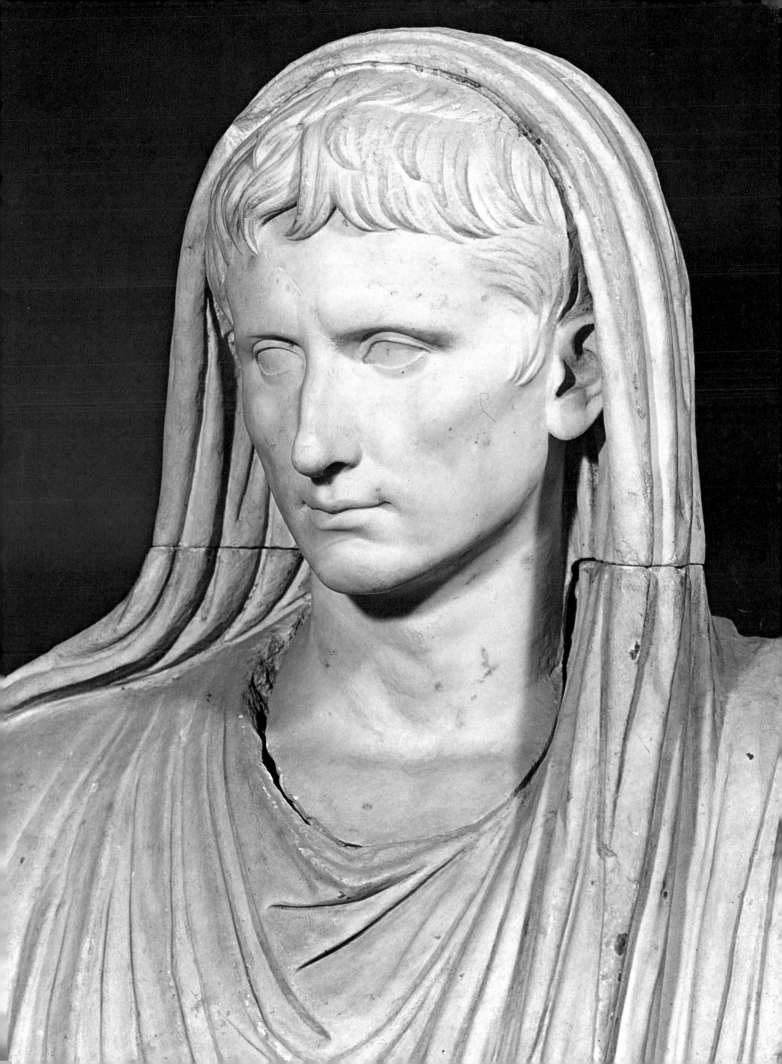

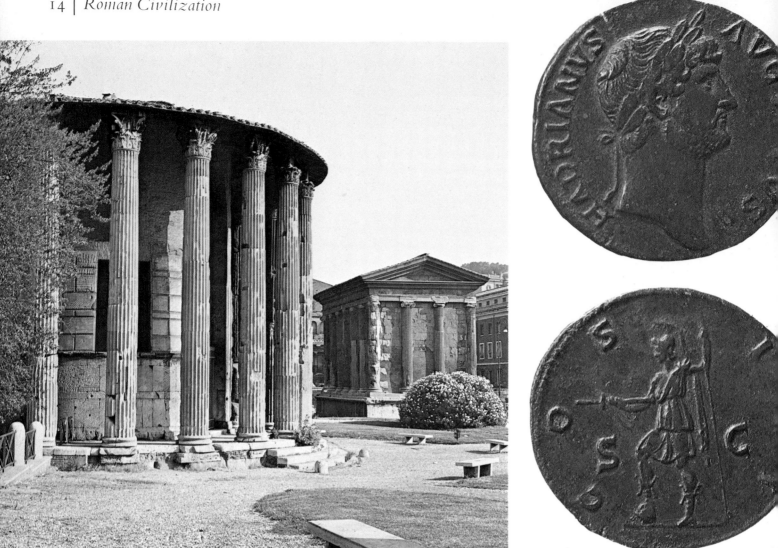

Above: the Forum Boarium with the Temple of Vesta (left) and the Temple of Fortuna Virilis.

Right: observe and reverse of a Hadrianic sestertius. 2nd century AD.

last ruler was the notorious Cleopatra, who, having been defeated at Antony's side at the Battle of Actium in 31 BC, committed suicide soon afterwards. Egypt then became the personal property of Augustus, who ruled over the country as, in effect, the successor of the Ptolemies – a king in all but name. The fertile valley of the Nile brought in an enormous revenue to the imperial purse, and Alexandria was the foremost commercial and cultural center of the Mediterranean. Augustus set up a granite obelisk there, which was moved to New York in 1880 where it now graces Central Park. Its library was unsurpassed, and though no books survive, many papyri of Roman date have been preserved at Oxyrhynchus, a small country town on the Nile. As early as 96 BC Cyrenaica had been willed to the Roman Republic by Ptolemy Apion, and Crete was included in the same province. Cyrenaica was Greek-speaking, and remained so throughout the Roman period, as did all the eastern Mediterranean. But while the Romans tolerated, indeed admired, Greek, they refused to accept Punic, a Phoenician dialect spoken throughout the western part of North Africa, as an official language. Consequently the former Carthaginian lands, the provinces of Africa, Numidia and Mauretania, all rich in fruit and corn, were Latinized.

Southern and eastern Spain had been rapidly Romanized in the 3rd and 2nd centuries BC, but northern Spain was more intractable, and it took Augustus many years to subdue the whole of the peninsula, which under the new order he established consisted of three provinces: Hispania Baetica, Tarraconensis and Lusitania. Gaul under the Empire was divided into four provinces: Gallia Narbonensis, Aquitania, Lugdunensis and Belgica. Narbonensis had been a province since 121 BC, and greatly benefited from Julius Caesar's city-founding activities, whereby the Celtic cantonal system was gradually replaced with the Italian system of urban communities. It was different in the other Gallic provinces, where the cantons for long remained the basic administrative units. Lugdunum (Lyons) was a kind of federal capital of the three Gauls and was the seat of a mint for striking imperial gold coinage. The difference between the three Gauls and Narbonensis can be illustrated by the town names of

modern France. In Narbonensis the local names super-seded the tribal names; thus Arelate, Vienna, Valentia survive in Arles, Vienne and Valence. Further north it was otherwise: the local names fell into disuse and the towns are now called by the names of the old Gallic tribes. Such, for example, is the case with Paris, the ancient Lutetia Parisiorum.

Britain became a province in 43 AD and both there and in Germany a constant problem was the defense of the northern frontier. Fortifications were erected where there were no natural barriers such as rivers. A stretch of 200 miles between the middle Rhine and the Danube, for example, was defended by means of a *limes*, a continuous palisade with an earthen bank and ditch and strengthened with forts at frequent intervals. The two Germanies – Germania Inferior and Germania Superior – occupied the west bank of the Rhine. A forward area beyond the river – the Agri Decumates – was settled by poor and adven-turous Gauls who were prepared to be exposed to the incursions of neighboring German tribes. Rhaetia, Nor-icum, Pannonia and Moesia were the Danube provinces, to the north of Italy and Illyricum. The northern frontier was to be Rome's Achilles heel, when ultimately the Western Empire fell before barbarian invasions.

The legacy of Rome. This book will be largely concerned with Rome's material legacy: the roads and bridges, towns and fortresses that were built or founded throughout the Empire, and which have in many cases left their traces until this very day: the line of a Roman road forming a modern parish boundary, or the site of a Roman fort recalled in the English suffix -*chester* or the Arabic *Qasr*

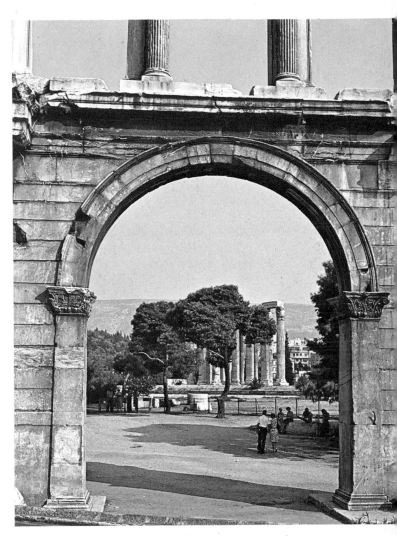

Above: Hadrian's Arch in Athens, built to commemorate his extension of the city's area.

Left: the Tiber valley near its source in the Apennines.

(both derived from the Latin *castra*).

The principal cultural legacy that the Romans left to the modern world was their legal system, which lies at the root of most western codes of law, apart from those of English-speaking countries. Roman law began as ancestral custom which owed its force to religious sanctions. When, however, the Romans came into contact with other nations, the sanctity which surrounded their ancient legal forms was relaxed, and a new conception arose, that of the *ius gentium*, a "law of the nations," which was thought to be a set of fundamental principles held in common by all men. Allied to this conception was the Stoic notion of "natural law" whereby Nature was assumed to favor simplicity and individual equality. Many Roman lawyers of the Empire adhered to the tenets of Stoic philosophy, which was but one of the doctrines that had been taken over from Hellenistic Greece. There was a growing insistence on the part of Roman jurists that the spirit of the law should prevail over the letter and that laws should be

interpreted in a benevolent manner. This humanitarian approach, this sympathetic attitude towards the individual, is characteristic of Rome's legal system in its developed form under the Empire. The best legal brains were devoted to perfecting the law in accordance with the new principles, and the fruits of their efforts were collected in the compilations of Roman legal and administrative practice that were put together at the behest of the Byzantine emperor Justinian in the 6th century AD.

Roman literature, another of Rome's precious legacies, flourished during the strife-torn years of the later Republic but reached its peak during the early Empire. The two main periods were the Ciceronian and the Augustan. From Greek literature were borrowed poetical meters and techniques, as well as literary motifs, but the tired Hellenistic forms were given fresh life by Roman writers. The poet Lucretius (94–55 BC) even propounded a Hellenistic philosophical system – Epicureanism – in the one poem he wrote, *On the Nature of Things*. Epicurus (341–270 BC) had adopted a version of an ancient view of atomic theory: matter consists of minute particles which fall eternally through space. Since all natural phenomena are susceptible of a purely material explanation, death should hold no fear. Man's one good is pleasure, but in moderation, not taken to excess. Lucretius had embraced this doctrine and preached its gospel with enthusiastic fervor and eloquence. The poetry of Lucretius' contemporary Catullus was also imbued with intense emotion, and he ranks as one of the greatest masters of self-revelation in any literature. His deeply personal poetry was largely concerned with his relationship with his mistress whom he calls Lesbia, but who was probably in fact Clodia, the sister of P. Clodius, a political enemy of Cicero's. Catullus' ode to Lesbia's sparrow is well known, but its amusing *double entendres* have until recently passed

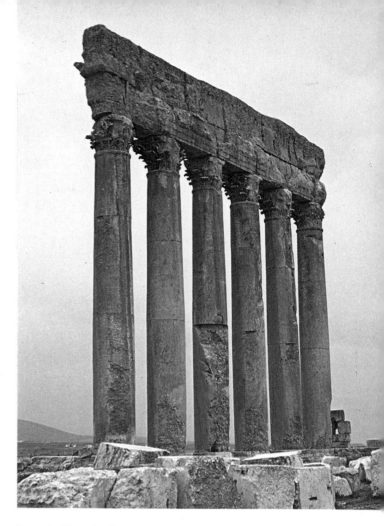

Above: the Temple of Jupiter at Baalbek.

Below left: mosaic from the House of the Evil Eye at Çekmeçe near Antioch showing a "lucky hunchback" and behind him the Evil Eye itself, attacked by various talismans. Antioch Museum.

Below: mosaic panel from a 3rd-century AD floor showing Soteria, a personification of Safety. Hatay Museum.

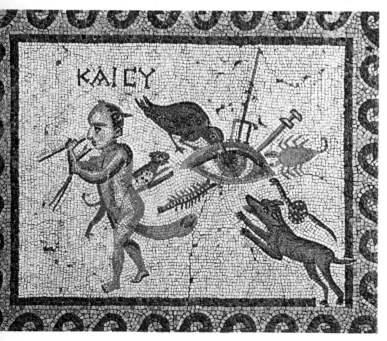

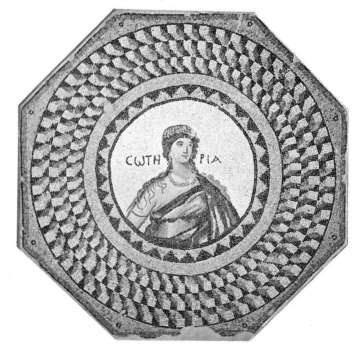

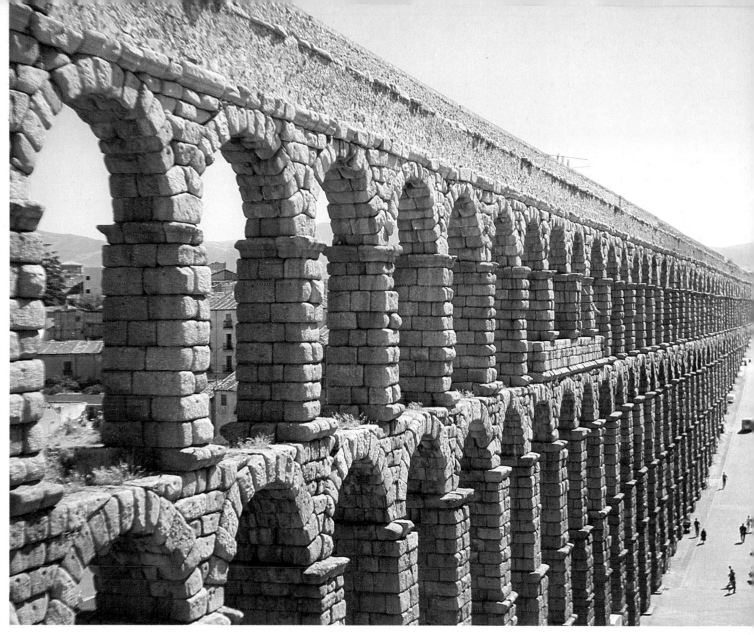

unnoticed. His art was closely based on Alexandrian Greek models but its spirit was his own.

The art of good prose writing had been brought to perfection in 4th-century BC Greece. In 1st-century BC Rome Cicero was foremost in creating equally high standards in Latin for his own and subsequent generations. Born in Arpinum in 106 BC, he was educated in rhetoric and philosophy at Rome and the major centers of Greece, and was thus abreast of current trends in literature and thought. He made his name as a young man as an orator in the law courts by displaying both eloquence and courage. In the speeches against Gaius Verres – perhaps the most damning review of anyone's life that was given to any public – he showed how abominably corrupt had been Verres' governorship of Sicily. Cicero's speeches, whether in legal or political contexts (and at Rome there was very often no difference between the two), set the "classic" Latin style of oratory: plain and straightforward as a rule, and always rhythmical, but ornamental and adorned when the occasion demanded.

He was none too successful in politics, being unable to

The aqueduct at Segovia, built in the 1st century AD and measuring 728 meters in length.

forestall the threat presented by Caesar, and after the latter's victory over Pompey in 48 BC, retired to his studies. Domestic troubles ensued, notably the death of his favorite daughter, but he found consolation in writing philosophical and rhetorical treatises, frequently having to devise expressions for Greek concepts that had never been expressed in Latin before. Throughout his life he was a profuse correspondent and his letters to his friend Atticus reveal him at his most informal. Cicero left his self-imposed retirement in 44 BC to become the head of the legitimate Roman government in the aftermath of Caesar's assassination. The main threat to political stability was from Antony, whom he attacked in a series of outspoken speeches in the Senate – the *Philippics*. The final words of the last speech, dealing with the honors to be paid to soldiers who had died fighting Antony, have a certain poignancy: "if they had been conquerors in life who are conquerors in death." They were in fact Cicero's last

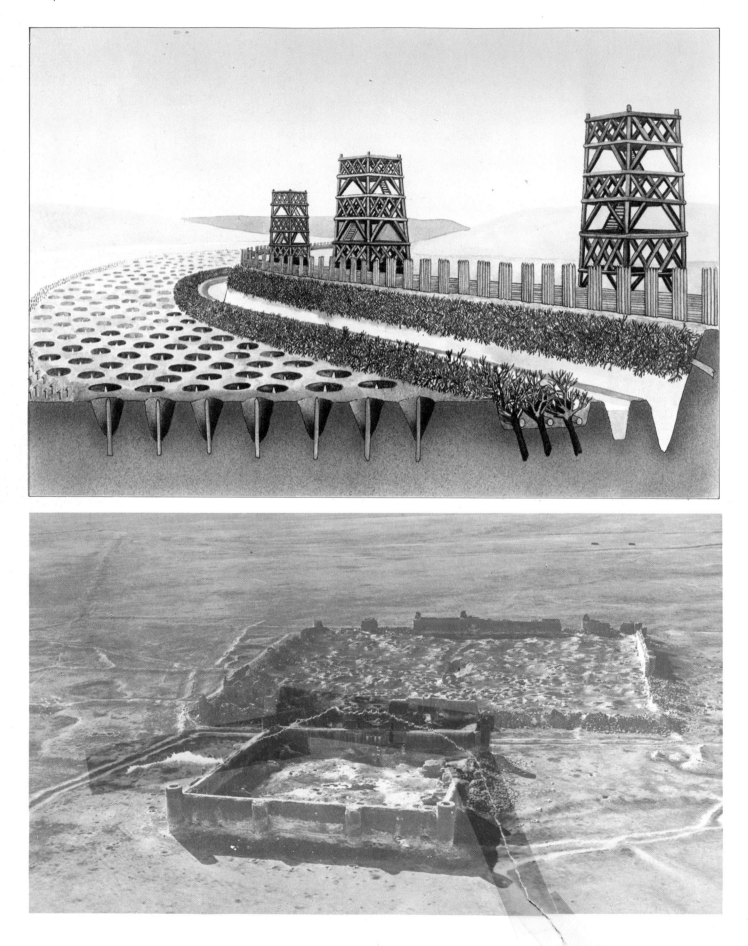

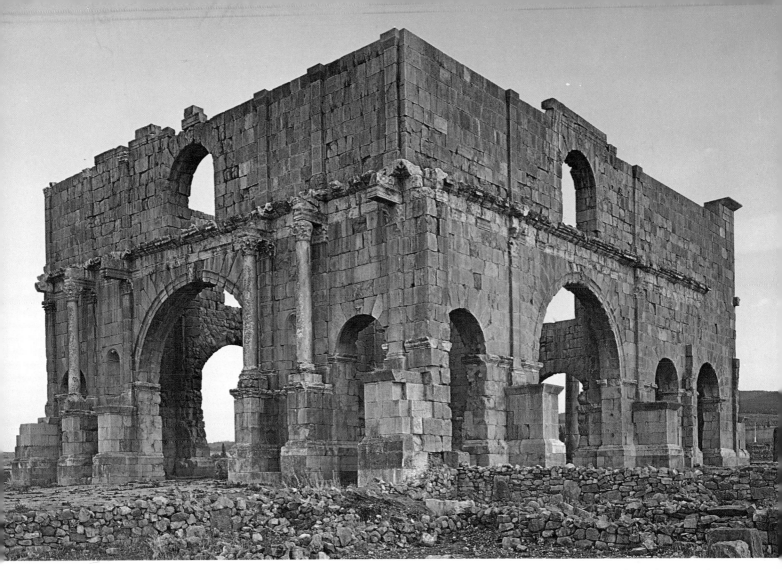

public utterance before he was murdered on the instructions of an outraged Antony at the close of 43 BC.

We shall see elsewhere how Augustus used the visual arts in order to put across his regime's propaganda. The message – that peace and stability had returned and that there was once more hope for the future – was in fact true, and the court poets who sang Augustus' praises did so with a complete lack of insincerity. The poets Horace and Virgil were supported by Augustus and his literary impresario Maecenas. Horace (65–8 BC) was the son of an auctioneer's clerk who had retired to Venusia on the borders of Lucania and Apulia, but took the boy to Rome to ensure that he received the best available education. Horace fought at Philippi, where he distinguished himself by the speed with which he ran away. He then returned to Rome where he earned a meager living as a treasury clerk

until his literary talents were recognized and he was given an entrée to court circles. His wide-ranging poetry might at one moment satirize the little foibles of the world and at another sing the praises of his Sabine farm whither he often retired. His high opinion of his own poetry ("more lasting than bronze, and loftier than the moldering pyramids of the pharaohs") was shared by Augustus who persuaded him to compose the *Secular Hymn* in praise of the imperial house and its deeds.

The poet who took the Augustan message most completely to heart, however, was Virgil. Born near Mantua in 70 BC and educated locally and at Rome, he would probably never have quitted northern Italy permanently had he not been dispossessed of his family estate as a result of Augustus' land reorganization. Echoes of the appropriation are to be found in the pastoral poems, the *Eclogues*, which established Virgil's reputation as a poet and attracted the attention of Maecenas who invited him to join the writers of the court circle and commissioned his next work, the *Georgics*. These beautiful poems were thinly disguised propaganda for Augustus' policy of encouraging a return to the land. They were composed in four books, dealing with crops and weather, the vine and the olive, stock breeding and beekeeping, all described as seen through the sympathetic eyes of a countryman.

Virgil's greatest work, though, was the epic poem the *Aeneid* on which he worked painstakingly for 15 years and which was still unfinished at his death in 19 BC. He had left instructions for the manuscript to be destroyed, but fortunately for posterity Augustus overruled his wishes and published the text more or less as it stood. The poem, loosely modeled on the Homeric epics, consists of 12 books recounting the legendary exploits of Aeneas, who fled from the destruction of Troy to found a new dynasty in Latium whence eventually Rome's equally legendary founders were to spring. There is much more to the poem than this, however, for the real hero is the Roman ideal, expressed as something worth living and dying for, and it is unmistakably implied that Augustus was the leader under whom this ideal was to be achieved. One episode, the love of the jilted Dido for Aeneas and her tragic suicide, captured the imagination of the world and has been a constant theme in literature and music.

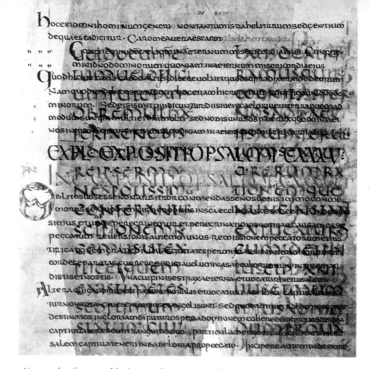

Above: the famous Vatican palimpsest of Cicero's *De Republica* (in a 5th-century hand) overlain by Augustine's commentary on the Psalms (8th century).

Rome produced many more writers of note: the historians Livy and Tacitus, the poets Ovid, Propertius and Juvenal, have all had their admirers in subsequent centuries; but, as so often happens, the most influential Latin writer in terms of the effect he had on modern European literature was neither personally attractive nor in literary terms a great author. Seneca was a moral hypocrite, and his literary style was characterized by Macaulay as being rather like a constant diet of anchovies. Nevertheless, later Christian writers felt that one who wrote so eloquently and edifyingly in his moral writings must have been a virtuous man, and Renaissance dramatists approached Greek tragedy through his melodramatic and oversensational plays.

Finally it should be recalled that the medium in which this literature was written, and in which the business of half the Empire was conducted, was Latin. Latin has left its traces in one form or another in every European tongue, survived for centuries as the language of educated men, and ceased only very recently to be the usual liturgical language of the Roman Church.

Left: bust of Cicero, Roman orator, statesman and philosopher. Uffizi, Florence.

2. The Breakdown and Rediscovery of the Ancient World

The bronze equestrian statue of Marcus Aurelius, one of the few pieces of sculpture at Rome that remained unscathed throughout the Middle Ages. It stood near the Lateran palace for centuries (as in the 15th-century drawing *below*) before being moved to the Capitol in 1538 where it is to be seen today (*above*). The drawing has the emperor dressed in medieval armor. Firestone Library, Princeton. In 1275 the statue was described to Benjamin of Tudela as being of Constantine.

Writing around the middle of the 15th century, Lorenzo Ghiberti describes in his *Second Commentary* the downfall of the ancient world: "In the time, then, of Constantine the Emperor and Sylvester the Pope, the Christian faith triumphed. Idolatry was violently persecuted in such a way that all the statues and paintings, of such nobility and ancient and perfect dignity were smashed or torn to pieces and, at the same time as the pictures and statues, the books and commentaries and drawings and rules that gave instruction in such outstanding and civilized art perished likewise."

This, however, is a highly simplistic view of what happened, and one that is probably colored by faint echoes of the Iconoclastic movement in 8th- and 9th-century Byzantium, but it is one that is still widely held, even in the mind of the educated man in the street.

Decline and fall. Even if Ghiberti had misunderstood its causes, there certainly was a good deal of destruction during the centuries following the great days of Rome and before interest in the antique was revived at the Renaissance. It was, however, a much more gradual business than Ghiberti thought and there were far more factors involved than he suggests. A striking example of the change that had been wrought during these centuries is provided by the number of statues known to have been

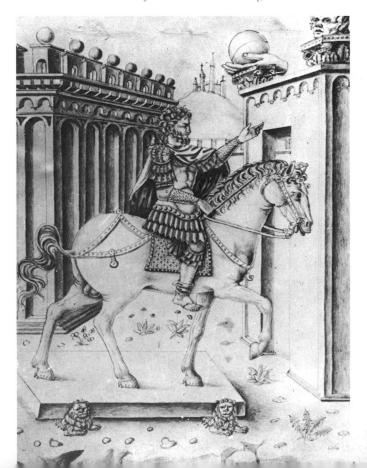

standing in Rome in antiquity compared with those which had survived the Middle Ages. Thus, the 4th- and 5th-century AD *Curiosum Urbis* and *Notitia Urbis* say that there were two colossal statues, 22 equestrian statues, 80 gilded and 74 ivory statues of deities, 36 triumphal arches and 3,785 bronze statues of various kinds. Nearly all of these had vanished by the 15th century, and only a very few arches and half a dozen bronzes remained. These included the Capitoline Wolf, the Spinario, a colossal head of Constantine the Great and an equestrian statue of Marcus Aurelius. The last was seen in 1275 by the Jewish traveler Benjamin of Tudela, to whom it was described as "Constantine, who founded Constantinople." A connection with Constantine, real or imaginary, was frequently enough to secure a monument's survival through the Middle Ages. Surviving bronze statues were clearly exceptional in the 15th century, and the disappearance of others is merely symptomatic of what had happened in Rome in the Dark Ages. But what had caused the change? Ghiberti, as we have seen, ascribed the decay of ancient art and the destruction of ancient artifacts to the supposed iconoclastic fervor of the early Church, but Vasari, writing a century later, was much closer to the mark in attributing them to the effects of the barbarian invasions.

Christianity played its part, of course, but it was a passive, rather than an active participant in the physical destruction of ancient culture. Events such as the destruction by religious fanatics of the Temple of Serapis at Alexandria in 391 AD were very much the exception; in

Roman buildings were frequently used as quarries when material was needed for church building. The choir of the church of San Salvatore at Spoleto contains columns from various buildings, which support a reused Doric architrave.

Rome itself at the very same moment the arguments as to whether or not there should be a statue of the pagan goddess of Victory in the Senate house were being discussed in a perfectly constitutional manner. Laws against paganism were not very efficiently enforced; there were too many pagans and sympathizers to do that, and the very frequency of anti-pagan edicts argues that the introduction of Christianity was a slow process. Generally speaking, though, the pagan temples were closed for pagan cults, and from 408 AD all the taxes originally intended for the upkeep of the temples were confiscated by the state. This inevitably led to problems of conservation and it was not long before *spolia* from dilapidated temples – columns, capitals, architraves and the like – were being incorporated in the large basilicas which became fashionable in the 5th century AD. S. Lorenzo fuori le Mura provides a good example of this at Rome, and even the building ordinance of Majorian, issued in 457, which forbade the demolition of old buildings for the construction of new ones could not halt the destruction. The process continued into the 6th century – and beyond. Thus the marbles moved from Rome to build Theodoric's palace at Ravenna can be paralleled in modern times by the marbles shipped from Lepcis Magna and other Roman sites in North Africa for the construction of Versailles.

The destruction of monuments. At Rome it was not merely a case of buildings falling in of their own accord and then being used as quarries; their destruction was hastened in the 5th century by three violent events: the sack of the city by the Goths in 410, by the Vandals in 455, and by the Goths again in 472. The Goths under Alaric had first appeared outside the walls of Rome in 408, but they had been bought off. Statues had been stripped of their gilding in order to raise the ransom. By August 410 the Goths, their appetites whetted, were back for more. Three days were spent in plundering the city of any valuables the invaders could lay their hands on. The Aventine, the aristocratic quarter of the city, suffered the most, and excavations there have revealed evidence for destruction in the early 5th century. Both public and private buildings suffered in the hunt for treasure. The Decian Baths for instance were undermined so that the main wall of the *tepidarium* leaned outwards, dragging neighboring walls with it. At least this is how we probably should interpret an inscription detailing restorations carried out by Caecina Decius Acinatius Albinus in 414 during the joint emperorship of Honorius and Theodosius II.

The events of 410, however, were merely a foretaste of what was to happen in 455 when the city was methodically sacked over a space of 14 days. We lack any really detailed knowledge of this sack, but one scrap of information is significant: half the roof of the Temple of Capitoline Jupiter was stripped of its gilt-bronze tiles. Metal-hunger was to be one of the main factors behind the deliberate destruction of Classical buildings during the

Middle Ages. Many such buildings had been erected without the use of mortar; instead, blocks of masonry were often bonded together by means of metal (bronze or iron) clamps, and marble revetment slabs were fixed by means of metal nails. The metal was frequently embedded deep in the stone, but in an age when mining and metal refining were much more limited than they had been earlier, it was often worthwhile attacking a Classical building for the metal to be found in it, so that today hundreds of monuments in what was the Roman Empire have a decidedly pock-marked appearance, and thousands more have disappeared altogether. Metal robbing could be conducted on any scale, and at any level in society. Thus, in 629, the Emperor Heraclius visited Rome and presented the gilt-bronze tiles still on the roof of the Temple of Venus and Rome to Pope Honorius I for use on St Peter's. The pope had probably had his eye on them for a long time, but since they were officially imperial property, he could not just seize them. This kind of treatment was not conducive to the survival of the temple's roof, and although a coffered concrete semi-dome still stands, most of the temple is open to the sky.

Another fate, for a marble building at least, was the lime-kiln. A striking example is provided by the Temple of Olympian Zeus in Athens, begun in the 6th century BC, and completed by the Emperor Hadrian in the 2nd century AD, when it was one of the largest temples in the ancient world. Nine-tenths of it, however, was reduced to lime over the centuries, and as recently as the 18th century the Waywode of Athens was still granting lime-burning licences. The lime-kiln is also the reason why even a comparatively well-preserved site such as Cyrene can be so denuded of marble – a site where marble was doubly precious for it had all to be imported from abroad. We know that at Cyrene a lime-kiln was situated in the southwest corner of the Agora, and a nearby temple has for many years been called the Temple of Demeter after a Roman statue of that goddess which was found close by. It now appears, though, that the Demeter was merely standing in line for the lime-kiln, for recent excavations have shown that the temple was in fact dedicated to Apollo.

At first, there were attempts to put a stop to such depredations. Reference has already been made to Majorian's legislation. Theodoric, who had himself re-moved architectural remains from Rome to Ravenna, revived in 500 AD the office of *Curator Statuarum* (an official responsible for the protection of sculpture in public ownership), on the advice of his counsellor Cassiodorus. And Cassiodorus himself tells us how ancient works of art (which significantly were already called *antiquitates*) were at the mercy of lime burners and metal robbers. It helped, he says, that the bronze statues were not dumb, but rang out when struck by the thieves' tools so that the police were alerted. But Theodoric's enlightened, conserva-tionist approach was short-lived, and in 537/8 the city was besieged once more by the Goths. They did not succeed in taking it, but they inflicted a blow from which Rome was not to recover until the 16th century: they cut the aqueducts which for centuries had supplied the city with

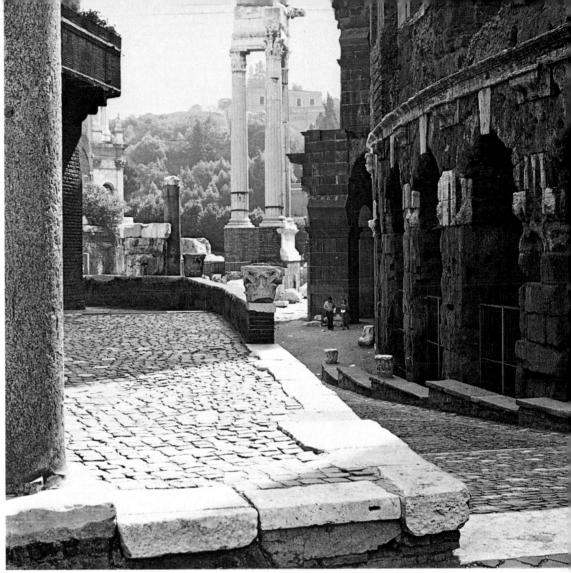

Right: the Theater of Marcellus at Rome, used as a quarry in the 4th century to repair the Cestian bridge. It became the stronghold of the Pierleonis in 1086 and is still inhabited today.

Opposite: the southwest corner of the Agora at Cyrene. In late antiquity there was a lime-burner's yard here which must have accounted for many marble blocks and statues.

water. There was no question of a water famine for there were sufficient wells in the city for survival, and the Tiber was – just about – drinkable, but it did mean that the public and private baths, the 1,212 public fountains and 247 reservoirs were put out of action. Residential quarters on higher ground lost their water supplies and were abandoned, though life went on in the valleys, albeit on a reduced scale.

These, then, are some of the reasons underlying the medieval neglect and abuse of Classical buildings at Rome. It would be possible to devise similar scenarios for other parts of the Roman Empire, with Saxons, Lombards, Huns, Slavs, Turks or Arabs in the starring roles, but the end result was in nearly every case the same: the stone robber, the lime burner and the metal hunter all had a field day.

The survival of monuments. So far, we have been examining reasons for the destruction of Classical monuments. Let us now consider why some of them survived. Some were in places that were isolated; either isolated in any case, or as a result of the depopulation that occurred after the barbarian invasions. Delphi and Olympia in Greece come into the first category; Lepcis Magna in

North Africa, and Aezani in Asia Minor the second. Many buildings, though, survived because they were put to new purposes. Many temples – state property – were handed over to the Church and were converted to ecclesiastical use. Thus, for example, at Rome the Emperor Phocas gave the Pantheon to Pope Boniface IV in 609, who dedicated it as the church of S. Maria ad Martyres. There is an interesting reason for this name. The countryside around Rome had become increasingly insecure and unhealthy, and it was felt necessary to house the bones of the martyrs within the city of Rome. Accordingly, 28 cartloads of bones removed from the catacombs were placed in a porphyry basin beneath the high altar of the new church. The Temple of Antoninus and Faustina in the Roman Forum became the church of S. Lorenzo in the 7th or 8th century. In the Forum Boarium, the Round Temple became first the church of St Stephen, but was later to be known as S. Maria del Sole, and the so-called Temple of Fortuna Virilis was converted into a church in 872. Secular Roman buildings, too, became churches: the Senate house in the Forum was dedicated to S. Adriano by Pope Honorius I in c. 630. In Trier the upper part of the Porta Nigra, or what was left of it, became the church of St Simeon in the 11th century, the hermit Simeon having

occupied it for many years as a kind of northern stylite. There are numerous other examples, but the point has been made.

Other Classical buildings were put to a more practical use. Many of the more imposing remains readily lent themselves to a defensive role. At Rome we know that in the later Middle Ages aristocratic families set themselves up in such buildings as the Theater of Marcellus or the Arch of Titus. This was when Rome had become even more impoverished and insecure after the Norman sack of 1084. Amphitheaters made particularly good fortresses. Those at Arles and Nîmes in Provence were fortified in the 8th century. Temples could become town halls. The Maison Carrée at Nîmes became the Hôtel de Ville in 1050, a function it was to perform until 1540, and even today the town hall at Pola in Istria is in a Roman temple, though its Gothic facade was added in the 13th century.

The columns of Trajan and Marcus Aurelius at Rome survived for yet another reason: they were a profitable source of income to their owners. The abbess of S. Ciriaco owned the first, and the monks of S. Silvestro in Capite the second. An inscription has been preserved which tells us that the Column of Marcus Aurelius and the church formerly at its foot were let out to the highest bidder, probably on a yearly basis. The successful entrepreneur could then collect the fees from the tourists and pilgrims who wished to see Rome from the top of the column.

Medieval encounters with antiquity. A handbook existed for the use of pilgrims, the *Mirabilia Urbis Romae* or *The Marvels of the City of Rome*. The information it contains was aimed at the pious, and most of the explanations of the remains of Classical antiquity are far-fetched or fanciful.

In a slightly different class is the *De Mirabilibus Urbis Romae* of Magister Gregorius, a cleric, probably English, who visited Rome in the 12th century. He recorded numerous monuments, both pagan and Christian, and occasionally displays a prurient interest in ancient statuary. A nude Venus in particular caught his eye, perhaps the Capitoline Venus, "on account of its extraordinary beauty." He says of it: "This image of Parian marble was made with such perplexing skill that it seems to be a living creature rather than a statue: for her face is tinged with a rosy glow like to one who is blushing at her nakedness. And if you go up close, you can see the blood infusing her snow-white cheeks. Her remarkable appearance so bewitched me that I was compelled to go back to see her again three times, even though she stood a couple of miles from where I was staying." His reaction is akin to that of a 15th-century humanist, and is in fact symptomatic of the "proto-Renaissance" which seems to have occurred in the 12th century.

John of Salisbury tells us of the antiquarian interests of yet another 12th-century cleric, again from England. Henry of Blois, bishop of Winchester and brother to King Stephen, visited Rome on three occasions in the middle of the 12th century. Before leaving after one of these visits "he obtained permission," we are told, ". . . to buy old statues at Rome, and had them taken back to Winchester." John tells us that a grammarian at the papal court teased Henry by quoting an apposite tag from Horace, and continues: "it was this man who was to reply for the bishop, unprompted, but perhaps expressing his point of view: that he had been doing his best to deprive the Romans of their gods to prevent them restoring the ancient rites of worship, as they seemed all too ready to do, since their illborn, inveterate and ineradicable avarice already made them idol-worshipers in spirit." While this statement may well reflect John of Salisbury's views, it almost certainly does not give an accurate account of Henry of Winchester's motivation. We might have had a better idea of this had the statues survived, but they have disappeared. It is very likely, though, that he too was influenced by what might be called the proto-humanism of the 12th century. This was the period when the great universities were being founded, and when a poet such as Hildebert of Tours could write verses in which the magnificent ruins of Rome evoke memories of an even grander past:

> Rome, thy grand ruins, still beyond compare,
> Thy former greatness mournfully declare,
> Though time thy stately palaces around
> Hath strewed, and cast they temples to the ground.

The same spirit recurs in an inscription immured in a medieval house at Rome which also incorporated Roman architectural fragments arranged in a decorative manner. The inscription reads, in part: "Nicholas, to whom this house belongs, well knew that the glory of the world was vanity. He was induced to build this dwelling, less by vanity than by the desire to restore the splendor of ancient Rome."

Smaller objects than sculpture and architecture were also appreciated by medieval connoisseurs, though not always for similar reasons. An Abbé Suger, it is true, might enjoy a collection of ancient intaglios in much the same spirit as Henry of Winchester might have done. But vessels made in precious metals – gold, silver or rock crystal – survived on account of their intrinsic value, often in cathedral treasuries. Ancient intaglios and cameos were often mounted on reliquaries or crosses and, if they were insufficient, new, cruder pieces might be made in glass paste after ancient models. There were sometimes superstitions concerning potsherds – fragments of broken pottery that litter many a Roman site. For example, when pieces of Arretine ware were found near Arezzo in the 1280s, we find Ser Ristoro d'Arezzo writing in his *Composition of the World* that this "exceedingly noble and miraculous artifice" had so much impressed contemporary artists that they decided that the potters must have been divine, and that the vases from which the

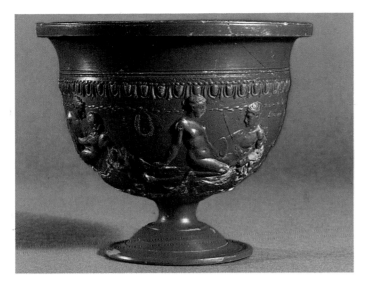

An Arretine bowl by the potter Tigranus (*fl.* 10 BC–10 AD). Arretine sherds found near Arezzo in the 13th century were said to have "fallen from Heaven." Ashmolean Museum, Oxford.

A sculptured head of the Emperor Augustus, such as the bronze example in the Vatican (*left*) with its classicizing features and stylized curls, was probably the model for the colossal stone head (*right*) of Frederick II, self-styled Emperor of the West from 1220 to 1250, which was found at Lanuvium (German Arch. Inst., Rome).

fragments came had descended from heaven! Even as late as 1348, Giovanni Villani could say in his *Florentine Chronicle* that it seemed that the pots found at Arezzo could not have been made by human hands.

Others clearly did know what they had unearthed. The imperial ambitions of Frederick II, self-styled Emperor of the West from 1220 to 1250, were well known, as was the fact that he closely modeled his regime on that of the Roman emperors. He stated that "We recall the ancient Caesars to men's minds by the example of our own person," and styled himself *Imperator Fredericus Romanorum Caesar Semper Augustus*. Against such a background, it is hardly surprising that a colossal portrait head of Frederick, found in the 1950s at Lanuvium, on the Via Appia about 20 miles southeast of Rome, should display typically Augustan features. There are obvious connections with contemporary Gothic art, but the underlying inspiration was undoubtedly a portrait of the Roman Emperor Augustus. Such portraits are known in their hundreds, and must have been made in their thousands, so it is easy to understand how Frederick knew what Augustus' features were like (even if he only knew them from coins) and instructed a sculptor to adopt an Augustan prototype for his own portrait. This is probably the first case in modern times of the political exploitation of

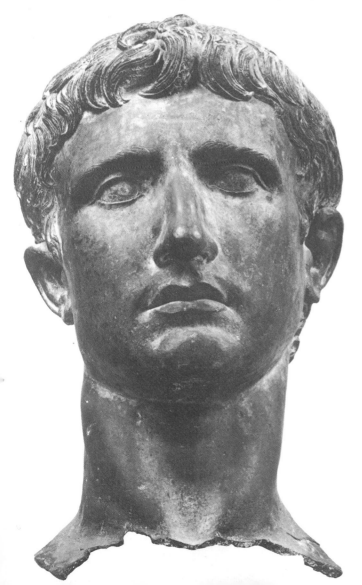

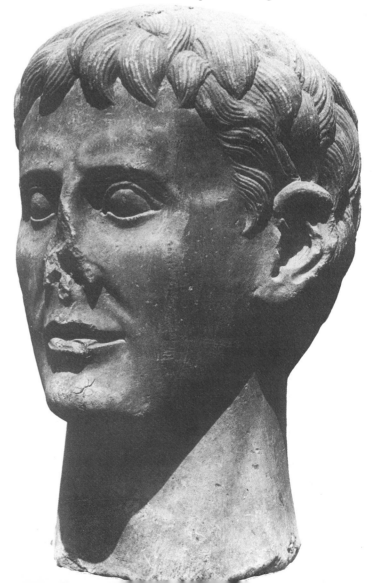

Stuart's drawing of a ruined portico of c. 300 AD known by the Spanish-speaking Jews who lived near it as the Incantadas – "the Enchanted Ones." Until it was removed to the Louvre in 1865, one of the principal sights of Thessaloniki.

Philip von Stosch and Roman antiquaries. Archaeologists' love of gossip was used in 18th-century Rome as a cover for espionage.

archaeological material (the most notable ancient example perhaps being the Invention of the True Cross). Frederick stands at the beginning of a tradition which included Lovato Lovati who in 1283 identified a large skeleton as that of Padua's legendary founder Antenor, and the ill-starred Cola di Rienzo who briefly rose to power at Rome in 1347 by exploiting his knowledge of Roman inscriptions; a tradition which has had a recent representative in the person of Mussolini, who attempted to recreate an empire modeled on Rome's and exploited Roman art to the full in furthering that aim.

But not everyone had such insight into Classical remains. Ancient marbles were still fair game for the lime burner, though many probably owe their survival to the fact that they entered popular folklore, which, to do it credit, sometimes reveals a hazy notion of antiquity. An extraordinarily large *oeuvre* was attributed to Constantine. Alexander the Great, too, collected stories and this was certainly aided by the success of the Alexander Romance in medieval Europe and Asia. Thus, for example, of the ruins of a portico of the late 3rd or early 4th century AD at Thessaloniki, it was said that the stone figures on it – all in fact figures from Classical mythology – were members of the Thracian court who had been petrified, on account of a

misunderstanding of an amorous nature, "by Alexander's conjuror, Aristotle."

Another way in which Classical remains were exploited was by artists finding inspiration in them. At more or less the same time as the artists of Arezzo were expressing devout thoughts about Arretine pottery, an artist at Pisa, Nicola Pisano, was already exploiting Classical prototypes. He was one of the first artists of the later Middle Ages to have been influenced by Classical sculpture. Vasari tells us that he saw, among "many marble spoils brought to Pisa by the Pisan navy, a few more ancient pieces . . . One of them was especially fine, on which was carved the hunt of Meleager and the Calydonian boar." Nicola set about imitating the sculptural style of this and other antique sarcophagi "with such effect that he soon came to be considered the best sculptor of the time." The word for spoils in the original Italian is *spoglie*, and is the one regularly used for recycled fragments of ancient marble, whether for rebuilding or for the lime-kiln. It had long been the practice of Pisan ships to collect *spoglie* from the ruins of Ostia at the mouth of the Tiber, as well as from Rome itself, and to take them as building materials for the cathedral at Pisa. *Spoglie* had thus been going to Pisa for centuries, but Nicola was the first to realize that any of them had any intrinsic aesthetic value.

Petrarch. There were other medieval encounters with antiquity of course, but those we have examined are typical. They are all remarkable for being exceptional in terms of the age in which they occurred. It was only after Petrarch (1304–74) that interest in antiquity was slowly to become the norm for the educated European. Petrarch's main interest lay in Classical literature and he was very active in collecting texts and building up a splendid library. His first visit to Rome in 1337 affected him deeply and his subsequent writings often express the sense of wonder and awe he had experienced when wandering among the ruins of ancient Rome. As a result of his close acquaintance with Classical literature, he was able to make useful additions to knowledge of the topography of Classical Rome. He also used Roman coins as historical sources, but was always conscious of the departed grandeur of Rome that they evoked. This emerges vividly from an account he gave in a letter to a friend of a meeting he had in 1355 in Mantua with the German Emperor Charles IV: "The occasion offered itself for me to do something that I had long intended. I gave him some gold and silver portraits of our emperors which had legends in extremely small old-fashioned letters, things that had always delighted me. Among them was a head of Caesar Augustus, who seemed almost to breathe. And I said, 'Behold, your majesty, you who are their successor, behold those whom you should strive to imitate and admire; fashion yourself after their shape and likeness. I should not make this gift to anyone but you, but your omnipotence impels me. My task is to know the customs,

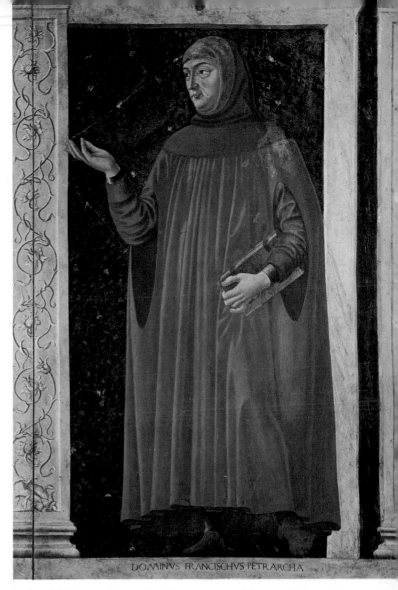

Andrea del Castagno's portrait of Petrarch, one of the most influential figures in the creation of Classical taste in 14th-century Italy. S. Apollonia, Florence.

The church of S. Nicola in Carcere at Rome can be seen in a 15th-century manuscript built up against a Roman temple. Darmstadt Landesbibliothek.

names and history of these emperors; yours, however, is not merely to know about them but to live up to them.'"

The impetus that Petrarch gave to iconographical studies left its mark in the decoration of the Reggia, the palace of the Carrara family at Padua. Several rooms of this building were painted with murals bearing scenes from mythology and ancient history. Details of one room, the Room of Famous Men, were derived directly from Petrarch's *De Viris Illustribus*, which was actually dedicated to Francesco I da Carrara. The frescoes, which depicted the deeds of Roman heroes, have long since disappeared, but we can get some idea of their probable appearance from an illuminated version of Petrarch's work, now in Darmstadt. In the background can be seen recognizable representations of Roman monuments – the Colosseum, the Pantheon, the Vatican obelisk, and even the church of S. Nicola in Carcere with part of an ancient temple immured in one of its walls. These details could well derive from the archaeological notes and (roughly) measured drawings made by Petrarch's friend Giovanni Dondi, a physician from Padua on a visit to Rome in 1375. Strangely, the participants are all shown in contemporary, late medieval dress. It was not in fact until Mantegna in the second half of the 15th century that Classical dress was to be used at all consistently in historical or mythological scenes. The only notable exception to this rule was in the matter of headgear, where artists sometimes attempted to approximate to Roman wreaths, helmets or crowns. This phenomenon attests the widespread knowledge of Roman coins, and sketches were made from them that circulated even before Petrarch began to take an interest in such things. An amusing late example occurs on one of a series of panels painted in Padua by Nicoletto Semeticolo around 1450, now in the cathedral at Padua. The emperors Diocletian and Maximian are shown in judgment on the martyr-to-be Sebastian. One emperor wears a conventional medieval crown, while the other wears the kind of spiky "radiate" crown that frequently occurs on late Roman coins. That the emperors are meant to be seated within a pagan temple is indicated by means of an antique marble statue of a nude hero standing on an altar; otherwise the setting is completely Gothic and unclassical.

The beginnings of epigraphy. We have seen that Petrarch remarked on the "old-fashioned" writing on Roman coins. What he meant was that it was very different from Gothic script, and it is clear from references by other writers that Petrarch's contemporaries found Roman inscriptions difficult, if not impossible, to read. Even when they could be read they were frequently misinterpreted: an inscription referring to the Roman freedman T. Livius Halys unearthed at Padua between 1318 and 1324 was widely regarded as belonging to the tomb of the historian Livy. From the early 14th century onwards, Roman inscriptions began to be collected in earnest, and the information on them exploited. Thus, in

1398, Pier Paolo Vergerio was able to show, simply by reading the inscription on it, that the Pyramid of Cestius outside the Porta S. Paolo at Rome was not the tomb of Remus as had been traditionally thought. Many Italian humanists compiled sylloges (as collections of transcriptions of inscriptions were called), haphazardly at first, but then more methodically, paying attention to where they were found. Cyriac of Ancona was one of the foremost of these early epigraphists. He had recorded inscriptions in Italy (correctly attributing the arch at Ancona to Trajan in 1420), before setting out on his journeys to Greece and Asia Minor where he gathered a great deal of antiquarian material – inscriptions both Greek and Roman, as well as descriptions and drawings of sculpture and architecture. His inscriptions were to enter the sylloges, and his sketches to inspire the compositions of Renaissance artists.

Cyriac's discoveries were spread largely through the activities of Felice Feliciano, a professional scribe of Verona who was also a man of letters in his own right, and who was known by his contemporaries as "the Antiquary." He too collected inscriptions, his interest stemming largely from the fact that they provided valuable information concerning Latin orthography. It is to Felice that we owe the delightful account of an archaeological field trip on Lake Garda which took place in September 1464. Those taking part were Felice himself, the artist Andrea Mantegna, the humanist Giovanni Marcanova and Samuele da Tradate. The first day's account is mostly concerned with the rich and abundant orchards on the north shore of the lake, though the intrepid travelers do discover a "retreat of the nymphs" and record one inscription. By the next day they have adopted the personas of ancient Romans: "Samuel was emperor, Mantegna and Marcanova were consuls, and yours truly was procurator. Merrily we went, covered with flowers, through the shady laurels. We made Samuel a crown of myrtle, ivy and sundry branches, and then we came across an old church of St Dominic. We went in and found an inscription of Marcus Antoninus Pius Germanicus Sarmaticus Emperor. Then, not far from a church of St Stephen, we found on a portico a fine inscription of the Divine Antoninus Pius, the grandson of the Divine Hadrian, a former inhabitant of the district . . . We found moreover a retreat of quiver-bearing Diana and the nymphs which we had good reason to know could not be anything else. When we had seen all these things we sailed by Benaco on Neptune's liquid plain in a boat fitted out with rugs and . . . adorned with laurels and other noble branches, the emperor Samuel himself playing the cithara and shouting for joy all the while. At length we crossed the lake in fine style and sought a safe port. We tied up our vessel and went into a church of the Blessed Virgin in Garda. There we praised the Supreme Thunderer and His Glorious Mother, in particular since He had inspired us to join forces and had given us the idea to seek out such grand spots; since He had made such excellent and diverse

Cyriac of Ancona's sketches of late Roman monuments in Constantinople contributed some details in Mantegna's *Agony in the Garden*: the *sphendone*, a tower on the walls and a statue of Justinian on a column. National Gallery, London.

A Roman Capriccio by Panini (1691–1765), with some of the monuments to be seen in Rome in the 18th century, including the Colosseum, Trajan's Column and the Farnese Hercules, Ashmolean Museum, Oxford.

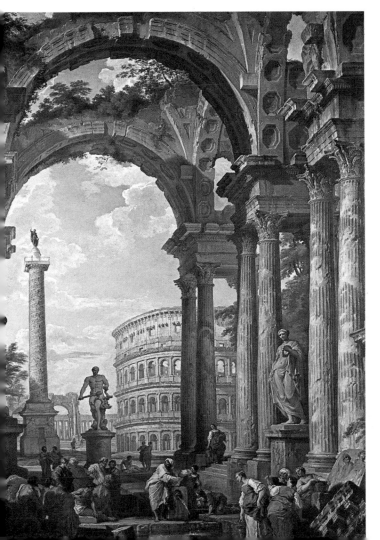

delights and so many antiquities appear with such promptness; and since He had bestowed on us such good sailing, and a safe landfall . . ." The "Supreme Thunderer" is of course a reference to Jupiter; there is a deliberate confusion of pagan and Christian in Felice's account which, however, was probably meant for literary effect rather than as an expression of strongly held heterodox beliefs. Moreover, despite the lightheartedness of the account – a kind of 15th-century *Four Men in a Boat* – the underlying objective of the participants was basically serious, namely to record inscriptions that had not been read with understanding for centuries.

Renaissance interpretations of antiquity. The antiquarian knowledge acquired by Renaissance humanists was applied in various ways. Mantegna would incorporate views of Classical ruins – real or fantastic – in his pictures, and even an occasional inscription. He would use drawings of Roman reliefs in sketchbooks that circulated among artists of northern Italy as the basis for the compositions of some of his pictures. Thus it has recently been possible to demonstrate that details of a Roman census frieze, now in the Louvre, underlay several passages of the *Triumph of Caesar* in Hampton Court. Others might write local history. Foremost among these was Flavio Biondo (1388–1463), described by his younger contemporary Vespasiano da Bisticci as "a diligent antiquarian who wrote several works which threw considerable light on past times" – as indeed he was: among his achievements was to invent the concept of the "Middle Ages." He wrote a history of Rome – his *Roma instaurata*, first printed in 1471 – "wherein," says Vespasiano, "he wrote luminously concerning the splendor of the republic, of its buildings, and everything else, for the benefit of those who desire to possess some knowledge of the times. After finishing *Roma instaurata* he saw how greatly Italy had changed; a number of cities and towns, which were formerly inhabited, now lay deserted and ruined and without any record that they had ever existed. Not only had the cities themselves disappeared, all knowledge of the men of mark who might then have inhabited them had also perished. Therefore Biondo determined to revive and illuminate the Italy of the past by writing a book, *Italia illustrata*, describing the country as it once was, not only those places and districts which remain, but every village, however small and humble it might be, and every river, and if any one of these had been the scene of memorable events in the past he names it. This is a work worthy of notice, and one over which he spent great care and close investigations. Biondo also deserves praise for the vast labor he devoted to the benefit of all, and, if others before him had been as diligent recorders as he was, we should see the past more clearly than we now see it, for it is a thousand years and more since anyone wrote as he has written. Therefore the whole world should be grateful to Messer Biondo for what he has given us."

An influential figure in the transmission of this kind of interest in local antiquities to other parts of Europe was Conrad Peutinger of Augsburg (1465–1547), who studied in various north Italian universities in the 1480s and also visited Rome. Here he seems to have met and been stimulated by Pomponius Laetus, who had founded an academy at Rome, modeled on the ancient academies of Greece and Rome. Its members took antique names, and they would gather in Pomponius' house on the Quirinal, the walls of which were decorated with 40 or 50 Classical inscriptions. Within a few years, Peutinger, back in Augsburg, was at the center of a similar circle of humanists. Local businessmen and even canons of the cathedral were members of a literary sodality, and they assisted Peutinger in systematically recording the Roman inscriptions of the neighborhood of Augsburg. We hear first of two, then eight, and then fifteen local inscriptions decorating the walls of Peutinger's house, in direct imitation of the houses he had seen in Italy. Twenty inscriptions were published in 1505. Soon collections of inscriptions from the countryside around Mainz and Trier were being published, and by 1534 the first corpus of all

the known Roman inscriptions in the world was printed at Ingolstadt, including examples from Spain and the Holy Land as well as Italy and Germany. These sylloges were often used as sources for the history of Roman settlement in a region. For example, the Bavarian historian Aventinus (1477–1534) included in his Chronicle a whole chapter on the ruins and inscriptions which proved Bavaria's Roman past (including a monument to the emperors Septimius Severus and Caracalla "from which an old woman had made a stool"). There were strong political reasons underlying this interest in Roman antiquities in Germany: the gentry wished to link themselves with the Roman Empire in order to strengthen the claims of the Holy Roman Empire and its successors. The French were slow to take an interest in Classical antiquity. The earliest inscriptions to be recorded from Lyons are preserved in a late 15th-century manuscript now in Oxford, and were probably collected by Francesco Sassetti, the manager of the Medici bank, who is known to have visited Lyons while attending to the bank's affairs in Geneva.

So far, the outlook of northern antiquarians was not at all dissimilar from that of Italian humanists, but there was to develop north of the Alps an archaeology that was less classically orientated, and one in which the Roman period was but one chapter in the history of a locality. Non-Italian humanists retained, nevertheless, a deep interest in the antiquities of Italy and many years were to pass before any real dichotomy is noticeable between Classical and local archaeologists. Two separate traditions did evolve, however, although it is often difficult to disentangle them.

Below right: the Porta dei Borsari at Verona, built in the mid-1st century AD at the west gate of the city. It was admired by Cyriac of Ancona in 1433, who noted that it was "constructed from living rock, had two arches and was adorned with 12 windows." When Felice Feliciano of Verona came to include the monument in an illuminated codex, he drew it according to Cyriac's description (*below*), without even going to look at it – a salutary commentary on the Renaissance attitude to antiquity. Biblioteca Estense, Modena.

The Triumph of Caesar

Andrea Mantegna was born near Padua in 1430, and at the age of 11 was apprenticed to Francesco Squarcione, a painter who encouraged his pupils to work from his collection of Classical sculpture and casts. Padua, where Mantegna spent his earlier life, and Mantua, the city in which he was to make his home (until his death in 1507) as painter at the Gonzaga court, were flourishing centers of humanism. Archaeology and ancient history

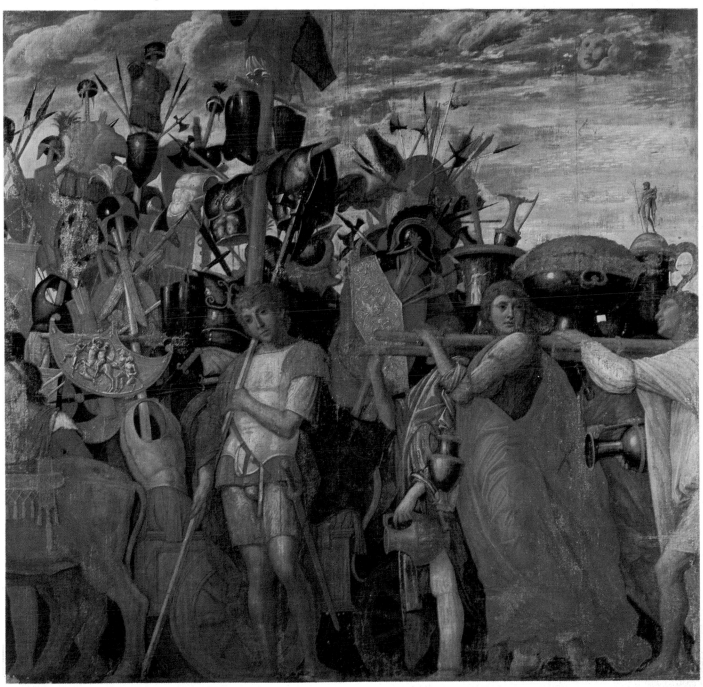

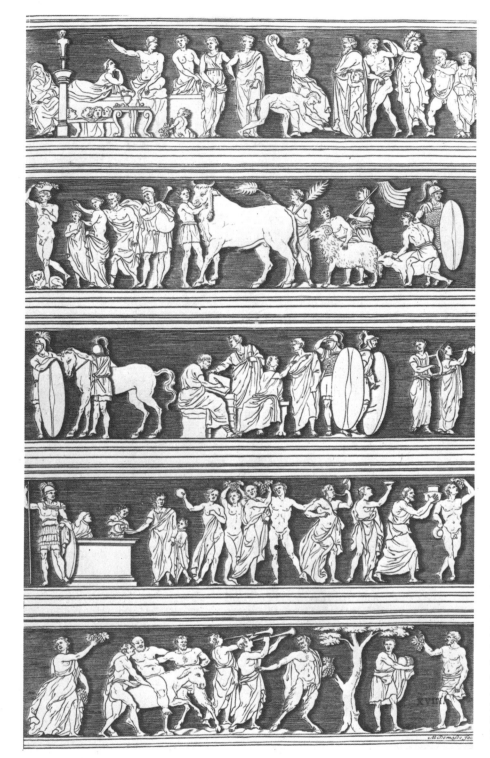

Around 1486 Mantegna acquired sketches of Classical reliefs that were visible in Rome in his day. Some of the original reliefs, which came from the same ancient monument, and stucco copies of the others were together in 1679 when the French antiquarian Jacob Spon saw them in Palazzo Santacroce in Rome and published sketches (*left*) in his posthumous *Miscellanea Eruditae Antiquitatis* (Lyons, 1685). The reliefs were recorded as being built into the frieze around the courtyard of Palazzo Santacroce (*opposite*) until the early 19th century when the Census frieze of the so-called "Altar of Domitius Ahenobarbus" (*above*) was sold to the Louvre, and a marine relief went to Munich. The stucco copies of an Ikarios relief and the Bacchic sarcophagi are not recorded after 1842.

Mantegna skillfully recomposed the figures in the sketches in the designs for his *Triumph of Caesar* and other works. Caesar's Gallic triumph was an appropriate theme for a work commissioned by the young Gian Francesco Gonzaga who had had a military education and had traveled through Gaul to attend the Diet of Frankfurt early in 1486.

were highly regarded, and Mantegna was inspired to use Classical prototypes in many of his paintings. Since he did not visit Rome until 1488, his knowledge of Roman monuments before then was derived from sketchbooks. The sketchbooks that Mantegna used have disappeared, but it is possible to reconstruct the contents of the one that he employed for many passages of the *Triumph of Caesar*, nine canvas panels painted between 1486 and the years immediately after 1490. They were originally intended to adorn a room in the palace at Mantua, but suffered various vicissitudes before being sold to Charles I in 1627.

They were placed in Hampton Court (a palace 15 miles southwest of London) where they have been virtually ever since. Between 1962 and 1975 they were cleaned of centuries of over-painting and now, for the first time in 500 years, we can see something of their original glory.

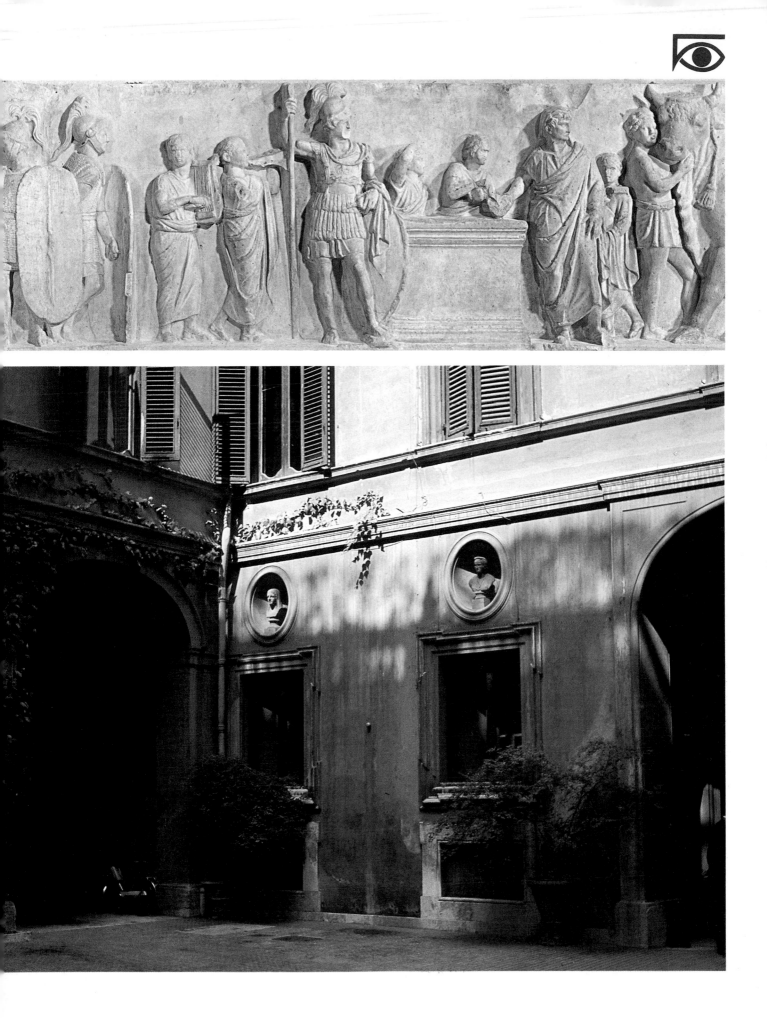

Although the Ikarios relief of Spon's top row (supposedly representing the visit of Dionysus to Ikarios) is now missing, we can gain some idea of its original appearance from another example of the same scene in the British Museum (*above*). The lost Bacchic sarcophagi (Spon's row 2, left; row 4, right; and 5) are less generic and do not have any precise extant parallels. One of them (row 5) shows a *Triumph of Silenus* and, as we shall see, Mantegna used the trumpeters before Silenus to lead his *Triumph* and the figure crowning Silenus to end it.

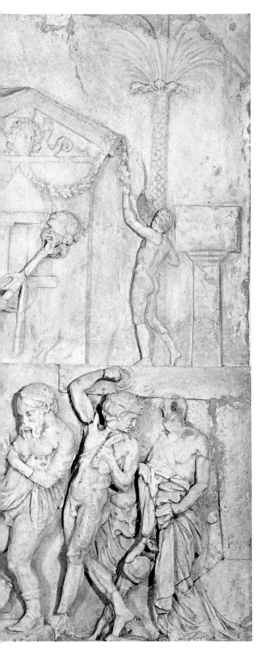

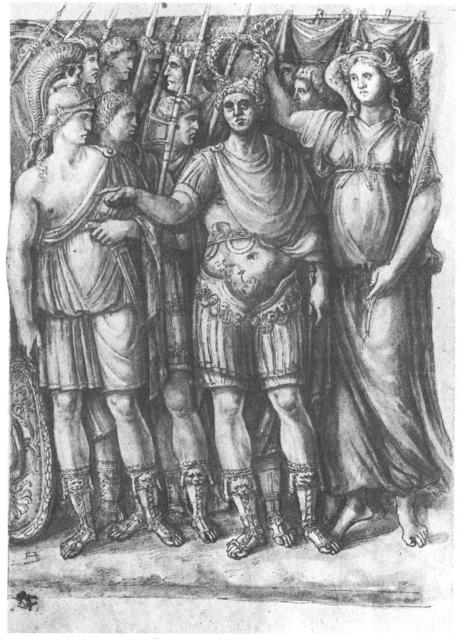

The languid youth to the right of Panel 4 of the *Triumph of Caesar* (shown on page 38) is generally supposed to be taken from the figure crowning Trajan in part of the Great Trajanic Frieze preserved in the Arch of Constantine at Rome (*right*). Whether this is the case or not, a sketch (*above right*) of part of the same relief by Jacopo Ripanda (1490–1530) gives us an idea of the kind of sketches Mantegna employed for his triumphal program.

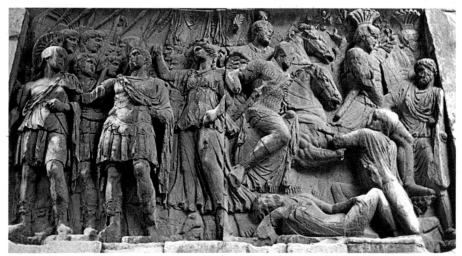

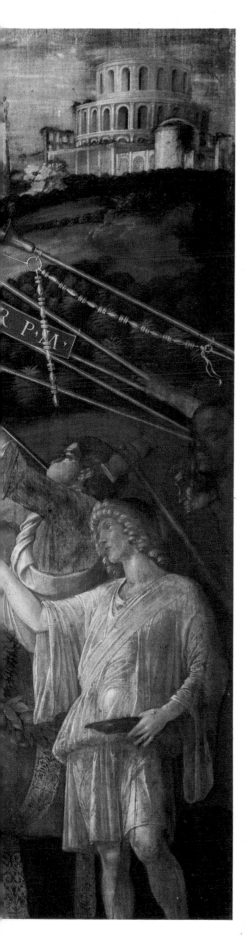

Mantegna based several of the figures in Panel 4 of the *Triumph of Caesar*, "The Vase Bearer" (*opposite*), on the sculpture in his sketchbook: the young stretcher bearer to the left was derived from the elderly satyr recorded by Spon (*above left, reversed*); they stride, hold up their arms and turn their heads in precisely the same way. The vase bearer himself resembles the bagpipe player (*above right*); they both hold their heads in similar positions and carry equally bulky objects. Finally, the bull in the right corner is based on the bull of the Census frieze (*below*), the head of whose handler has also been taken over by Mantegna.

The trumpeters of Mantegna's Panel 1 (*below*) who lead the triumphal procession are taken from the trumpeters who lead Silenus on one of the Bacchic sarcophagi (*far left, reversed*). The soldier with his back to us on the right is more complicated. He seems to be a conflation of elements taken from the Mars of the Census relief (*left*) and another two soldiers on the same frieze (*opposite above*).

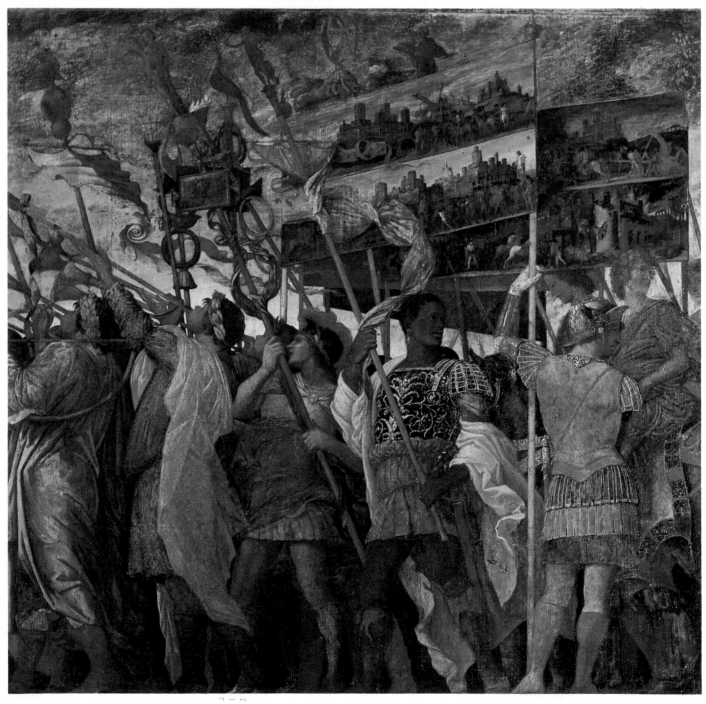

The soldier to the right of Mantegna's Panel 8 (*below*) closely resembles his companion on Panel 1 and likewise appears to be a conflation of two or three soldiers on the Census frieze (*right and opposite above left*). His neighbor was probably derived from the togate figure standing next to the soldiers already referred to. The black shawm player is from a tubby Silenus on the missing Ikarios relief illustrated by Spon (*far right*).

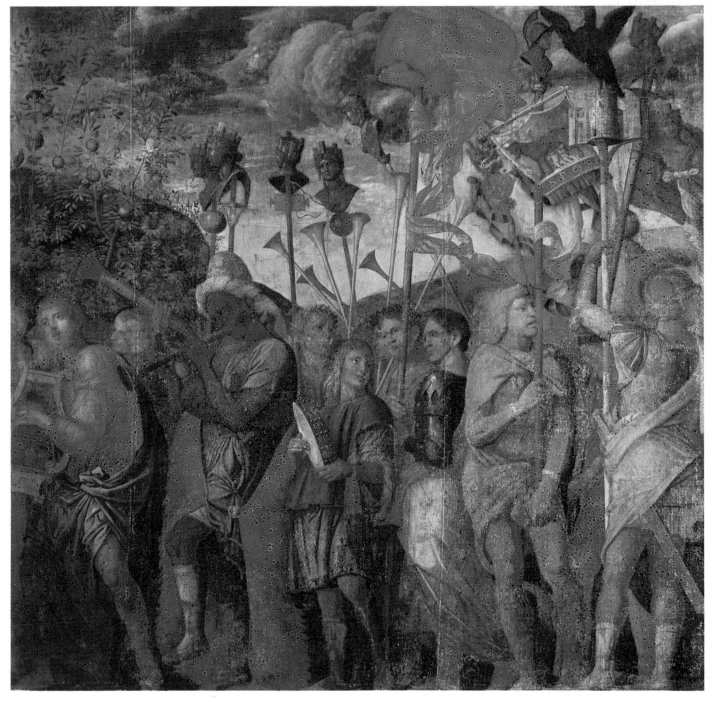

The background of Mantegna's Panel 9, "Caesar on his Chariot" (*below*), is dominated by an arch modeled on the Arch of the Sergii at Pola (*far right*). The figure of Caesar is, partly at least, dependent on that of our Census taker (*center right*), while the figure of Victory who is crowning him looks back and reveals her leg in the same way as the figure crowning Silenus on one of the Bacchic sarcophagi (*immediate right, reversed*).

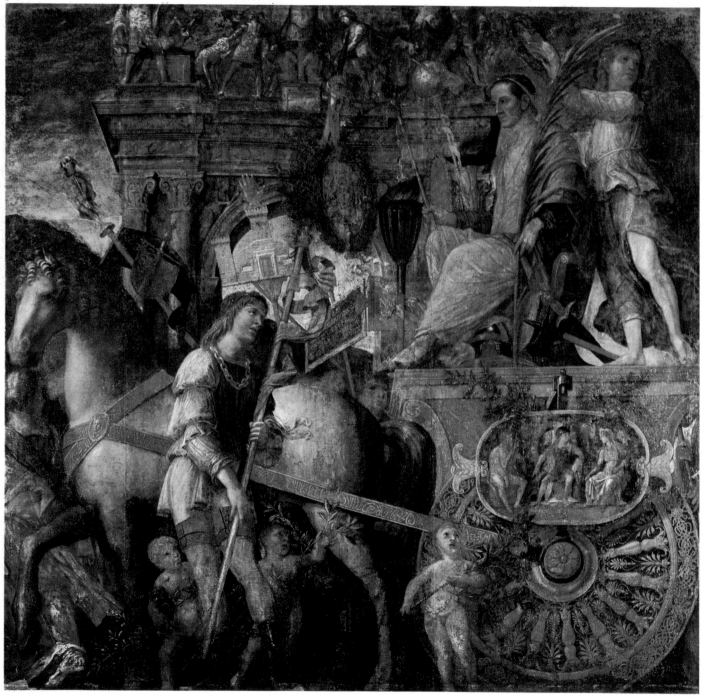

3. Field Archaeology and Excavation

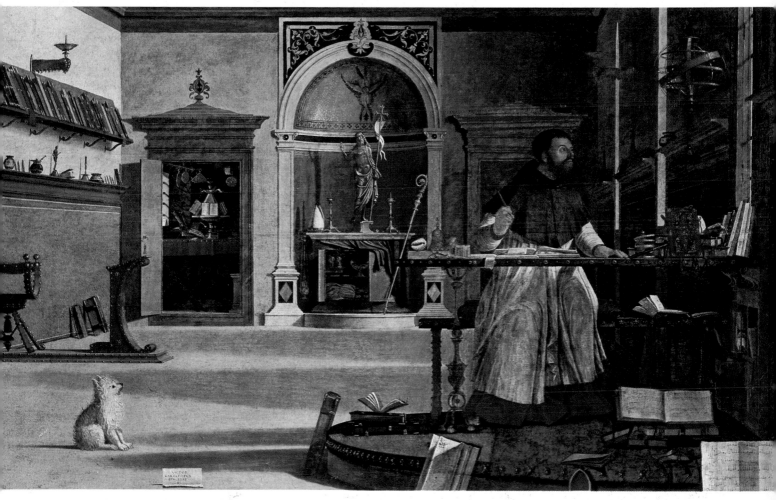

Carpaccio's *Vision of St Augustine* (c. 1505). The saint has a small collection of antiquities beneath his bookshelf. Venice.

Antiquarians and the first collectors. Most antiquarian discoveries in the Renaissance, and indeed many since, occurred accidentally. An exception is the work instigated by Cardinal Prospero Colonna at Lake Nemi in the Alban hills, southeast of Rome, in the 1450s. A humanist in outlook, his curiosity was aroused by reports from his tenants of two immense ships sunk deep in the lake, so strong and so well preserved that they resisted all attempts to raise them or to break them up piecemeal. Flavio Biondo tells us how Prospero was curious to discover why two vessels of such dimensions should ever have been launched on such a small lake cut off from the sea, and how they came to be wrecked. He brought in the best engineer of the day, Leon Battista Alberti, to help him. He built a raft of beams and empty barrels from which were suspended large four-pointed hooks on long iron chains. Genoese seamen, "who looked more like fish than men," placed the hooks in position around the prow of one of the

ships. Unfortunately, the wreck was too heavy for Alberti's equipment and most of the chains broke. But the frogmen did bring to the surface fragments of the sides of the ship; they were made of boards three inches thick, caulked with tar and pieces of sail, and protected by sheets of lead fastened with copper nails. Inside, Alberti found evidence for an iron framework which supported a concrete floor, and also discovered a lead pipe engraved with the name of the Emperor Tiberius. There were several attempts in succeeding centuries to examine the ships – including an inspection by diving bell in 1535 – but it was not to be until 500 years after Alberti's first attempt that the ships at Nemi – which were imperial state barges – were to give up their secrets. The lake was drained in the late twenties and thirties of this century, but the ships

unfortunately did not survive the last war. Underwater archaeology is generally regarded as a late arrival on the archaeological scene, but it is diverting to think that one of the earliest archaeological explorations of all actually took place underwater.

Prospero Colonna's new inquiring attitude towards antiquity was one that became widespread during the 15th and 16th centuries, at least in educated circles. But scientific curiosity usually took second place to the urge to collect antiquities. The most powerful stimulus for excavation was the hope of finding new material for the collections that were becoming increasingly fashionable on both a small and a large scale. A good example of a small collection is to be seen on a shelf in the background of Vittorio Carpaccio's *Vision of St Augustine* in the Scuola di San Giorgio in Venice (painted in 1502), where there are displayed bronze statuettes and a few pots, the originals presumably taken from ancient tombs. Such collections must have been very common, but far more spectacular were the fruits of the huge excavations conducted by members of the Farnese family in Rome on the Palatine and in the Baths of Caracalla. A page from the sketchbook of Andrea Palladio (1518–80), drawn before the depre-

dations, shows the quality of the material that was preserved in the latter. There were still columns and entablatures *in situ* in the *frigidarium* and precious vases of porphyry lying scattered on the ground. We know of the contents of some of the collections that were amassed in the 16th century from the sketches of Martin van Heemskerck (active in Rome from 1532 to 1536) or from the descriptions of Ulisse Aldrovandi (which first appeared in 1556). Among the Farnese finds, Aldrovandi mentions the group of Dirce tied to the horns of the bull, the colossal Hercules of Glycon, a colossal Pallas, a Flora, a Diana, four other figures of Hercules, a Venus, a hermaphrodite, some busts of Antoninus Pius, many unidentified torsos and heads, and one of the two large granite basins which now adorn the Piazza Farnese.

This process continued at Rome throughout the 16th century. New discoveries were made; old collections were enlarged and new ones created; but it was all at the expense of the remains of the world to which the collectors were supposed to be devoted. Material progress, then as now, counted for more than culture in the eyes of the rich. If a Roman arch stood in the way of a cardinal's plans for a new palazzo, the arch was destroyed. In 1625

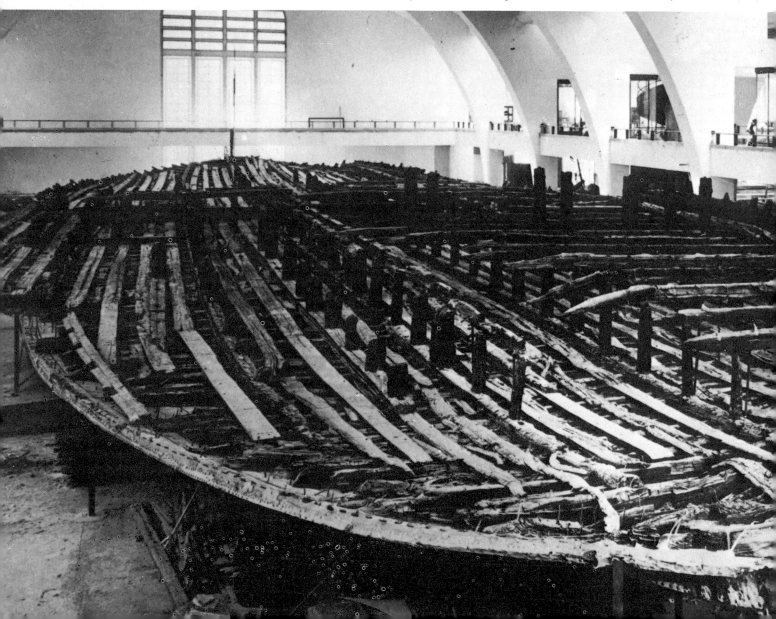

the Barberini pope, Urban VIII, owner of one of the finest collections of antiquities in Rome, was in need of material for making cannon and so, in the words of a contemporary diarist, "he caused the portico of the Pantheon to be stripped of its bronze roof, a marvelous work, resting on the capitals of the columns. But no sooner was the destruction accomplished than he found the alloy of the metal was not hard enough for gun-casting." Urban's action gave rise to the well-known tag: "Quod non fecerunt barbari, fecerunt Barberini" – "What the barbarians failed to do, the Barberini did."

More or less serious attitudes. The later 16th and early 17th centuries were characterized by religious struggles and new trends in art and science. The study of antiquity had lost its original spark, and Classical art was becoming a vehicle for cultural paternalism. Some of the innocence of earlier students of antiquity was retained, however, by the amateurs of local history, in Italy, France, Germany, the Low Countries and England. Added to their innocence was often a good deal of common sense in interpreting the

One of the Nemi ships salvaged in the 1930s.

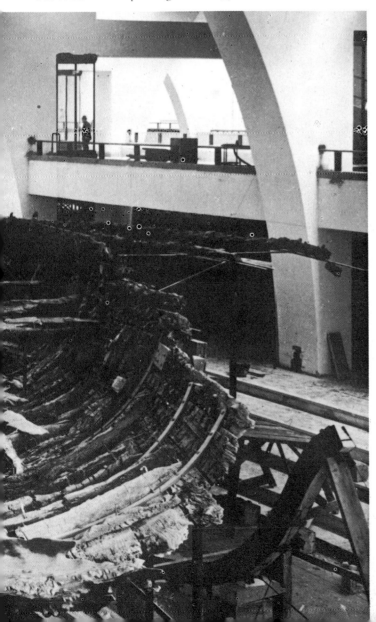

material evidence of the past, and many of these early antiquarians stand in the direct line of development of modern archaeology. Thus in 1598, for example, we find Richard Stow in his *Survey of London* describing the discovery of a Roman cemetery at Spitalfields in 1576 and drawing the same kind of conclusions that an archaeologist would make today. Some onlookers had thought that nails found on the site had served the unlikely function of smashing in the skulls of the corpses, but Stow neatly demonstrated that they had belonged to the coffins by showing that some of the nails still had wood attached to them, and that one of the bodies had nails "round about him, as thwart his head, along both his sides, and thwart his feete."

The learned priest was a common figure in the 17th century. His learning was often confused, but he could be a patient and acute observer. Such a one was Meric Casaubon, a canon of Canterbury who, in an appendix to a translation of Marcus Aurelius which appeared in 1634, has an excursus dealing with some "Roman pots and Urnes, almost of all seyzes and fashions, and in number very many" found in a field near Newington in Kent. He even published a sketch of some of the pots, which included a samian bowl of which "such was the brightness and smoothnesse . . . that it rather resembled pure Corrall." More remarkably still, he drew a series of highly reasonable conclusions concerning the site from the evidence presented by the pottery: "First, from the multitude of these urnes, that it was once a common burying place of the Romans. Secondly, from the Historie of the Romans in this land, that no urne is there found, but is 1200 or 1300 Yeares old, at the least . . . lastly, from the place, which is upon an ascent . . . not far from the sea, and neere the high way; we may affirme that in all probabilitie, that it was once the seate of a Roman station." Casaubon was not unaware of the work of continental antiquarians – indeed, he cites the collection of Roman inscriptions of Jan Gruter which had appeared in Holland in 1603 – and he is in effect a distant and very late representative of that northern humanism that we observed in the previous chapter.

At much the same time two Jesuits in Luxemburg, the brothers Wilhelm and Alexander Wiltheim (1594–1636 and 1604–1694) were taking similar notice of the Roman antiquities of the region in which they lived. Their work, *Luxemburgum Romanum*, was conceived on a large scale, but has never been properly published. The contents of the manuscript are of interest, however, since they show how remarkably modern in outlook were these two 17th-century antiquarians. Most of the fieldwork seems to have been carried out by the younger brother, Alexander, who realized the potential importance of Roman pottery, drawing and describing potsherds and fragments of glass – objects which would have been dismissed as valueless by most 17th-century antiquarians. He did not, of course, overlook the more usual subjects for archaeological

research, and recorded inscriptions and sketched views of the ruins of Trier. He was particularly interested in topography, in the Roman names of towns in the locality and especially in the routes of Roman roads. It would seem that he actually conducted excavations to discover how these were constructed, and he even made section drawings of what he found – one of the first to use what is now a standard archaeological technique. With hindsight, we can see that Alexander Wiltheim was often wrong in the conclusions he arrived at, but he foresaw this, and expressed his attitude in the words of any honest research worker today: "If I have expressed an opinion, or if I have made some conjecture, or if I have guessed, then accept that as opinion, as conjecture, as the fruit of my imagination. If, on the other hand, I have made an assertion, or if I have made some things out to be certain, nay indubitable, then either believe me, or, if you do not agree, prove that I am wrong and express some better truths!"

More clergy, though, must have come up against popular superstitions connected with the remains of antiquity. One example must suffice: in 1771 we hear of a Bavarian priest having a huge statue of Priapus broken up and the fragments buried. Priapus was one of the several Roman gods of fruitfulness and boasted a male organ of colossal proportions. The offending statue had apparently stood in the garden of an inn and "barren women, in the hope that they might in this way become mothers, made pilgrimages to him and rubbed their bellies on him."

But even those who were considered to be learned men could be as gullible and credulous as any Bavarian peasant. Elias Ashmole, Comptroller of Excise and historian of the Order of the Garter, as well as the heir to the Tradescants' "cabinet of curiosities" which formed the nucleus of the Ashmolean Museum at Oxford (which he founded in 1683), also dabbled in alchemy, astrology and sympathetic magic. He even cast magic symbols of caterpillars, moles, rats and fleas in order to restrain these vermin in his house and grounds.

Stukeley and the Society of Antiquaries. Another English "character" with more than a streak of madness was William Stukeley (1687–1765), but fortunately, his worst extravagances – he believed that the Bronze Age stone circles at Avebury and Stonehenge were Druidical temples – do not concern us here. He was, however, influential in the early development of the Society of Antiquaries of London. The aims of this society were expressed in a draft scheme drawn up in 1708, where a distinction was drawn between those interested in Greek and Roman civilization on the one hand and local antiquities on the other: "The last Ages have Employed the Learned and Curious, Cheifly in the Considerations of the Greek and Roman Antiquities ... But as the History of a man's own Country is (or should be) dearer to him than that of Foreign Regions; so there have been very many

Left: the Baths of Caracalla at Rome were used as a marble quarry by the Farnese pope, Paul III. A page from one of Palladio's sketchbooks shows a rough outline of the east wall of the *frigidarium* before it was stripped. In his day there were even vases of porphyry lying scattered on the ground.

Opposite: detail of a view of Segovia by the Dutch artist Anton van den Wyngaerde (*fl.* 1544–70), the greatest draughtsman of city views of his time. Ashmolean Museum, Oxford.

Below: the earliest publication of Roman pottery found in a recorded archaeological context was made by Meric Casaubon in 1634. Most of these pots came from a Roman burial ground near Newington, Kent.

who have been inquisitive after the Laws, Customs and Ways of living used by their Ancestors and the Remains left by them." But the society was not to be founded immediately – "Shall the Goths at Upsal boast such a Society," complained one of its proponents, "and shall we be backward?" – not, in fact until 1717, when Stukeley was elected its first secretary.

Stukeley was interested in every aspect of British archaeology: prehistoric, Roman and medieval, but in its early years the members of the Society of Antiquaries seem to have been overinterested in non-Roman matters for Stukeley's taste and that of some of his friends, for in 1722 we find them founding a club for the study of Roman Britain which called itself the "Society of Roman Knights." Its members took their names from Celtic personalities connected with the Roman conquest of Britain. As far as possible the names evoked the regions from which its members came. Thus Lord Winchelsea took the name of Cingetorix, a Belgic prince of eastern England, and the Yorkshireman Roger Gale called himself Venutius, after the Brigantian ruler. There were originally only 16 members, but later more were added, including women: the Duchess of Hertford became a member in 1723, taking the name Bonduca. Mrs Stukeley was known as Cartismandua. The Society of Roman Knights had a basically serious objective, summed up in Stukeley's own

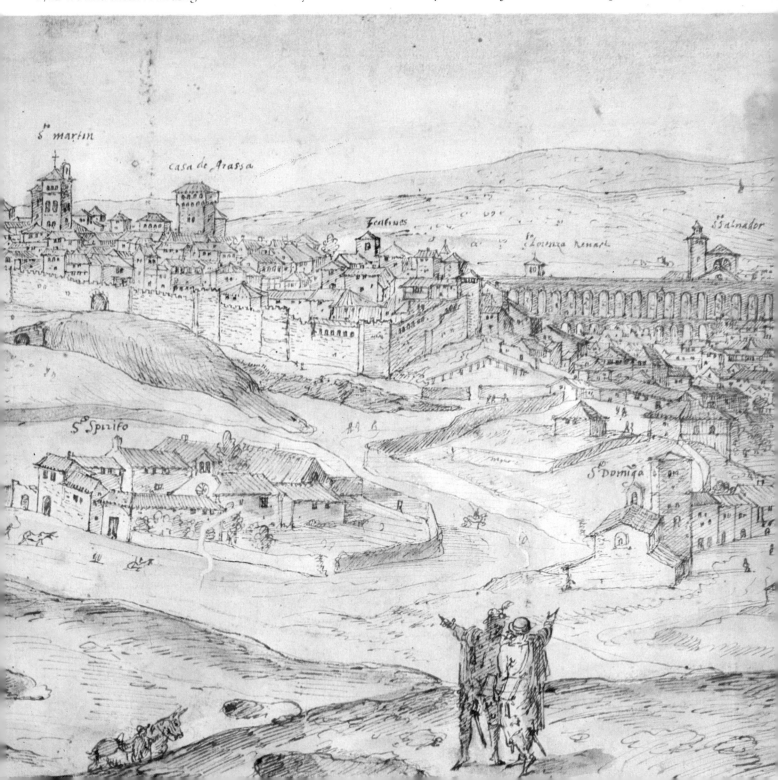

[handwritten manuscript text in Latin, partially legible:]

ROMANA 168

Glarea
Ruderatio
Nucleus
Statumen

Sape admiratio subijt, via huius nullam ss... litteris memoriam, cum maximis civitatibus, Divoduro et Treviris ratic...pta, hinc Gallijs, hinc Germanijs itu rediva... pra bere commercium, ne... op... Uti ... arum, quas c... libras antiquitas, ne... integritatis, qu... rum nunc durant vestigia, interior... spirant...

To Alexander Wiltheim (1604–84) we owe the first known drawing of an archaeological section, a cutting through a Roman road near Dalheim. Archives de l'État, Luxemburg.

Alexander Wiltheim's archaeological work was concentrated in the area between the Meuse and the Moselle. This map, in Wiltheim's hand, shows the principal towns of the area with their Latin names, as well as the main roads, rivers and forests. Musée d'Histoire et d'Art, Luxemburg.

words: "With what grief have these eyes seen the havoc, the desolation, the fate of Roman works, owing to the delusion and abominable superstition of cloyster'd nuns and fryers, what the fury of wars could not demolish, their inglorious hands have destroyed. . . . Whilst others therefore are busying themselves to restore their Gothic Remnants, the glory is reserved for you to adorn and preserve the truly noble monuments of the Romans in Britain. . . . The business of this Society is to search for and illustrate the Roman monuments in the Brittanic Isles. The name of the Knights (equites) dictates to us that travelling is part of our province and we are so far to answer our title of Roman, as never to return home without conquests. We are to encounter time, Goths and barbarians . . . we are to fight, pro ara et focis, to save citys and citysens, camps, temples, walls, amphitheatres, monuments, roads, inscriptions, coyns, buildings, and whatever has a Roman stamp on them. . . ."

The Society of Roman Knights was short-lived, but Stukeley's devotion to antiquity was unflagging. His *Itinerarium Curiosum*, published in two parts, one in 1724, the other posthumously in 1776, was based on numerous excursions made all over England as far north as Hadrian's Wall, as well as reports made by members of the Society of Antiquaries. On one of these excursions, in 1719, he noticed how the corn in a field near Great Chesterford in Essex revealed the plan of a Roman building: "I summoned some of the country people," he wrote in a letter to Roger Gale, "and, over a pot and a pipe, fished out what I could from their discourse, as we sat surveying the corn growing on the spot. . . . The most charming sight that can

In a manuscript written in 1465 a rustic shrine to Priapus was recorded, some three Roman miles outside Padua. The deity was originally shown more resplendently but the picture was bowdlerized in a puritanical age. Firestone Library, Princeton.

be imagined in the perfect vestigia of a temple, as easily discernible in the corn as upon paper. . . . The people say, let the year come as it will, this place is ever visible . . . and fancy the fairies dancing there causes the appearance." Stukeley was thus the first to observe and exploit cropmarks, nowadays the stock in trade of archaeologists who use aerial reconnaissance as a survey technique.

The discovery of Herculaneum and Pompeii. We must now, though, return to the continent to look at two cities whose discovery caught the imagination of 18th-century Europe, and whose story bears retelling even today. Herculaneum and Pompeii both lay at the foot of the volcanic mountain Vesuvius just south of Naples: Herculaneum had been an aristocratic seaside retreat and Pompeii a bustling mercantile town a little way inland. At one o'clock on 24 August 79 AD they were both overwhelmed by a sudden eruption of the volcano. Herculaneum, being nearer, was inundated with molten lava and volcanic mud, whereas Pompeii succumbed to a shower of ashes and pumice. Neither city was revived after the fatal eruption, and the site of Pompeii even was forgotten. The thick layer of volcanic material discouraged casual exploration, and it was only when excavations were carried out in connection with engineer-

The amphitheater at Silchester as recorded by William Stukeley in his *Itinerarium Curiosum*.

ing works in the 16th and 17th centuries that the buried cities began to give up their secrets – which were not always recognized for what they were.

Herculaneum was first discovered in 1684 by some farmers who were sinking a well immediately above the theater of the ancient city. A record was preserved of the strata that were pierced: first a thick bed, 10 feet deep, of cultivable soil, then came 10 alternating courses of lava and earth before water was reached at a depth of 90 feet (18 feet below the level of the floor of the Roman theater). Various inscriptions and fragments of metal had been found on the way down. Around 1706 the well came into the possession of the French Prince d'Elboeuf, the commander of an imperial army that had been sent to Naples, and he proceeded to build himself a palace near it. The well was used as a convenient source of marble fragments for the terrazzo floors of the new building. Marble statues were also found, and three of them were sent to Prince Eugene of Savoy in Vienna. In 1736 they entered the collection of the Elector of Saxony at Dresden, where they were greatly admired. In 1735 Charles III of Bourbon, the 19-year-old son of Philip V of Spain, had come to the throne of Naples

and in 1738, by a quirk of fate, he married none other than the daughter of the Elector of Saxony, Maria Amalia Christina. The newlyweds shared a passion for antiquity, bought d'Elboeuf's property at Herculaneum and began to sponsor the excavation of Herculaneum on a large scale. In charge of the operations was the first of many archaeologists with a military background, Rocque Joachin de Alcubierre, the Spanish commandant of the engineers' corps of the Neapolitan army. His organizational skills were unfortunately not matched by the meticulousness that is necessary when delicate objects that have been buried for centuries are being unearthed. J. J. Winckelmann, the art historian, was to say of him later on that "through his inexperience he was responsible for much damage, and for the loss of many beautiful things." Nevertheless many finds were successfully brought to light: fine houses decorated with mosaics and frescoes, statues in marble and bronze, and in 1752 a whole library of carbonized papyrus scrolls. Work on unrolling these scrolls and reading them is still in progress, but the chief contents of those that have been successfully opened seem to be works connected with the late Hellenistic philosopher Philodemus. The discoveries at Herculaneum were brought to the notice of the world in a series of lavish volumes produced by the Neapolitan court.

Between 1595 and 1600 the architect Carlo Fontana was digging a canal from the River Sarno to the mills of Torre Annunziata on the coast by cutting through the hill known as Cività which now overlaid the site of Pompeii. Even though fragments of masonry and a dedication to

This plan of the area around Vesuvius which appeared in 1755 shows the site of Pompeii marked as Civita. It was not recognized as Pompeii until 1763.

Roman Herculaneum vanished beneath layers of lava which flowed from Vesuvius on 24 August 79 AD. It was the first Roman town to be systematically excavated.

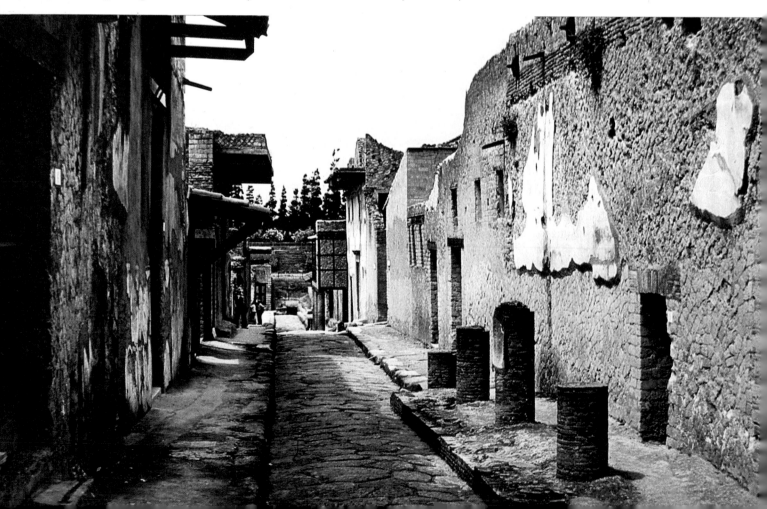

Venus physica pompeiana were found, no one realized that Pompeii had been rediscovered. It was Alcubierre who began archaeological investigations at Cività: he was inspecting Fontana's canal and saw remains of buildings showing in section in its sides. The Swiss engineer K. Weber was put in charge of clearing operations which were conducted in a rather unplanned and unsystematic manner, at first in the amphitheater and then in odd spots both within and without the city walls. It seemed that mosaics and frescoes, villas and tombs could be found wherever a spade was put into the ground. It was not in fact to be until 1860 that excavations were put on a systematic basis, when G. Fiorelli gave numbers to the *insulae* – the housing blocks – and names to the streets, and began excavating methodically according to a pre-determined plan. The first excavators were rough and ready in their methods, and the buildings once excavated did suffer from neglect, but techniques were gradually developed for recovering the most macabre and poignant records of Pompeii's last few minutes. The compressed ash served as a mold, and when plaster of Paris was poured into promising-looking holes, a dog writhing in agony might be discovered, or a suffocated muleteer. Organic matter had often been carbonized by the heat, and in a Temple of Isis, for example, the priests' half-eaten and hastily deserted meal of eggs, fish and nuts was found still lying on a table.

Drawing by William Pars of a 2nd-century AD arch at Mylasa in Caria, made for the second volume of the *Antiquities of Ionia*, published in 1797.

Grand Tourism. Italy had long been the goal of the sons of the English aristocracy who were anxious to improve themselves on the Grand Tour. This institution had grown up during the 17th and 18th centuries and to it can be attributed the introduction of Italianate styles of architecture into England and Scotland. Tourists flocked to see the new discoveries at Herculaneum and Pompeii, and a vogue for "Pompeian" styles of furniture and interior decoration enjoyed a passing favor in England and elsewhere (to be revived later in France as an element in "le style empire"). This, however, was merely one phase in a movement that was inspired by the desire for new architectural models, but which had as an important by-product the detailed recording of many ancient buildings, some of which have since disappeared, not just in Italy, but in the Balkans, Asia Minor and Syria. Robert Adam's *The Ruins of the Palace of the Emperor Diocletian at Spalatro in Dalmatia* (1764) was an exhaustive study of the visible remains of an important late Roman building. Between 1751 and 1753 James Stuart and Nicholas Revett were in Athens preparing their *The Antiquities of Athens*, of which the first volume appeared in 1762 and which was to include several monuments of Roman date among the Greek. Robert Wood and James Dawkins had visited Syria in 1757, and *The Ruins of Palmyra* (1753) and *The Ruins of Baalbec* (1757) were to become important source books for Neoclassical architects. An important body which fostered this kind of research was the Society of Dilettanti, which had been founded in London in 1734 and was composed largely of those who had been on the

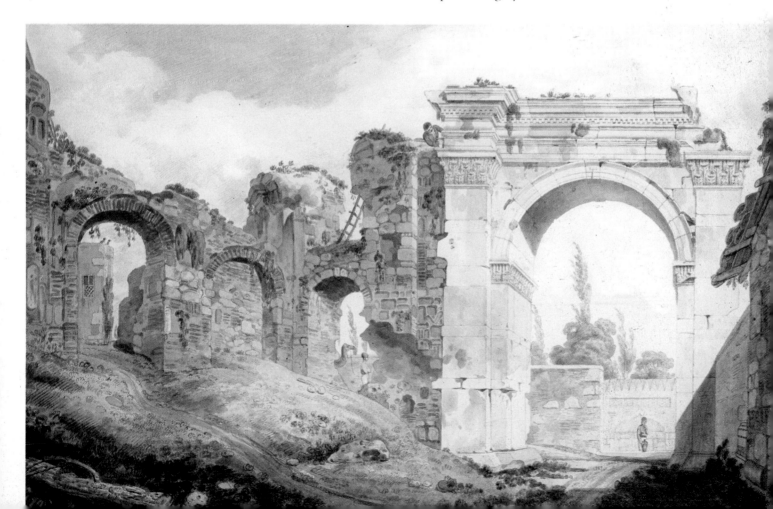

Grand Tour. They sponsored Stuart and Revett and in 1764 sent out their "first Ionic expedition" to western Asia Minor, consisting of Revett, Richard Chandler and William Pars, which resulted in the publication of the influential *The Antiquities of Ionia* (1769–97).

Little distinction was made in these works between monuments of Greek and Roman date; indeed, in the eastern Mediterranean it is often very difficult to draw a line between one period and the other. Nevertheless, two diverse trends were emerging in Neoclassical art: one favoring what was considered to be "Greek" – directly influenced by J. J. Winckelmann's *History of Ancient Art* (*Geschichte der Kunst des Altertums* [1764]); and the other staunchly "Roman" – in this context Italian. This dichotomy of taste does not directly concern us, except that somehow Greek art, and hence the study of it, came to be regarded as more ennobling, as more worthy, than Roman art. This view, one might even call it a prejudice, lasted throughout the 19th century, and still lingers on in some quarters even today. It was given some hard knocks by art historians of the Vienna School in the late 19th century: Franz Wickhoff claimed that Roman art was not a degenerate form of Greek art as Winckelmann had maintained, but that positive contributions had been made to the problems of artistic representation during the Roman period. Alois Riegl objected to Winckelmann's view that Greek art of the 5th and 4th centuries BC was the standard by which all other art was to be judged, and proposed the notion of *Kunstwollen*, whereby each period had its own particular artistic personality. Both these views have proved to be oversimplistic and it would be

untrue to say that the "problem of Roman art" has been solved – or even formulated; but thanks to the work in this century of scholars such as Eugenie Strong in England, R. Bianchi Bandinelli in Italy, and numerous German archaeologists, Roman art is now considered a fit subject for study.

Some Grand Tourists would keep up the interest in antiquity they had gained in Italy when they returned to their own country. Others made a study of local antiquities a substitute for the Grand Tour. In contrast with the often well-preserved Classical remains of Mediterranean lands, these local antiquities were frequently of a nondescript character. This fact, however, necessitated the development of rather more subtle techniques for recovering evidence for the past than those used by an Alcubierre or his successors. We have already observed Alexander Wiltheim in Luxemburg making a cross-section of a Roman road and William Stukeley in England tracing the plan of a Roman temple from crop-marks in a cornfield. The major developments in technique were in fact to be made in northwestern Europe during the 19th century, but have only become at all widespread even there in the 20th.

Richard Colt Hoare. A transitional figure between the 18th-century Grand Tour and 19th-century archaeology was Richard Colt Hoare. His grandfather had been in the vanguard of the "Roman" wing of Neoclassicism, having built in the grounds of the family seat at Stourhead in Wiltshire a version of the Pantheon at Rome in 1757, and in 1765 a "Temple of Apollo" in imitation of the Temple

Robert Wood and James Dawkins' *The Ruins of Baalbec* (1757) included this drawing of the round temple (*below*) which inspired Henry Hoare to build a copy of it on his estate at Stourhead in Wiltshire, seen here (*right*) in a 19th-century watercolor by F. Nicholson. British Museum.

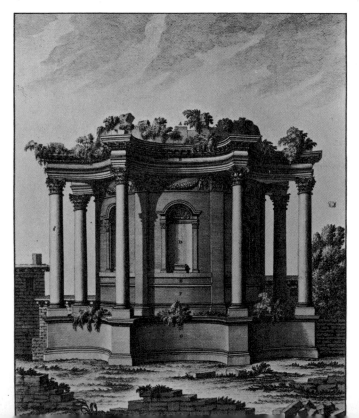

of Venus at Baalbek of which Wood had published drawings some years earlier. Colt Hoare himself as a young man combined his tourism with a specific archaeological aim. While staying in Siena in 1785 he conceived the plan of identifying the sites of the Etruscan cities mentioned by Classical authors. He visited not only existing towns of Etruscan origin such as Volterra, Populonia and Saturnia, but attempted to explore the sites of Vetulonia, Ansedonia and Rusellae. He found the last after a second attempt, and observed that "the quantity of trees, thorns and coppice wood, which render the approach difficult may at the same time have contributed to their preservation. Of these remains the most noble and perfect part is exposed towards the north, and faces the great road, leading to Siena. Here we may see the works of a nation, who by several centuries preceded the Romans, and on whose ruins the Romans laid the first foundations of that mighty power, which afterwards overshadowed the whole civilized world. . . . With wonder and amazement we may here contemplate the traces of a people who flourished before the dawn of authentic history. . . . In exploring these awful remains of so remote an age, we shall find ample cause for astonishment, at the profound knowledge of mechanics, which must have been employed in raising and placing stones of such extraordinary magnitude."

Colt Hoare's interest in the past continued when he returned to England. He cooperated with William Cunnington in excavating prehistoric barrows on Salisbury Plain, a work which culminated in Colt Hoare's *History of Wiltshire* (1810–21), which has been described by Glyn Daniel as "a great forward step from antiquarianism to archaeology." Cunnington and Colt Hoare had the benefit of sound advice from their friend Leman in the matter of the careful recording of archaeological finds. He wrote to Cunnington: "You will excuse me I am sure when I take the liberty of pointing out to you the necessity of *immediately pasting a small piece of paper on every piece of pottery or coin* that you may hereafter find, describing with accuracy the very spot in which you found them. The people who succeed us may possibly know more about these things than we do (or else I am confident they will know very little) but we ought . . . to afford *them* all the information we can, with clearness. We are too apt to suppose that even we ourselves shall know *tomorrow*, what we have learn'd *today*, yet every day's experience has told me that I do not, & as it may possibly be so with others, I would wish you to be on your guard against this fatal error.

"To collect either coins or any other pieces of antiquity without it is done with the honest zeal of being of use to others . . . is little better than collecting Rubbish which may impede, but cannot add to our improvement." The underlying principle remains as sound today as it was in 1802.

Colt Hoare did not overlook the Roman remains of Wiltshire. He took a deep interest in his friend Hasell's excavation of a Roman villa at Pitney in 1829. There was evidence of at least two mosaic floors, and as those at a villa nearby had been destroyed "by the idle curiosity of the vulgar," Colt Hoare urged Hasell to employ watchmen at his expense and to erect sheds over the remains. Even so, Hasell reported: "the common people in the night come and break down the sheds and commit every species of injury which mischief can devise; indeed so far do they carry their resentments that I am obliged to keep two night watchmen upon the grounds. Serious as the effects of their displeasure is, the cause which moves it is truly ludicrous. These people cannot imagine that from mere curiosity I should expend so much time and money, confusing the Romans of old with the Roman Catholics of the present day, they believe the concessions made to the latter in point of religion is to be followed by the restoration of their former property and that I am employed by the *Pope* to discover where this is."

The first archaeologists. The developments that took place in the 19th century were in the direction of improved excavation technique and the recording and publication of finds. Dutch archaeology was put on a sound footing by the careful work of Caspar Jacob Christiaan Reuvens, born in the Hague in 1793, and by the age of 28 appointed to a newly created chair of archaeology at Leiden, which was, incidentally, the first chair anywhere which included non-Classical archaeology in its rubric. Reuvens' main work was on the Celtic field system in Drenthe, but he also excavated a Roman town at Arentsberg near the Hague between 1826 and 1829. He set high standards of recording, producing oblique views of sites and excavations.

Reuvens anticipated many of the techniques that were to be independently evolved by General Pitt Rivers much later in the century. In 1880 Pitt Rivers inherited 29,000 acres in Wiltshire including much of Cranbourne Chase. He had already carried out many excavations in England and Wales, and from the start proposed to investigate the antiquities of his new property: "I felt . . . that an unseen hand had trained me up to be the possessor of such a property . . . I at once set about organizing such a staff of assistants as would enable me to complete the examination of the antiquities on the property within a reasonable time, and do it with all the thoroughness which I had come to consider necessary for archaeological investigations . . ." His large-scale excavations in Cranbourne Chase lasted until 1900. He aimed at "*total* excavation of his sites, with a *total* publication of the results." He did this by means of numerous illustrations including plans and section drawings and had models made of all the main sites. He maintained that all objects, irrespective of beauty, should be of equal interest to archaeologists, writing: "Tedious as it may appear to some, to dwell on the discovery of 'odds and ends' that have, no doubt, been thrown away by their

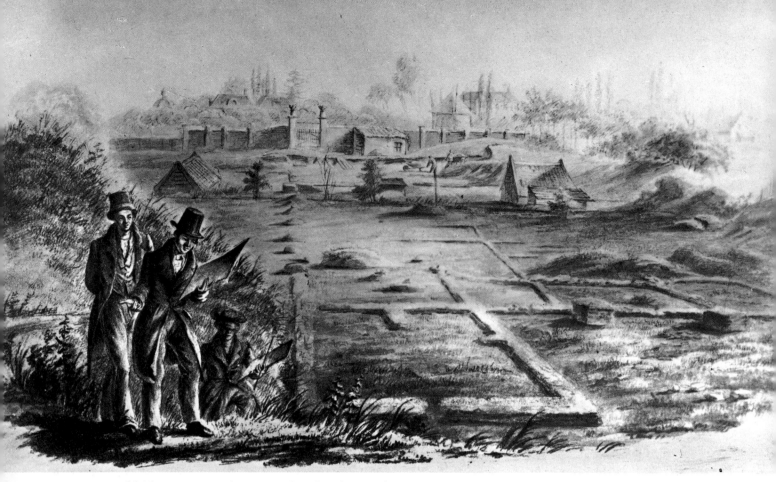

owners as rubbish . . . yet it is by the study of such trivial details, that Archaeology is mainly dependent for determining the dates of earthworks . . . The value of relics viewed as evidence, may on this account be said to be in an inverse ratio to their intrinsic value."

Even information that might not appear important to an excavator should be recorded and published: "Excavators, as a rule, record only those things which appear to them important at the time, but fresh problems in Archaeology and Anthropology are constantly arising, and it can hardly fail to have escaped the notice of anthropologists, especially those who, like myself, have been concerned with the morphology of art, that, on turning back to old accounts in search of evidence, the points that would have been most valuable have been passed over from being thought uninteresting at the time. Every detail should, therefore, be recorded in the manner most conducive to facility of reference, and it ought at all times to be the chief object of an excavator to reduce his own personal equation to a minimum." A good example of the pains that Pitt Rivers insisted be taken in recording the details of an excavation is to be found in a finely executed watercolor drawing of the stratigraphy of the Roman granary at Iwerne Courtenay which must be one of the earliest attempts to preserve an accurate record of soil color. The principle of stratigraphic recording is exactly the same today, although the method of recording is simpler and less pictorial in appearance, with conventional symbols used to indicate changes in the earth rather than delicate watercolors.

C. J. C. Reuvens excavating the Roman town at Arentsberg between 1826 and 1829. Rijksmuseum van Oudheden, Leiden.

The drawing of a Roman granary at Iwerne Courtenay, Wiltshire, made for Pitt Rivers in 1897.

The importance of aerial photography. During the 20th century, the attitudes of the 19th-century pioneers have become widespread and their techniques refined. There is probably less emphasis on excavation now and a greater concentration on the physical environment of ancient societies. A technique of archaeological exploration which is of permanent importance in this respect is aerial surveying, or aerial archaeology as it is coming to be called. Features invisible to the observer on the ground can become immediately apparent when seen from an aeroplane. Low rays of light cast by a setting sun can cast

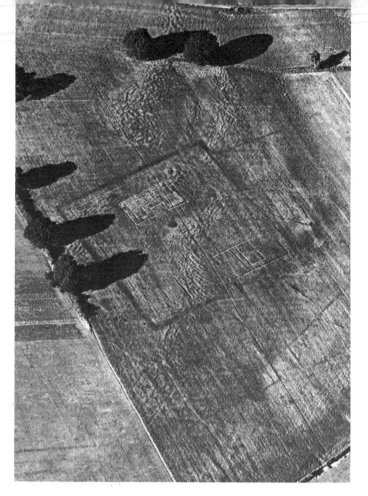

The villa at Ditchley, Oxfordshire, an important site in the development of archaeological reconnaissance from the air.

shadows of ramparts or causeways; soil-marks, especially in a freshly plowed field, can reveal traces of buildings or humus-filled ditches, as can crop-marks at certain times in the year and in certain climatic conditions. One of the pioneers of aerial photography was Major G. W. G. Allen who during the 1930s made a detailed study of Oxfordshire from the air. A photograph taken over Ditchley in June 1934 revealed the plan of a Romano-British villa with projecting wings standing within an enclosing dyke. There were also outbuildings, and a dark circle immediately in front of the villa proved on subsequent excavation to be a well.

Despite the developments that were occurring in field archaeology, there was – and still is – a desire on the part of many museums and private collectors to own objects from Classical antiquity whether they come from controlled excavations or not. The situation gets worse year by year with antiquities changing hands at millions of dollars apiece, but recently techniques have been developed whereby whole cemeteries can be surveyed and explored and their contents (when anything is left) saved from the plunderer.

The problem of grave robbing is most acute in Italy, and especially in Etruria, and the major breakthrough in the exploration of Etruscan cemeteries occurred as a direct result of the aerial photography during World War II of large parts of enemy-occupied Europe undertaken as a matter of routine by the Royal Air Force.

John Bradford was a British Army officer serving with R.A.F. photographic intelligence in Italy, who had been actively involved in archaeology before the war. As a student at Oxford he had worked on the excavation of an Iron Age site at nearby Dorchester on Thames owned by Major Allen and his brother, and so was wholly familiar with the opportunities presented by aerial surveys. In Italy he naturally looked for the chance to apply the principles in a new context. From 1943 onwards he was able to examine photographs taken by the R.A.F. over Etruria and realized that they contained a mine of valuable information. It had been intended to destroy the aerial cover of Europe after the war, but Bradford managed to acquire the photographs for the University of Oxford (where they are preserved in the Pitt Rivers Museum), and in 1947 published an article in the British archaeological periodical *Antiquity* entitled "Etruria from the Air" in which he set the study of Etruscan cemeteries on a new road. Several years of fieldwork on the ground enabled him to give a greatly expanded account of his discoveries in his book *Ancient Landscapes*, published in 1957.

Aerial surveys of Etruria. The photographs upon which Bradford based his findings had been taken over the cemeteries at Cerveteri and Tarquinia during the extremely dry summer of 1944 when the vegetation on the ground above the tumuli which had been leveled by continuous plowing was differentially parched according to whether or not there was rock or earth beneath. The core of a tumulus was a circular drum cut out of the natural rock and its height was often raised by the addition of extra blocks of tufa masonry and the excavated rock debris was then placed on top to create the mound. Weathering and plowing over the years in many cases caused the silt and debris to fall back into the moisture-holding depression around the tumulus, and in dry weather the vegetation there would remain green, and so show up more darkly on an aerial photograph than the thin, parched vegetation immediately above, which shows up as light in color. In the same way, cemetery roads, which were cut into the rock, had accumulated additional humus which also remains greener, and hence shows up as darker on a photograph.

At Cerveteri Bradford studied two cemeteries, the Banditaccia necropolis to the north, and Monte Abetone to the south of the site of the ancient Etruscan city. In both cases he was able to add hundreds of hitherto unknown tumuli to existing plans. The name of Banditaccia itself includes a hint as to the nature of the terrain. It was not derived, as was supposed in the early 19th century, from the number of bandits who might be thought to lurk in its "caverns and holes," but really means communal land belonging to the municipality of Cerveteri which was *terra bandita*, or "land set apart," presumably since in the past it

was rough and uncultivated ground. By 1944, however, the land had been extensively plowed and was planted with corn. Vertical air photographs taken on 9 March showed markings caused by tumuli, though not very clearly, but a series taken on 14 May revealed with extreme clarity the marks of tumuli in the ripe corn. Even the positions of the entrance passages of many of the tumuli were visible as dark lines leading inwards from the circumference (produced by the depth of soil in the passage and the consequently healthier growth of the vegetation above). The sites of over 400 leveled tumuli were established, most of which had been entirely unknown until Bradford recognized them for what they were. The courses of several buried roads were also visible on the photographs, including one which could be traced for 200 yards. An example of a large, silted-up courtyard, or *piazzetta*, was detected – of a type known elsewhere to have been lined with rock-cut tomb facades.

The next stage was to test Bradford's hypothesis that these marks really did represent tumuli, and this was done in 1957 by a team of young archaeologists from Rome directed by the doyen of Etruscan studies, Massimo Pallottino. A few weeks' work in a promising-looking corner of the Banditaccia revealed, as expected, small rock-cut tumuli of the first half of the 6th century, having steps leading down to a central tomb-chamber. The tombs had been robbed in antiquity, but some of them still had imported Greek pottery in them. The remarkable fact was that the diameters of the excavated tombs ranged between 33 and 35 feet, which was precisely the measurement that Bradford had estimated from the aerial photographs.

The cost of conventional excavation is such, however, that it would not be practicable for archaeologists to treat every tumulus with the same care. The fact, moreover, that most tombs have already been looted, whether in ancient or modern times, makes it even less advisable to expend limited financial resources if the expected returns are somewhat uncertain. At least, thanks to aerial photography, it is now much more certain where clusters of tumuli are to be found. But not every archaeological feature is susceptible to detection from the air, for some are buried too deep to be seen. Infrared photography from the air is proving to be of a certain value in overcoming this, but there is still a need for survey techniques which work at ground level.

Geophysical techniques. Many of the more recent developments in ground survey techniques have occurred as a result of one man's fascination with the Etruscans. Carlo Maurilio Lerici was born in Verona in 1890, and in 1947 founded the C. M. Lerici Foundation at the Milan Polytechnic School. This foundation specialized in geophysical exploration for mineral ores, water, natural gas and petroleum. In 1955 the Lerici Foundation began promoting the application of geophysical methods to archaeological, and especially Etruscological, research.

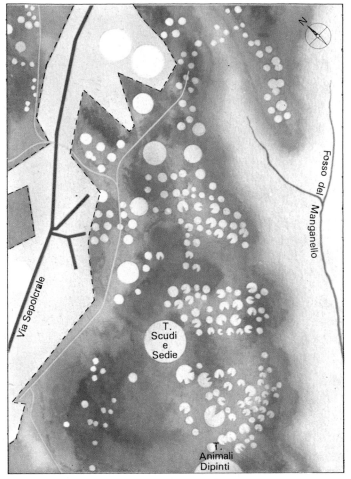

Plan of the Banditaccia cemetery at Cerveteri, made from photographs taken by the R.A.F. during World War II. After Bradford.

One of the techniques employed was to take electrical resistivity measurements in the area to be investigated, and then record any anomalies in such measurements caused by the presence of archaeological features beneath the ground. The discovery of the Tomba dei Olimpiadi at Tarquinia in 1958 is a case in point. Electrodes were laid out in a straight line, and then the voltages present in the soil measured. When expressed in graphic terms, the peaks indicated depressions in the ground which on subsequent investigation included the *dromos*, or entrance passage, of one of the most exciting tombs to be discovered during the whole exploration program.

The resistivity technique, however, is only really effective when archaeological features are fairly widely spread. From 1960 the Lerici Foundation used another technique of archaeological prospection that had been developed at the Oxford Research Laboratory for Archaeology and the History of Art. This involved a device known as a proton magnetometer, which was capable of detecting changes in the magnetic properties of the earth that had occurred as a result of human occupation. The results are plotted on a diagram, and by selecting the more important anomalies the characteristics, and even the plan, of archaeological features can be reconstructed.

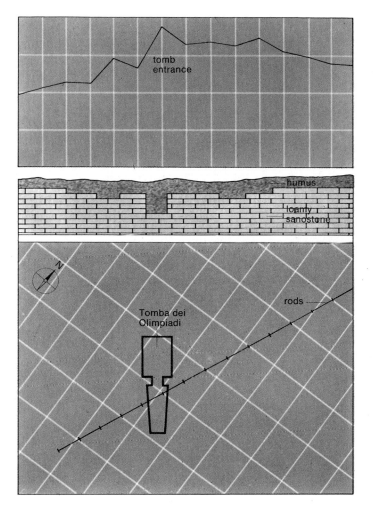

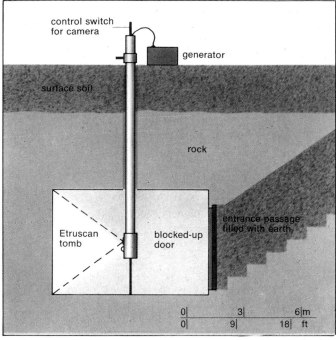

Periscope photography in action (*below*) and in section (*above*, after Bradford). In order to keep one step ahead of modern tomb robbers, the Lerici Foundation of Milan Polytechnic invented a periscope which could be let into a tomb so that photographs could be taken of the interior to see whether excavation would be justified.

These two diagrams show how electrical resistivity readings were taken at Tarquinia in 1958: a line of rods was laid out at regular intervals and the highest reading was found to occur where the line passed over the passageway of the Tomb of the Olympics. After Lerici.

The location of a tomb, however, was only half the battle. The problem that then exercised the prospectors was how to discover the nature of its contents without going to all the expense and inconvenience of excavation. A probe, consisting of a miniature camera and a flash unit mounted at the end of an aluminum tube, was devised in the Lerici Foundation's laboratories. A hole would be drilled into the ground above a tomb, often to a depth of 18 or 20 feet, and the probe introduced into the chamber of the tomb to see whether it would be worthwhile continuing with the exploration. Since between 1956 and 1960, 98 per cent of the tombs located had been looted, many recently, and 60 per cent completely devastated, it was clearly sensible to have this aid to fieldwork, if only to keep abreast of contemporary grave-robbers, who were not now merely interested in the objects within the tombs but were using modern methods of removing wall-paintings. It was also becoming increasingly necessary, with the general improvement in agricultural techniques, to rescue as many wall-paintings as possible from the

damage caused by the use of modern fertilizers in the fields above the tombs. When nitrogen-enriched rainwater seeps down into a painted tomb it often leaves a deposit on the surface of the wall which can lead to the colors fading. Even worse, the roots of plants and shrubs on the surface, activated by the fertilizer, were penetrating some of the tombs and were causing paintings to flake.

Rescue archaeology. It happens very often nowadays that archaeological sites are threatened as a result of building or highway development, but in recent years steps have been taken, in Britain at least, to meet the problem halfway. With the application of a little foresight it has been possible in many cases to anticipate the developers and to complete programs of archaeological research before they come on to the scene. A good example of this is provided by the M40 Archaeological Research Group which was created in 1970 in anticipation of the construction of a new highway in southeast Oxfordshire. The team spent many months carrying out fieldwork – surveys and excavation – along the proposed line of the road which ran from Stokenchurch to Great Milton. Of 15 sites that were excavated, 14 proved to be archaeologically productive, and have made a large contribution to our knowledge of the history of the region, not just in the Roman period, but in the pre-Roman Iron Age, as well as the medieval period. A close eye was kept on the ecological evidence. Remains of carbonized seeds, bones and shells once analyzed can give us an insight into the diet and physical environment of Oxonians who lived centuries ago. The main contributions to our knowledge of the Roman period were the discovery of a villa-type settlement at Lewknor, as revealed by its boundary ditches which lay directly in the path of the highway, and of a late or immediately post-Roman cemetery at nearby Beacon Hill. The most remarkable "Roman" finds, however, were made at Tetsworth where in a 12th- to 13th-century medieval house were found the cut-down bases of five Roman vessels, apparently gathered from a Roman occupation site and perhaps used as counters or gaming pieces – yet another example of the kind of continuity between Rome and the Middle Ages that we saw in the last chapter.

Modern excavation in progress at the 1st-century AD palace of Fishbourne in Hampshire, discovered in 1960.

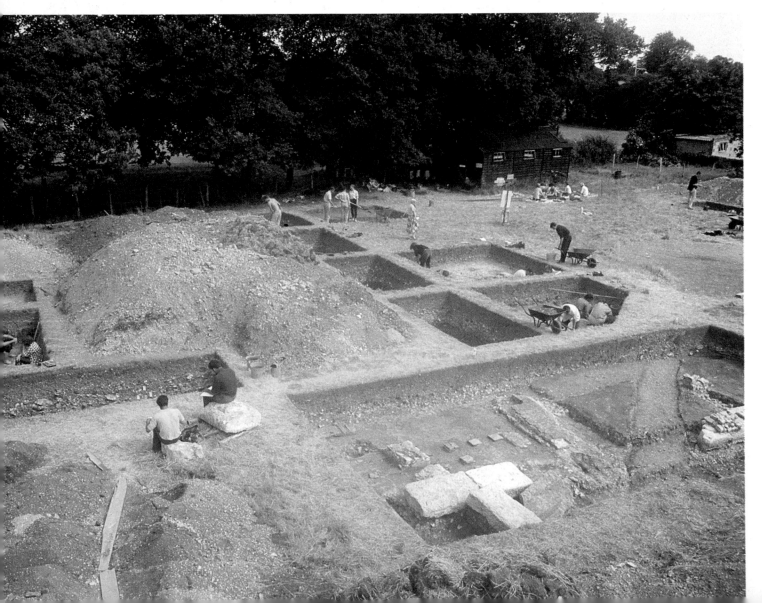

Pompeii

The twenty-fourth of August 79 AD was a fatal day for the inhabitants of several towns in the Bay of Naples: Pompeii, Herculaneum, Stabiae, Oplontis and others were destroyed. Those closest to Vesuvius were overwhelmed with flowing lava, while those some distance away succumbed to the pumice and ash which fell over a wide area to the south of the volcano. Pompeii was one of these. Even in Misenum, more than 10 miles away across the bay, the midday sky was black with ashladen smoke and we have a vivid account by the 18-year-old Pliny the Younger of how, when he and his mother were fleeing the town "we were enveloped in night, not a moonlit night or one dimmed by cloud, but the darkness of a sealed room without lights. Only the shrill cries of women, the wailing of children, the shouting of men were to be heard. Some were calling to their parents, others to their children, others to their wives, knowing one another only by voice." Pliny survived, but thousands nearer the center of the eruption must have died miserable deaths, to some of which we can be witnesses even today thanks to the skill of the excavators of Pompeii. Many inhabitants, however, seem to have fled the city; at least no ridable animals were found there. But it is an open question as to how far they may have got before being overcome by volcanic fumes or struck by flying rocks. The destroyed city remained virtually untouched for nearly 1,700 years, like a fossil preserved in a geological layer, before archaeological exploration commenced in the 18th century and Pompeii began to reveal its secrets.

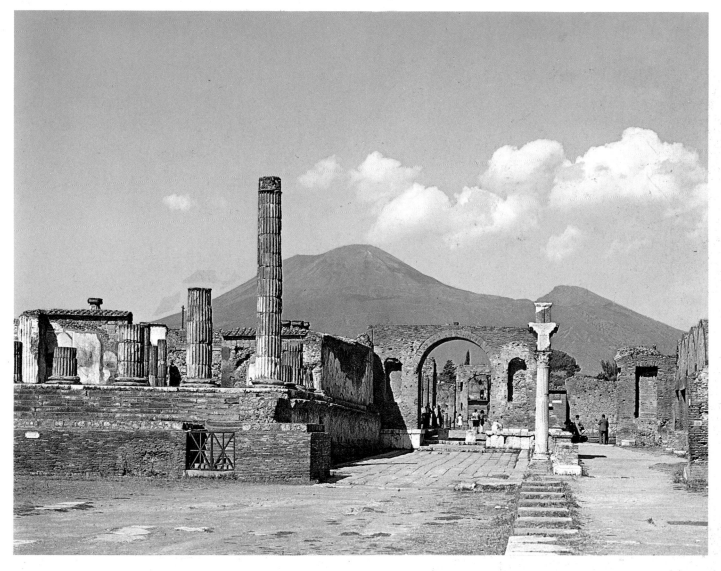

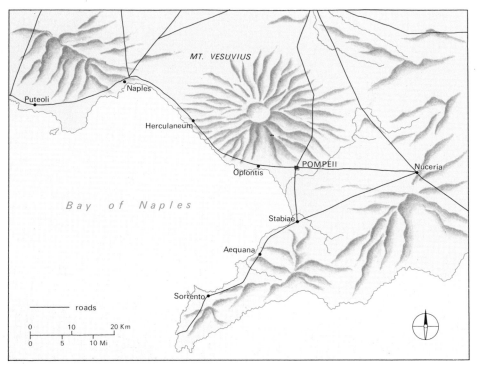

Above: Pompeii lies a little way inland on the fertile slopes of Vesuvius. Further west lay Oplontis (Torre Annunziata, where a Roman villa has recently been discovered) and Herculaneum.

Below: Pompeii started as a small Samnite settlement in the 6th century BC and this early nucleus can be seen in the southwestern corner of the city plan around the Forum.

Opposite: from the Torre di Mercurio ("Tower of Mercury") on the northern city wall, built to withstand Sulla's attack in 89 BC, the visitor gains a splendid view over Regio VI in the direction of the Forum. The streets are laid out in a grid pattern based on principles of town planning derived from the Greek world. High sidewalks kept pedestrians out of the muddy thoroughfares.

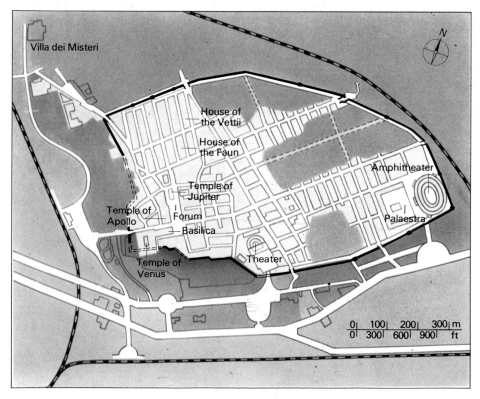

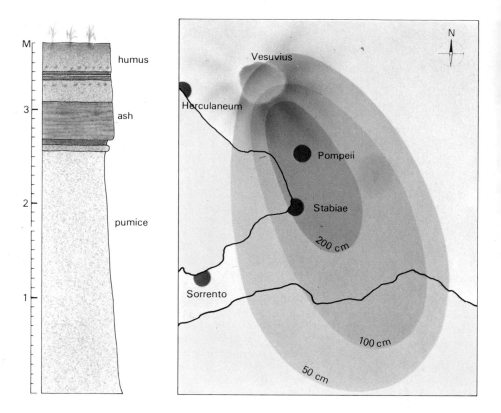

Right : the eruption of Vesuvius threw up a vast amount of ash and pumice which was blown towards the south. The heavier pumice fell to earth first and at Pompeii forms a layer some two and a half meters deep.

Below right : the Pompeians fled or hid, often leaving the food for their midday meals behind them. In several cases the food was carbonized, and in the Pompeii Museum can be seen dishes of eggs, hazelnuts, almonds and dates, and a loaf of bread.

Below : there had been an earthquake at Pompeii in 62 AD which had caused superficial damage. The experience of this doubtless encouraged some Pompeians to seek refuge from the eruptions of 79 in cellars and the like. They reckoned without the suffocating fumes which accompanied the ash and pumice. A cast in the Pompeii Museum shows a crouching boy coughing his last.

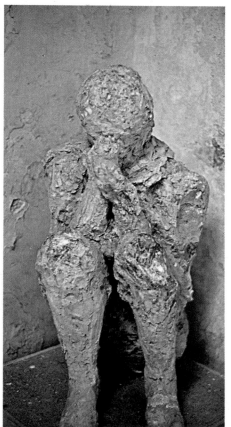

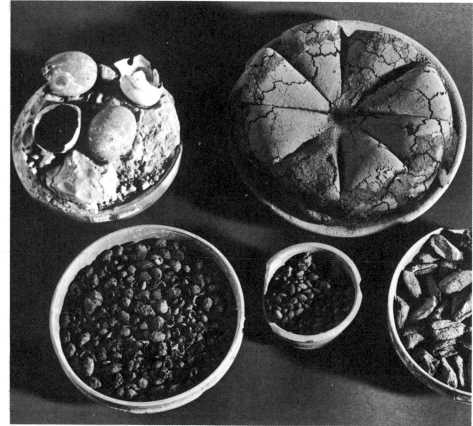

Left: Pompeii had very many snack bars (*thermopolia*) open to the street. Here food would be kept warm in containers set into the top of the counter.

Below: bread was the principle element in the Pompeian diet, and several bakeries have been found in the city. They frequently ground their own grain and are regularly equipped with a mill room containing several stone mills (as shown here). The grain was poured in the top and the upper stone turned in capstan fashion causing the grain to be ground against a stationary conical stone beneath. The flour would then fall onto the platform below and be ready for use.

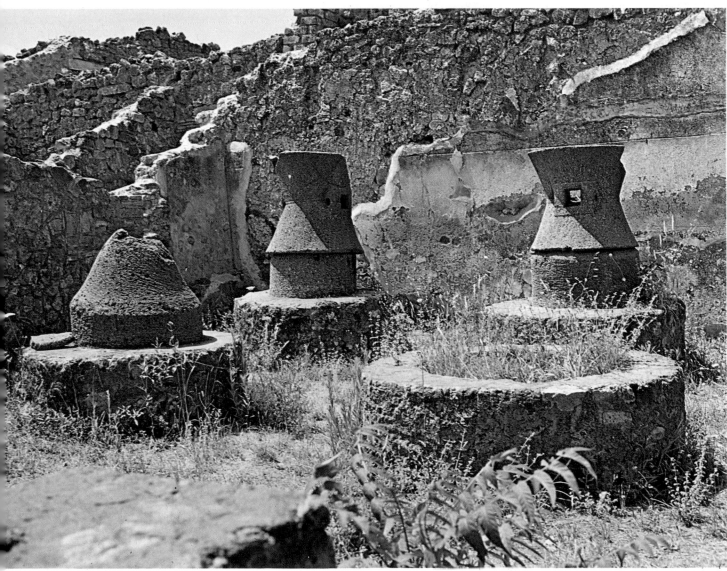

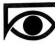

Opposite: the small covered theater built between 80 and 75 BC holds no more than 1,500 spectators and was used for musical recitals and mimes. It lies near a larger theater in what was the cultural center of the city.

Right: the Basilica was the commercial center of Pompeii: the equivalent of the Bank and Stock Exchange today.

Below right: the courtyard in which the Temple of Apollo stood was surrounded by a Doric portico. In front of one of the columns is a bronze statue of Apollo drawing his bow.

Below: a terracotta statue of Jupiter was found together with a statue of Juno and a bust of Minerva in the cella of the Temple of Zeus Meilichios which served as the temple of the Capitoline triad after the earthquake of 62 AD.

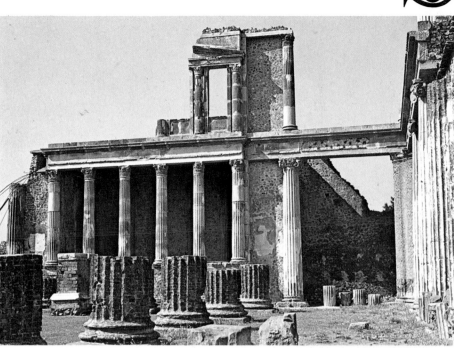

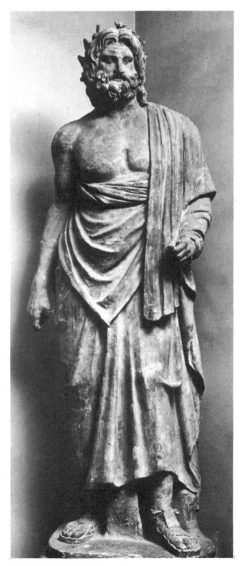

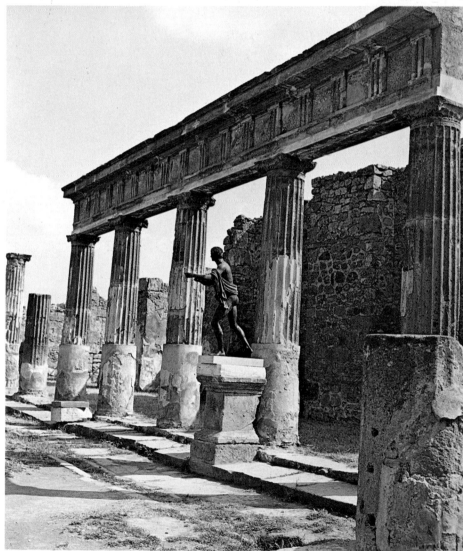

Pompeian houses are unpretentious externally (*left*) but could be grandiose inside: from the atrium (*below*) could be seen the garden across an open dining room. The garden of the House of the Vettii (*bottom*) shows how a Pompeian garden might have appeared with its ornamental plants, fountains and statuary. The meaning of the frescoes of the suburban Villa of the Mysteries (*opposite*) is hotly disputed; perhaps they show the initiation of a bride or brides in the Dionysiac mysteries.

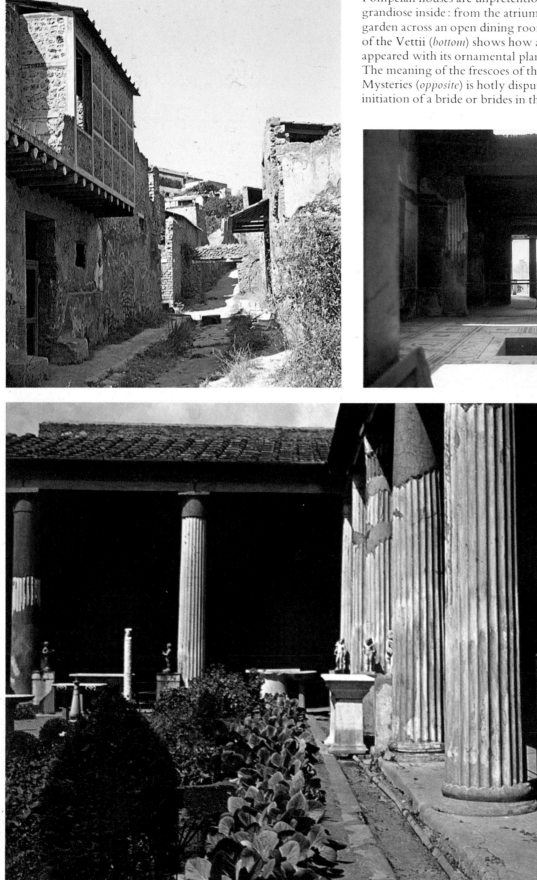

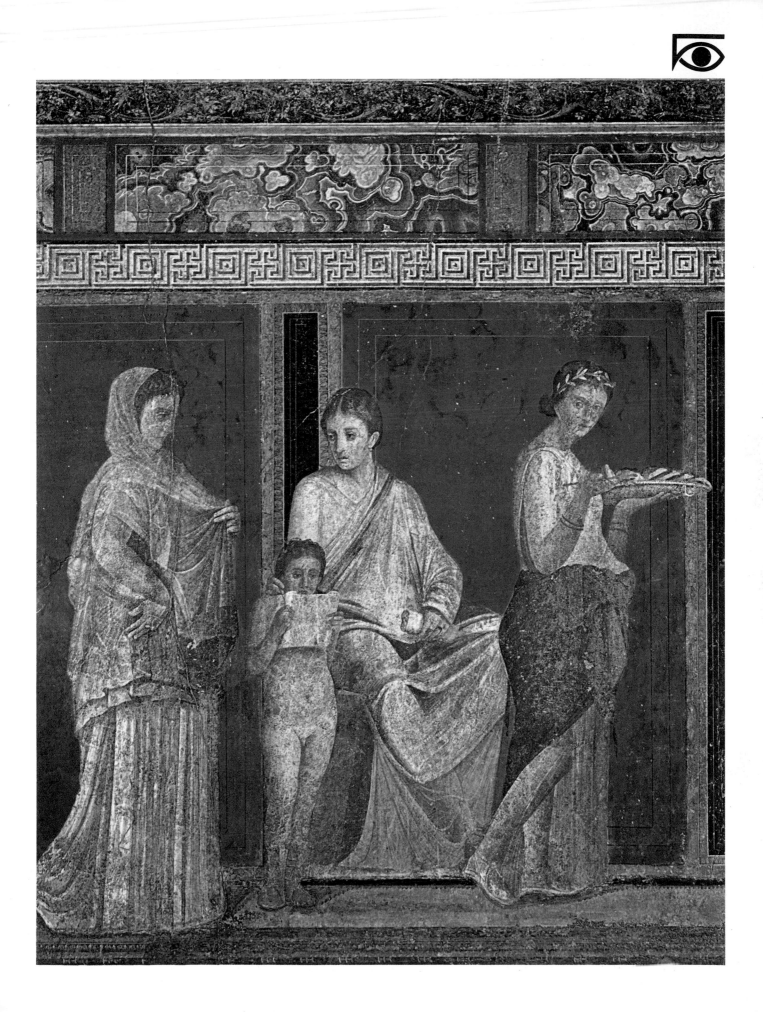

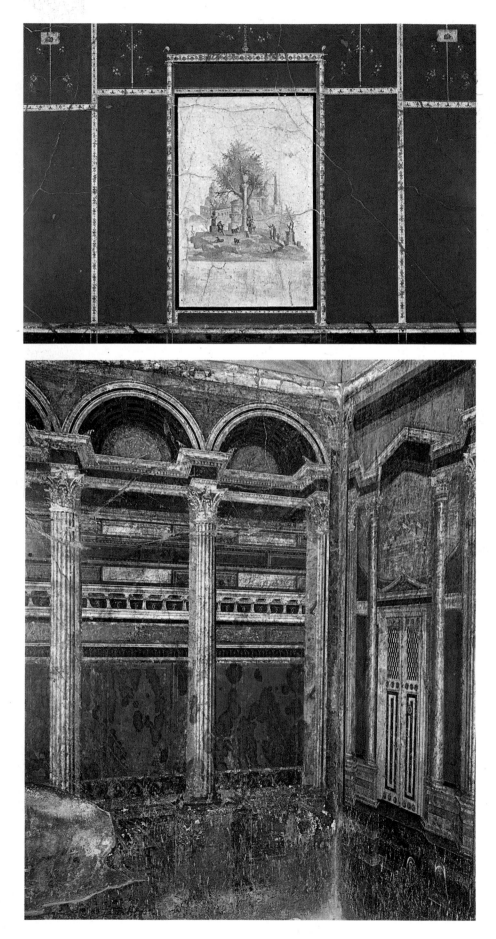

The frescoes on the walls of houses at Pompeii are among the best-preserved Roman wall decorations that we have. Few are of really high artistic quality, however, and the temptation to overrate them should be resisted. In general they represent middlebrow taste in a Roman country town and simply reflect the fashion of metropolitan Rome rather than being in any way original themselves. Ever since their discovery in the 18th century, the frescoes of Pompeii and Herculaneum have exerted a great influence on European and American interior decoration. In 1882 August Mau divided Pompeian frescoes into four styles, categories which are now applied to all Roman wall decoration of the period c. 200 BC–79 AD. The First Style simply imitated in colored plaster the ornamental schemes of rich Hellenistic houses of the eastern Mediterranean that had walls encrusted with marble slabs. The Second Style (*below left*) reached Pompeii when it became a Roman colony in 80 BC. Elements of the First Style were retained, but by the imposition of columns elaborate illusionistic effects were achieved. In Cubiculum 16 of the Villa of the Mysteries (of c. 60 BC) an impression of space is created by means of added columns supporting projecting architraves. The Third Style had been introduced at Rome by 12 BC and its earliest manifestation in the Pompeii area was in the Villa at Boscoreale (*upper left*) which was built for Agrippa Postumus in 11 BC. The architectural members have become exceedingly dainty: the columns have minute capitals and bases and have almost ceased to be functional. The decorative elements above are already in the realm of fantasy. The central picture on its white ground looks very effective against the Pompeian red. There are no examples of the Fourth Style at Pompeii before the earthquake of 62 AD. One of the earliest and most elegant is the Garden Room in the House of the Vettii (*opposite*). This detail well shows how far the trend towards fantasy was taken by the practitioners of the Fourth Style. The columns have become spindly twirls and slender scrolls and are merely decorative.

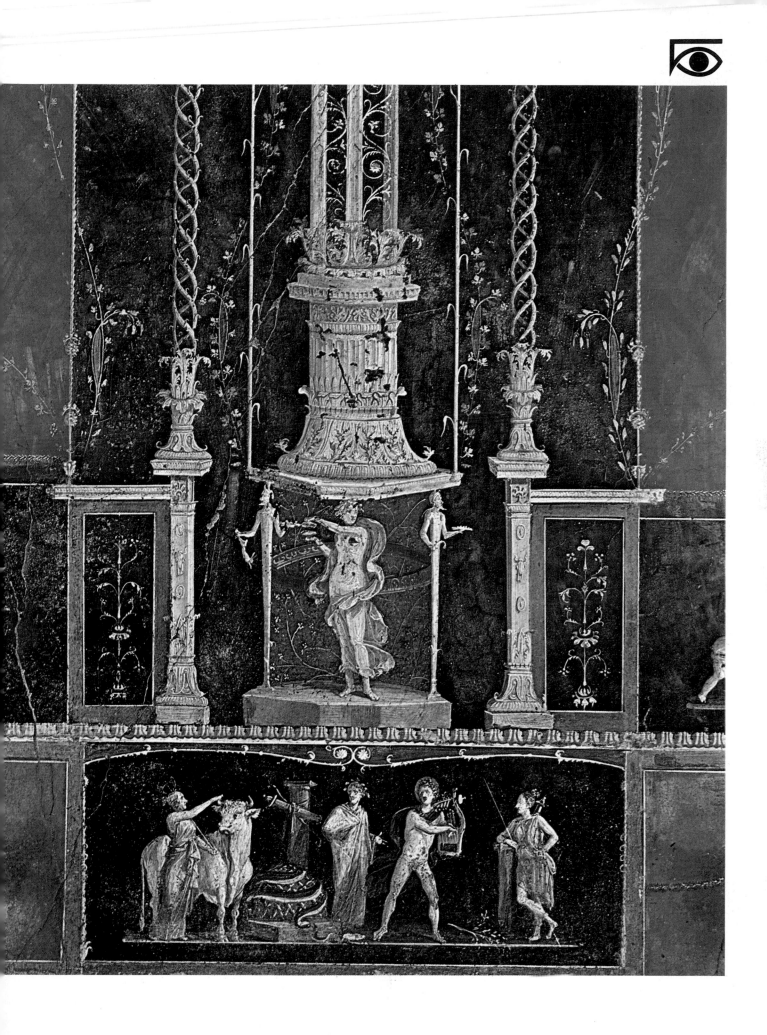

Above: an 18th-century tourist souvenir: the design on this fan was based on a fresco at Herculaneum.

Left: early 19th-century designs for the Hofgarten in the Residence at Munich employed a variation of the Pompeian Third Style.

Below: the J. Paul Getty Museum at Malibu, California, which opened in 1974, is based on the Villa dei Papiri at Herculaneum. The walls of the inner peristyle reproduce First Style decoration from the House of the Faun at Pompeii.

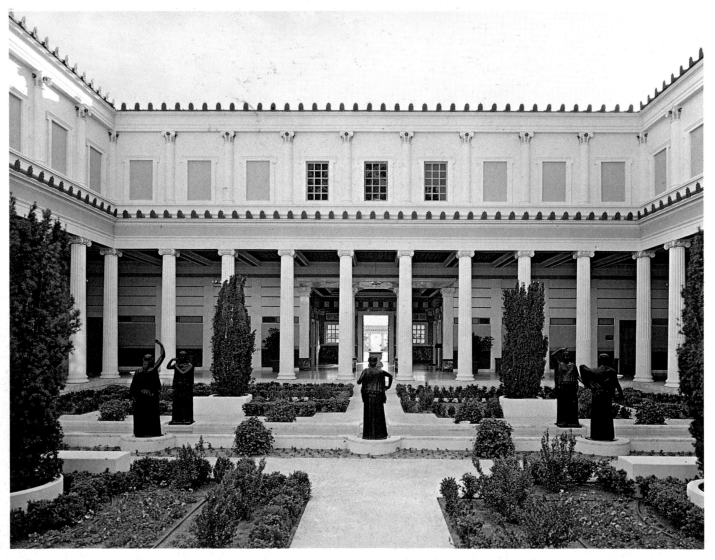

4. The Etruscans and their World

The Etruscans, that not-so-mysterious people (we know far more about them than many another ancient people) whose civilization flourished in central and northern Italy between the 8th and 4th centuries BC, caught the imagination, first of patriotic humanists in Tuscany and their successors, and later of the rest of Europe. But even before interest in *Etruscheria* had led to *Etruscomania* on a European scale, a scholar from distant Scotland, Thomas Dempster, wrote his *De Etruria Regali* between 1616 and 1625. It was a symptom, however, of the relative lack of interest in the Etruscans during the 17th century that his "diligent and powerful work . . . marred by apocryphal erudition and much fantasy" was not published for another hundred years. Equally, though, the foundation of the Etruscan Academy at Cortona in 1726 and the publication of Dempster's work a few years earlier were indications of how much interest in the Etruscans had grown by the early 18th century. There were, of course, many misconceptions, notably that the Greek, mainly Attic, vases that were found in Etruscan tombs were of Etruscan manufacture – a misconception that was to lead the English industrialist Josiah Wedgwood to call his Staffordshire factory, where he produced pottery bearing Classical decoration, "Etruria." This particular error was only cleared up by L. Lanzi in 1806, and even then not everyone believed him – and there is still an Etruria near Stoke on Trent.

The knowledge that we have of the Etruscans has been derived partly from what the Greeks and Romans said about them, and partly from the tombs which exist in large numbers in the vicinity of every Etruscan town, notably Vulci, Cerveteri, Tarquinia, Chiusi and several others. The finest works from these tombs are now displayed in the Villa Giulia Museum in Rome, the Gregorian Museum in the Vatican and the Archaeological Museum in Florence, as well as in local museums near the sites. We have already seen how some Etruscan tombs have been discovered in recent years; this chapter will be concerned first with the history of the exploration of some of these cemeteries in the 19th century, and then with an account of what can be learned about the Etruscans' history from the tombs and their contents.

Exploring Etruscan places. Richard Colt Hoare explored Etruscan cities in the 1780s, but the bulk of exploration was done by Italian antiquarians. Public and private collections were built up, and a good deal of scholarly work was published; the classic, and highly

Previous page: detail of the terracotta statue of Apollo from the Portonaccio sanctuary at Veii, c. 500 BC. Villa Giulia, Rome.

Right: the Etruscan world.

Below: chamber tombs in the Crocefisso del Tufo necropolis at Orvieto.

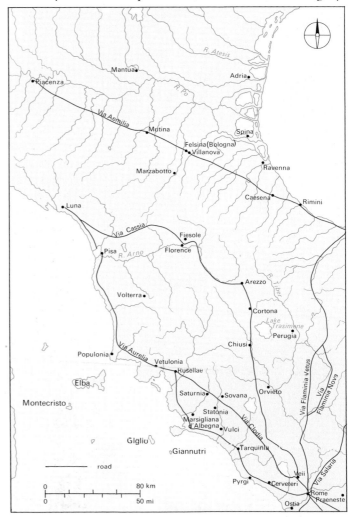

The interior of the Tomb of the Tarquins at Cerveteri as seen by George Dennis and published in his *The Cities and Cemeteries of Etruria* (1848).

readable, *The Cities and Cemeteries of Etruria* by the Englishman George Dennis did a great deal to spread knowledge of the Etruscans among a much wider public than before. He made several tours in Tuscany between 1842 and 1847; his book appeared to wide acclaim in 1848. Dennis was interested in many aspects of the Italian scene besides antiquity, and after a long description of, say, shepherds making cheese in the Roman Campagna, he would liken the men with "their nether limbs clad in goatskins, with the hair outwards" to "the satyrs of ancient fable," albeit "they had no nymphs to tease, nor shepherdesses to woo."

When he was in the neighborhood of Vulci, he watched with considerable dismay the excavation of a tomb on the estate of the Princess of Canino (her late husband, Lucien Bonaparte, Prince of Canino, had begun a series of annual excavations in 1828; the first season had brought to light more than 2,000 objects). The practice was for work only to be done in the winter and for the tombs when rifled to be refilled with earth so that the land could then be sown with grain. In this way the princess could gain two harvests, "the one of literal, the other of metaphorical gold." "They were just now commencing for the season," Dennis wrote. "At the mouth of the pit in which they were at work sat the *capo*, or overseer, his gun by his side, as an *in terrorem* hint to his men to keep their hands from picking and stealing. We found them on the point of opening a tomb. The roof, as is frequently the case in this light friable tufo, had fallen in, and the tomb was filled with earth, out of which the articles it contained had to be dug in detail. This is generally a process requiring great care and tenderness, little of which, however, was here used, for it was seen by the first object brought to light that nothing of value was to be expected . . . Coarse pottery of unfigured, and even of unvarnished ware, and a variety of small articles in black clay, were its only produce; but our astonishment was only equalled by our indignation when we saw the labourers dash them to the ground as they drew them forth, and crush them beneath their feet as things 'cheaper than seaweed'. In vain I pleaded to save some from destruction; for, though of no marketable worth, they were often curious and elegant forms, and valuable as relics of the olden time, not to be replaced; but no, it was all *roba di sciocchezza* – 'foolish stuff' – the capo was inexorable; his orders were to destroy immediately whatever was of no pecuniary value, and he could not allow me to carry away one of these relics which he so despised. It is lamentable that excavations should be carried on in such a spirit; with the sole view of gain, with no regard to the advancement of science."

Dennis, of course, was perfectly right. *All* the material from a tomb is of importance archaeologically speaking, and very often the most helpful diagnostic features for dating and interpreting a tomb group (as the contents of a single burial or cremation are called) are the most commonplace and aesthetically insignificant things. A pot of the kind that Dennis' *capo* ("a lewd fellow of the baser sort") would have had destroyed might provide the evidence whereby a tomb could be placed within a cultural or chronological framework, as well, perhaps, as

providing information concerning the economic and commercial relations of the people in whose territory the burial was made. The present writer, for instance, has been able to date within a decade or two a type of cut-glass bowl that had formerly been dated to "the second half of the first millennium BC," thanks to the discovery of a specimen in a tomb the date of which was made possible by the presence of other, datable objects – mainly "unfigured" pottery.

Treasures of the tombs. Since objects other than gold were held in such low esteem, many tombs that Dennis visited retained some of their contents. A few vases can be seen, for example, lying around the "Tomb of the Tarquins" in the Banditaccia cemetery at Cerveteri, as shown in Dennis' woodcut. This tomb was relatively late in terms of the development of Etruscan tombs, and is to be dated to the 4th or 3rd century BC. The interior has been made to take on the appearance of what we must assume to be a room in an Etruscan house, with a gently sloping roof supported on massive piers. A much earlier tomb at Cerveteri – the "Regolini-Galassi Tomb" of c. 650 BC – was constructed in a rather more coarse, but none the less complex, fashion. It had long since been cleared of its immensely rich contents by the time of Dennis' visit (they had been taken to the newly founded Etruscan Museum in the Vatican shortly after their discovery where they can still be seen). In Dennis' own words: "The sepulchre at Cervetri which has most renown, and the greatest interest from its high antiquity, the peculiarity of its structure, and the extraordinary nature and value of its contents, is that called after its discoverers – the archpriest Regulini, and General Galassi. This is one of the very few virgin-tombs, found in Etruscan cemeteries. It was opened in April 1836. It lies about three furlongs from Cervetri, to the south-west of the ancient city, and not far from the walls. It is said to have been inclosed in a tumulus, but the mound was so large, and its top has been broken by frequent excavations, and levellings of the soil for agricultural purposes, that its existence is now mere matter of history.

"The sepulchre opens in a low bank in the middle of a field. The peculiarity of its construction is evident at a glance. It is a rude attempt at an arch, formed by the convergence of horizontal strata, hewn to a smooth surface, and slightly curved, so as to resemble a Gothic arch. This is not, however, carried up to a point, but terminates in a square channel, covered by a large block of *nenfro*. The doorway is the index to the whole tomb, which is a mere passage, about sixty feet long, constructed on the same principle, and lined with masonry. This passage is divided into two parts or chambers, communicating by a doorway of the same Gothic form, with a truncated top."

Hardly any pottery was found in the tomb, "but numerous articles of bronze, silver and gold . . . In the outer chamber, at the further end, lay a bier of bronze, formed of narrow cross-bars, with an elevated place for the head. The corpse which had lain on it had long since fallen to dust. By its side stood a small four-wheeled car, or tray, of bronze, with a basin-like cavity in the centre, the whole bearing, in form and size, a strong resemblance to a dripping-pan . . . On the other side of the bier lay some thirty or forty little earthenware figures; probably the lares of the deceased, who had not selected his deities for their beauty. At the head and foot of the bier stood a small iron altar on a tripod, which may have served to do homage to these household gods. At the foot of the bier also lay a bundle of darts and a shield; and several more shields rested against the opposite wall. All were of bronze, large and round . . . and beautifully embossed, but apparently for ornament alone, as the metal was too thin to have been of service in the field. Nearer the door stood a four-wheeled car, which from its size and form, seemed to have borne the bier to the sepulchre. And just within the entrance stood, on iron tripods, a couple of cauldrons, with a number of curious handles terminating in griffons' heads, together with a singular vessel – a pair of bell-shaped vases, united by a couple of spheres. Besides these articles of bronze, there was a series of vessels suspended by bronze nails from each side of the recess in the roof."

Opposite: one of the frescoes in the Tomba delle Leonesse at Tarquinia of c. 520–500 BC. It shows a reclining banqueter holding a wine cup in one hand and an egg in the other.
Below: a fresco in a tomb of c. 500 BC at Chiusi with lively scenes of dancing and wrestling. The referee will punish any infringement with a stroke of his cane.

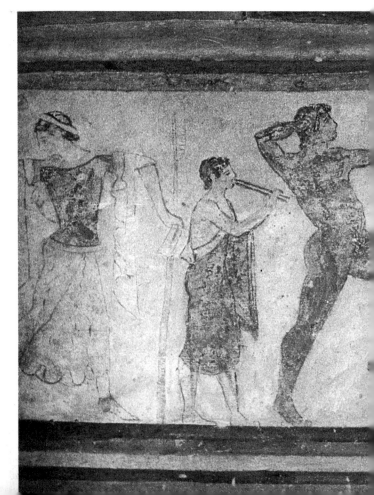

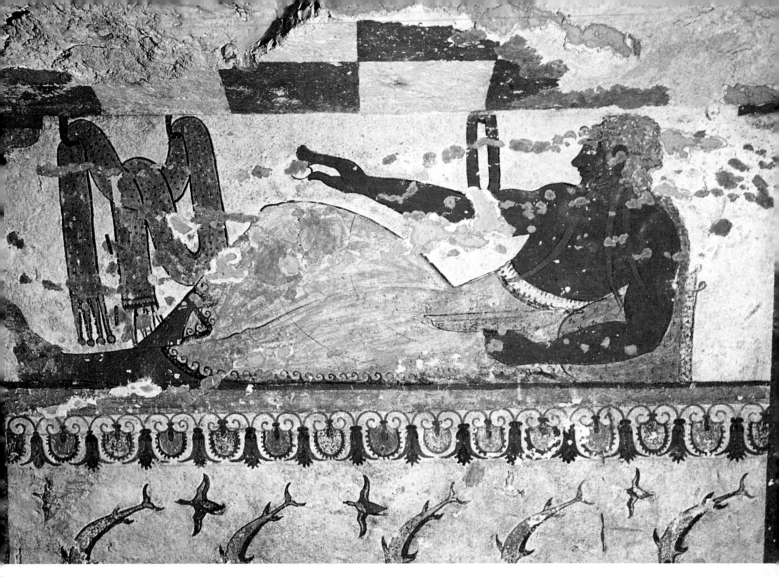

The outer chamber contained the body of a warrior, whose grave-goods were striking enough, but the inner chamber contained objects of almost unparalleled magnificence: an embossed breastplate in gold, earrings of enormous length, massive bracelets decorated with filigree work, 18 fibulae and the remains of what appears to have been a garment made of gold, the fragments of which "crushed and bruised were alone sufficient to fill more than one basket." This, however, was not all; there were in fact three burials in the Regolini-Galassi tomb. The earliest was that of the richly decked woman in the inner chamber, and the latest the male occupant of the outer chamber. Between them, in both place and time, in a niche to the right of the entrance to the inner chamber were the cremated remains of a man in a large urn surmounted by the figure of a horseman; buried with him were his bronze chariot and weapons of war.

There were many other tombs of the 7th century in southern Etruria which were equally magnificent, though most had been looted before they could be examined by archaeologists. They attest the wealth of an emergent Etruscan aristocracy during the 7th century when they were rich enough to afford luxury "Orientalizing" imports from the eastern Mediterranean. They perhaps derived their wealth from the trade in metal, especially

iron ore, with the Aegean. Although the sources of the ore were in northern Etruria, it is likely that the southern Etruscans acted as agents for its sale to the Greek colonists of southern Italy, and exacted a heavy levy on the material as it passed through their territory.

Some Etruscan tombs are decorated with paintings on their walls which can provide us with useful information concerning Etruscan everyday life – how, for instance, they dined with their womenfolk, in contrast with the Greeks who are on record as regarding such a practice with distaste. Their love of music and dancing is clear from the paintings, as is their liking for the chase, and every new discovery gives us fresh insights into Etruscan life and art.

The origins of Etruscan culture. These discoveries need to be seen against the background of what we know about the Etruscans in general. At the risk of over-simplification, it is possible to summarize the main developments in Etruria as seen by the archaeologist as follows. During the Bronze Age, which began in Italy *circa* 1650–1500 BC, there seems to have been a fairly homogeneous culture in northern Italy – the so-called Apennine culture – the economic basis of which was metal-working and stockbreeding. It had close cultural links with the Aegean, but with the breakdown of the Mycenaean civilization around 1200 trade links were forged instead with the north: with the Po valley and beyond. Baltic amber, which was to be a popular form of decoration for centuries in Etruria, found its way to Italy for the first time. Probably by the 9th century BC techniques for working the great iron resources of Etruria were developed, slowly at first, but on an ever-increasing scale. The Iron Age culture of northern Italy is usually referred to as Villanovan, after the village of Villanova near Bologna where evidence for the culture was first discovered over a hundred years ago. It is a mistake to employ the expression "the Villanovans" as some authorities still do; the term refers simply to the culture, the way of life of the people, rather than the individuals concerned. Evidence for the Villanovan culture has been found in Etruria and the Po valley; again, it is quite uniform,

though with minor local variations. There are distinct signs of increased prosperity in Etruria at this period, and the population appears to have grown as a result.

A remarkable fact is that Villanovan settlement sites coincide with later Etruscan cities: Tarquinia, Cerveteri, Vulci, Chiusi, to name but a few, all had Villanovan predecessors. The prevailing burial rite was cremation, with biconical urns buried in simple tombs known as *a pozzo*, on account of their well-like characteristics. We shall look at some specific examples of Villanovan products later in this chapter. Insofar as we can tell – and the chronology of the Iron Age in Italy is hotly debated – this earliest phase of Villanovan in Etruria lasted from around 850 to 750 BC. The problem of chronology is made more difficult by the fact that there is no independent dating evidence until the beginning of Greek colonizing

Right: the 2nd-century BC gateway at Volterra.

Opposite: bronze statuette of a warrior from Vulci, imported to Etruria from Sardinia in the 9th century BC. Villa Giulia, Rome.

Below: the site of Vulci today

activity in southern Italy around 750 BC. The Villanovan phase in Etruria appears to have begun earlier than that of the Po valley, presumably on account of the existence of Etruria's rich mineral resources. During the next 50 to 70 years or so, using the conventional chronology, a specifically Etruscan culture developed, with fairly distinct regional variations. The practice of inhumation was on the increase, and this was especially the case in southern Etruria, in contrast with the northern and inland Etruscan centers. It has been suggested that this gradual change in burial practice is a reflection of changes that were occurring in social conditions – which is preferable to the notion that it represents an influx of a new race of people. Quite what the changes were is another matter. We might perhaps speculate that the change in burial practice in Etruria was a similar phenomenon to that which is occurring in England at the present time, but in reverse. In just a few decades cremation has become in England the normal rather than the exceptional means of disposing of the dead. There have been no invasions of cremating strangers accompanying this change in custom. It has simply occurred because public taste has turned away from 19th-century funerary pomp. Might not the reverse have occurred in Etruria?

There is evidence for a new aristocratic class in most Etruscan cities from c. 700 BC onwards; at least this is what burials of warriors in full panoply might lead us to believe. Could the Etruscans have adopted the practice of inhumation as offering greater opportunities for the conspicuous consumption of wealth? Inhumation did not become common practice everywhere; inland conservative Chiusi was an exception, as we shall see, but even there there are signs of increasingly rich cremation burials during the 7th century BC. An indication of the wider horizons of the Etruscans from about 675 BC onwards, and an index of their wealth, is the presence in ever-increasing quantities of imports from Greece and the eastern Mediterranean. The luxurious contents of the Regolini-Galassi

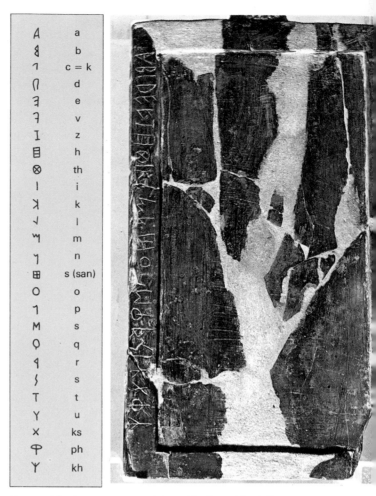

Above: mid-7th-century BC writing tablet from Marsigliana d'Albegna. It has the Etruscan alphabet, remarkably similar to ours, engraved along its edge. Museo Archaeologico, Florence.

Opposite: Vulci was famous in antiquity as a center of bronze manufacture. This stand supported by a nude male figure was made there c. 500 BC. Staatliche Antikensammlungen, Munich.

Left: Villanovan cremation urn in the form of a wattle-and-daub hut from Vulci, 8th century BC. Villa Giulia, Rome.

tomb at Cerveteri described above provide a case in point. By the middle of the 7th century BC, the Etruscans possessed an alphabet, and an art that owed nearly everything of a formal nature to the artistic products that were imported from the Aegean and beyond, or which were even made in Italy by immigrant Greek craftsmen. In visual terms, Etruscan civilization is largely a provincial version of Greek, and by any reckoning, Etruria was a cultural backwater during the 7th and subsequent centuries.

The cultural developments outlined above manifested themselves in slightly different ways in various parts of Etruria. It is a mistake to think of the Etruscans as a single nation with a uniform culture; rather they consisted of a loosely knit confederation of cities (12 in all) which display distinct regional variations in their arts and artifacts. It might be instructive to examine the archaeological record

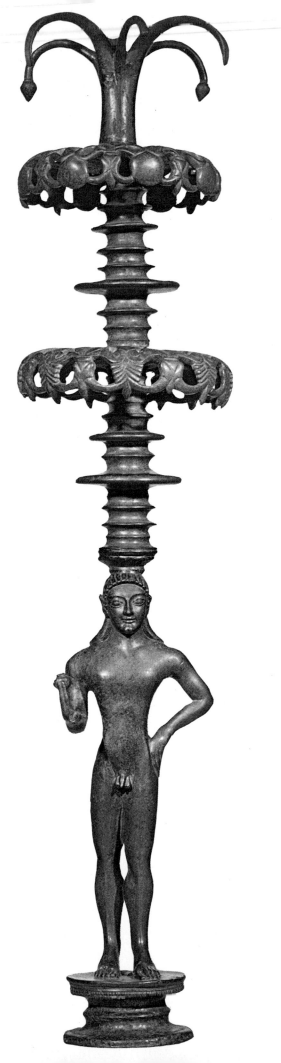

of just two cities in order to emphasize the point. Vulci and Chiusi were cities whose territories shared a common border. The one was close to the sea and had a cultural and artistic development that was typical of other coastal cities. The other was situated well inland, and was subject to different influences.

Vulci and the Etruscan littoral. Vulci (*Velc* or *Velecha* in Etruscan) is situated on a low plateau in the valley of the River Fiora about eight miles from the point where the latter debouches into the Tyrrhenian Sea. The site of the ancient city is now covered with cornfields, but the principal harvest over the years has been gathered from the tombs which abound in the immediate vicinity. We have already noted Dennis' reaction to their overexploitation in the earlier 19th century. Fertile plains surround the city, but the territory which it controlled at the height of its power was far more extensive, being bounded on the north by that of Rusellae, on the west by Chiusi and the south by Tarquinia. Other important Etruscan settlements within its territory included Cosa, Sovana, Stratonia, Maternum, Caletra (near Marsiglia d'Albegna), and perhaps also the offshore islands of Giannutri, Giglio and Montecristo, for Vulci was a maritime, as well as a land, power, and evidence has recently been discovered for cultural links with Sardinia at a very early date.

This evidence was found in the "Bartoccini Tomb" of the late 9th century BC, so called for its excavator in 1960, Renato Bartoccini. In many ways it is a typical cremation burial of Villanovan type, containing a large biconical pottery urn surmounted by an inverted cup which served as a lid. Both vessels are decorated with geometric patterns which have been inlaid in bronze. The presence of a bronze chain around the neck of the urn is a hint that the latter may have been thought of in anthropomorphic terms, as was certainly the case at Chiusi with regard to cremation urns of a later date. Other bronze objects in the "Bartoccini Tomb" include a small five-footed incense burner, a small two-handled vessel with a lid for oil or perfume, a fragment of a belt with finely engraved spiral decoration and birds'-head ornaments, as well as a large number of fibulae, disks and chains. The most significant find, however, was a bronze statuette of a warrior, of a kind made in Sardinia, and which must have been imported from there. He is shown bending forward with his right arm stretched out. In his left hand he holds a large shield, apparently of leather. His eyes are large and round and his nose short and thin. He has a high pointed cap, and two braids of hair fall down to his middle over a belted cloak. This extraordinary figure stands out as a unique example of representational art in Villanovan Etruria, and is also important as an indication of the extent of Vulci's commercial ties at the period.

Another characteristic form of cremation urn at Vulci and elsewhere in southern Etruria during the Villanovan period was the hut-urn, made in either clay or bronze.

They can be either oval or rectangular in plan and represent the dwelling houses of the living. Finds of actual huts on the Palatine at Rome allow us to interpret them as having walls of wattle and daub supported by posts driven into the ground. The roofs were pitched and presumably thatched, and on urns from Vulci have particularly deep overhanging eaves. Holes in the gable ends of the roof allowed smoke to escape. The drab appearance of the clay of the urns is often relieved with brightly colored geometric patterns on the roof, walls and the detachable door.

Vulci, being on the coast, was subject to Greek and Oriental influences from the mid-8th century BC onwards. One of the earliest acquisitions that the coastal cities made was knowledge of the alphabet, derived from a north Semitic source via the Greeks. Literacy quickly spread among all classes of Etruscan society. A precious document for the history of writing in Etruria is an ivory writing tablet found at Marsigliana d'Albegna in the territory of Vulci in a context that would date it to the mid-7th century BC. Along one edge is engraved a retrograde Etruscan alphabet of 26 letters, many of which are easily recognizable. There is not, in fact, any difficulty so far as the decipherment of Etruscan is concerned, for the language is perfectly legible. A great problem arises, however, with the interpretation of the numerous (well over 10,000) Etruscan texts that we possess. They are mostly inscriptions and are nearly all short. It has not proved possible to demonstrate with any degree of plausibility any connection between Etruscan and any known language, and the consensus of opinion is that Etruscan belongs to a pre-Indo-European substratum. Any advances in the interpretation of Etruscan have come about as the result of the internal comparison of the known texts. Consequently, the meanings of about 300 words, their cognates and derivatives are now known in broad outline. But we still know so little about the Etruscan language that even new texts, such as the three gold plaques found at Pyrgi in 1964, one of which was helpfully in Punic, create more problems than they solve.

Greek influences in Etruscan art. The most obvious debt that the Etruscans owed to the Greeks was the inspiration for the forms, and much of the content, of their visual arts. A striking example of this is the *nenfro* (local limestone) centaur found in a tomb in the Poggio Maremma area of Vulci in 1921. Attached to the half-life-size figure of a man, who stands with one leg in front of the other and his hands close to his sides, are the trunk and hindquarters of a horse. The creature itself is derived from the Greek mythological menagerie, while the style can be closely paralleled in nearly every respect – stance, proportions, hairstyle, facial features, bulging eyes – by a pair of statues of the twins Cleobis and Biton carved by the sculptor Polymedes of Argos and dedicated at Delphi in the first quarter of the 6th century BC. There can be no

doubt that the Vulci centaur was strongly inspired by contemporary Greek art.

Apart from widespread imitations of Greek pottery shapes by Etruscan potters, and the manufacture in Greece of vases specifically designed for the Etruscan market, there is evidence for Greek craftsmen actually working in Etruria. The decoration on a series of pottery hydrias (water-jars) found at Cerveteri and Vulci can be attributed to a Greek artist who seems to have settled at Cerveteri and produced a series of painted vases with lively representations of Greek myth and legend during the last third of the 6th century BC. He was probably an immigrant from Ionia in Asia Minor, and his work was just one of the elements contributing to the distinctively Ionian character of much of 6th-century Etruscan art. The scenes he depicts on his vases include the blinding of Polyphemus, Heracles and Cerberus, and the heroes of Troy. A vase from Vulci in the British Museum is in a related style, and is attributed to the Micali Painter, probably another immigrant Greek. On this vase he has painted non-mythological, though still Greek, scenes: a pair of boxers sparring to the accompaniment of the flute, a discus thrower, runners, and a team of chariots in full flight, the illusion of speed being enhanced by the presence of a running hound at their feet. Greek gem cutters also practiced in Etruria at this period, and laid the foundations for a strong indigenous tradition of the glyptic art.

Some Etruscan cities became famous for various kinds of manufactured goods. Veii, for example, had a name for terracotta, and the Veientine artist Vulca was commissioned to make statues for the adornment of the temple of Jupiter Optimus Maximus at Rome in the closing years of the 6th century BC. Vulci, and later Perugia, were famous for their bronze industries. During the 6th and 5th centuries Vulci exported votive bronzes, especially vases, candelabra, tripods and decorative stands of various kinds, not only to other parts of Italy, but also to central Europe and even to Greece, where examples have been found at Olympia. An ornamental bronze stand now in Munich was made in Vulci around 500 BC. It consists of a youth apparently balancing the other two-thirds of the object on his head. This may seem strange to us, but the use of human figures in this way was in fact quite common in Greek, and especially Etruscan, art of the Archaic and Classical periods.

Among the commonest Etruscan bronze objects are mirrors. They are circular in shape with a projecting tang which would be inserted into a bone or ivory handle, most of which have not survived. One side of the disk would be highly polished or tinned, while the reverse would be engraved, often with a mythological scene. Etruscan engravers of the 5th and 4th centuries BC were particularly accomplished, and decorated bronze vessels (*cistae*) as well as mirrors. A mirror from Vulci in the Vatican of the late 5th century BC bears a scene that links Greek mythology with Etruscan practice. Within a band of ivy leaves and

berries is shown the figure of the seer Calchas standing by a table inspecting the liver of a sacrificial animal. We know it is Calchas, for his name is given (spelled "Chalchas"). He was the seer who foretold that the Trojan War would last for ten years. The inspection of liver was known as hepatoscopy, and was a form of divination that was widely practiced in Etruria. It was thought that messages from the gods could be communicated via the appearance of the liver of a sacrificed animal, and special colleges of priests known as *haruspices* existed who were both skilled in divination and were the guardians of Etruscan religious traditions known as *Etrusca disciplina*. *Haruspices* were members of the Etruscan aristocracy and handed their art

down from father to son. These priesthoods were regarded as highly important institutions in both Etruscan and Roman society, so much so that when they appeared to be in decline around the 2nd century BC the Roman Senate passed a measure ensuring the continuity of the *disciplina*. Thus it was that a chief seer, a *summus haruspex*, warned Caesar not to cross to Africa before the winter solstice, and another (or it may have been the same person), whose Etruscan name Spurinna has been recorded, warned him of the Ides of March.

Only two tombs at Vulci are known to have had wall-paintings. One was opened in 1835, but the paintings soon disappeared. A copy had been made however (now in the British Museum), and it can be seen that the missing paintings represented Charon in the Underworld: the kind of scene one might well expect in a funerary context. The other painted tomb was called after its discoverer the

Detail of a vase painted by the Micali Painter, an immigrant Greek artist. Boxers spar to the accompaniment of the flute, and a boy holds a sponge for use between rounds. British Museum.

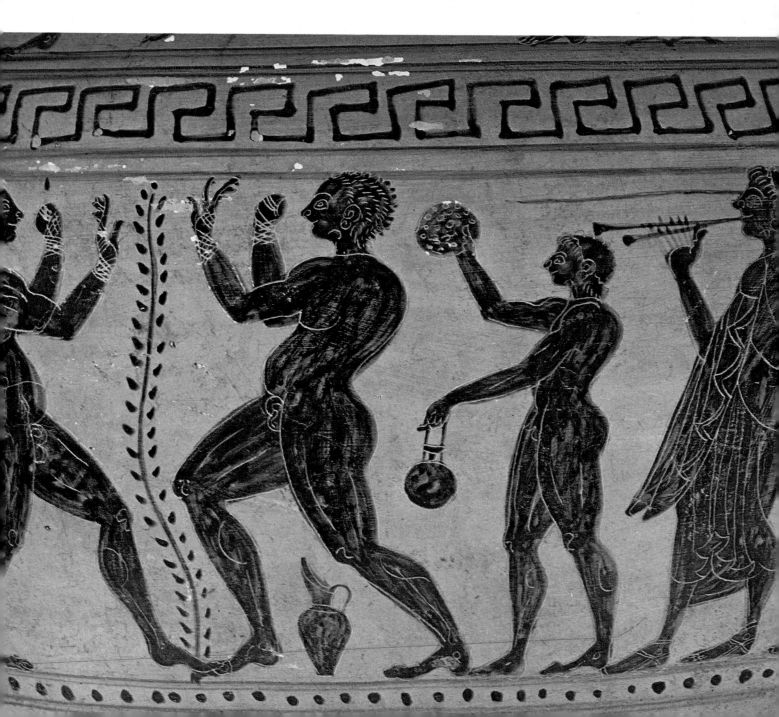

"François Tomb" and the paintings can now occasionally be seen in the Museo Torlonia in Rome. One panel has a mythological scene of Achilles sacrificing Trojan prisoners to the departed spirit of his buddy Patroclus, but another panel has an important representation of an event, not just in Etruscan, but also in Roman history. Rome, as we shall see, was under Etruscan domination for most of the 6th century BC. The Vulci tomb painting is of interest in that it gives a version of an event that differs from that of Roman tradition. Servius Tullius, king of Rome in the mid-6th century, was equated in Etruscan tradition with Mastarna who appears in the Vulci painting as the ally of Aulus and Caelius Vibenna ("Aule" and "Cele Vipinas"). Gnaeus Tarquinius Romanus ("Cneve Tarchunies Rumach") seems to have been killed in the mêlée. The Etruscan story, borne out by the François Tomb paintings, was that Servius Tullius had seized power by force, but the Roman version was of a peaceful transfer of power. Even though the tomb is Hellenistic in date, the paintings represent a much earlier version of a historical event. There is other evidence, in fact, which shows that Aulus Vibenna, at least, did actually exist. A fragment of a mid-6th-century bucchero vase found in a sanctuary at Veii shows that one "Avile Vipiennas" made a dedication there at the time that Servius is supposed to have ruled in Rome.

If the Etruscans were a power to be reckoned with in the 7th to 5th centuries BC, by the 4th Rome was strong enough to besiege and capture Veii (in 396). Legends grew up around this event which attributed to it many of the features of the Trojan War, but there is a basis of fact in the emergence of Roman military power at the time. Despite the setback of the sack of Rome by the Gauls in 390, Rome first dominated Latium, and later, by the 3rd century BC, Etruria and northern Italy. Etruscan centers of southern Etruria, such as Vulci, went into a steady decline and most sites are now deserted. Inland cities, however, which in any case developed later than the coastal towns, flourished mainly during the last phase of Etruscan civilization and under Roman domination. Chiusi is just one such city.

Chiusi and the Etruscan hinterland. Chiusi (in Etruscan *Clevsin* and Latin *Clusium*), a site that has been occupied continuously from Etruscan days, lies well inland. It stands on a height and is surrounded by rich agricultural land, whence it derived its wealth. In Etruscan times the territory of Chiusi shared a common border with that of Vulci, but the two cities were rather different places. The key to the understanding of this difference is that Chiusi did not lie on the sea. Any non-Etruscan influences that it received came via other Etruscan centers and not directly. The 7th century BC had seen the growth of an Etruscan culture in the cities near the coast, but it was not until the 6th century that Chiusi started to develop Etruscan characteristics. An index of the relatively conservative nature of the inhabitants of early Chiusi may be seen in the fact that the practice of inhumation is not to

Opposite: the hinterland of Etruria near Montepulciano.

Left: a 5th-century BC tomb at Chiusi with its original stone doors.

Below: a late 5th-century BC mirror from Vulci shows the seer Calchas inspecting the entrails of an animal. Divination was a skill that was highly regarded in both Etruscan and Roman society. Vatican.

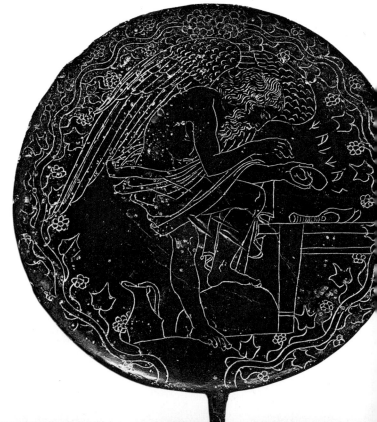

be found much at all before the 6th century. Cremation, moreover, predominated even when inhumation had become fairly common.

The earliest burials at Chiusi were of the customary Villanovan type: biconical urns provided with lids. By the 6th century, however, it was customary for the lids to be in the form of human heads, and for the bodies sometimes to be given rudimentary arms. These urns are usually called "Canopic vases" on account of the superficial resemblance that they bear to a series of Egyptian funerary vases which also have heads, but which contained the viscera of the dead. The analogy between the two kinds of vase is not, strictly speaking, correct, for the Chiusine urns were meant for ashes, but the name is now so widely used that it would be impossible to change it. A particularly fine Canopic vase from Chiusi, which displays a remarkable degree of stylization, is in the Museo Archaeologico in Florence. The head is smooth and egg-shaped, with small sharp features. A lunate ear is pierced in the lobe and supports a bronze earring. There are holes, too, pierced into the interior through the ears and in the side of the nose. It seems to have been felt that any fumes or exhalations from the ashes should be allowed to escape; some heads of Canopic vases present a decidedly pock-marked appearance with holes all over the brow, cheeks and chin. The body of the vase in Florence is almost as interesting as the head, for two stylized arms with flat outspread fingers appear to be holding in the belly, and the "chest" is indicated by means of small pointed nipples. The urns are made of either bronze or terracotta, though the heads are usually of pot. We have already seen that at Vulci there were indications that Villanovan burial urns may have been thought of in anthropomorphic terms. The frequent presence of helmets in lieu of lids on urns at Tarquinia suggests that the same attitude may have prevailed there too. These hints find corroboration in the Chiusine Canopic vases, with their heads and other features.

There was another, related, type of urn at Chiusi in the late 7th and early 6th centuries BC of which a few examples are extant such as those in Chiusi, Berlin and Philadelphia. There was one formerly in the Paolozzi Collection in the city, where it greatly impressed George Dennis: "But the strangest monument is a pot of uncoloured clay, with a large female figure standing on the lid, of most archaic character, with arms attached by metal pins; holding in one hand an apple or other fruit. Her body is hollow, and the effluvium of the ashes in the urn passed off through a hole in her crown. She rises like a giantess from a circle of eleven Lilliputian females with hands on their breasts; and round the outer edge of the urn stand seven other similar figures, alternating with large heads of snakes or dragons, with open jaws. All these figures are removable at pleasure, being merely attached to the urn by pegs. This is one of the most remarkable articles to be seen at Chiusi. In truth, though its details find analogies elsewhere in Etruria, as a whole it is unlike every other monument of

Above: 6th-century BC cinerary urn from a tomb near Chiusi. The shoulder and lid are decorated with griffins' heads, a large female figure and tiny attendants. Chiusi Museum.

Left: 6th-century BC Canopic cremation urn from Chiusi remarkable for its elegantly stylized form. Museo Archeologico, Florence.

this antiquity yet discovered, and in the uncouth rudeness of its figures and their fantastic arrangement, you seem to recognise rather the work of New Zealand or Hawaii, than a production of classical antiquity." The "uncouth rudeness" can be put down to Chiusi's provincial status in c. 600 BC.

We must, however, return to Canopic vases. The features on their faces became progressively more lifelike during the 6th century, and the anthropomorphic aspect of the urns was further enhanced by the custom of placing them on bronze or terracotta thrones which stood in chamber tombs. These thrones were probably made to resemble wickerwork chairs that were in domestic use, and they provide a link with a later series of enthroned

figures in stone, often over life-size, but which are nevertheless urns for the reception of cremated ashes. The earliest example, dated to the end of the 6th century, is now in Palermo. The bulky form of the figure sits on a throne with curved sides similar to those on which Canopics sat. The upper part of his body, together with the back of the throne, is removable. The head too, which is close in style to the latest Canopic vases, can also be removed, thus providing a further point of contact with the earlier tradition.

One of the best-known of these enthroned figures is the so-called Mater Matuta from Chianciano now in the Museo Archeologico in Florence. It represents a mother with a babe in arms seated on a throne with a square back and sphinxes on the sides. There exists an account by L. A. Milani of the discovery of the group which is of some interest: "The statue was found *in situ* right in the middle of a chamber tomb cut in the rock, which had its entrance flanked or guarded by two roughly carved crouching lions in tufa . . . Within the hollow of the statue . . . together with the burned bones, were found: (1) a gold pin with some balls (? pomegranates) worked in filigree; (2) a solid gold ring decorated with the figure of a warrior in relief on whose breastplate could be read, so it was said, an Etruscan inscription; (3) two spiral earrings in filigree; (4) a Greek vase painted with a woman's head which by the style and technique could be dated to an Attic workshop of the later 5th century." The fashion for seated figures at Chiusi eventually gave way in the 4th to 2nd centuries BC to reclining ones, perhaps as a result of influence from Volterra, where alabaster urns surmounted by such figures were the norm.

Greek vases and Etruscan cemeteries. The reference to a Greek vase being discovered with "Mater Matuta" reminds us that thousands of Greek vases have been found in Etruscan cemeteries, especially those of Vulci and Chiusi. Indeed, one of the largest and most elaborately decorated Attic vases known was discovered in a tomb at Chiusi, by the same François as discovered the François Tomb at Vulci. It stands 66 centimeters high, and is 57 centimeters in diameter. It is crowded with figures participating in scenes ranging from an Athenian ship arriving to pick up Theseus and the Athenian youths and maidens he had rescued from the Minotaur, and the Calydonian boar hunt, through the marriage of Peleus and Thetis, Achilles ambushing Troilus, to a battle of pygmies and cranes on the foot. The names of many of the figures are given in the form of Greek painted inscriptions written by their heads. Vases on such a lavish scale were probably specially made for export: a parallel in bronze is the vastly greater (1·64 meters high) Vix crater, found in France, but probably made in a Spartan workshop. There were even special shapes of vase made in Athens for the Etruscan market. Nicosthenic amphoras are a good example. These have horizontal ridges and wide strap handles in imitation

of an Etruscan bucchero vessel which may itself well go back to a metal form. They bear figure decoration and bold painted inscriptions usually declaring that they were made by the potter Nikosthenes. It was presumably considered "chic" in Etruscan circles to possess vessels bearing Greek inscriptions. It may even be that makers' and potters' inscriptions – and even nonsense inscriptions – were put on vases in order to satisfy Etruscan taste, for it is a curious fact that most signed Attic vases have been found in Italy.

The presence of Greek works of art in great numbers, coupled with the likely presence of Greek craftsmen, could not fail to influence the art even of a conservative city like Chiusi. We have already seen how the funerary urns developed in the direction of anatomical realism, a

The so-called Mater Matuta urn from Chianciano, in the form of a mother and child. Late 5th century BC. Museo Archeologico, Florence.

realism that was Classical Greek in character. There was, however, another large class of sculpture at Chiusi which seems to have owed a great deal to the graphic, rather than the sculptural, arts of Greece. A large number of funerary *cippi* (short columns that were erected over graves) from Chiusi have survived. They are made of fine local sandstone (*pietra fetida*) which easily lent itself to carving in low relief. "The subjects are," in Dennis' words, "purely national-religious or funeral rites and ceremonies – scenes of civil or domestic life – figures in procession, marching to the sound of the double-pipes, or dancing with Bacchanalian furor to the same instrument and the lyre." A small *cippus* in Oxford, almost certainly from Chiusi, well illustrates the nature of these works. Groups of men and women appear on each of the four sides, and they are all carved in very low relief. It is an art purely of outlines, for there is no molding or gradation of planes. It is in effect a two-dimensional art, and presumably owed a great deal to the influence of Greek painting.

It should be clear now that Vulci and Chiusi, while sharing a common cultural background, were cities of a distinctly different character. An analogy might be found in the way that any two cities of central or northern Italy today would be found to have distinct identities. It would be possible to show how other cities of the Etruscan Federation had their individual characteristics, but space forbids.

The town of Marzabotto, laid out with a regular grid plan in the late 6th century BC. Evidence for iron working has been found in some of the houses.

Marzabotto – an industrial city. So far, we have been largely concerned with the Etruscans in death. This can hardly be avoided since so much of the evidence we have comes from funerary contexts. It is time now to look at just one example of an Etruscan city which has provided us with evidence for the industrial life of the Etruscans who lived there. This city, whose ancient name is uncertain, is situated near the modern village of Marzabotto about 15 miles south of Bologna. It was laid out in the closing years of the 6th century BC at a time when Etruscan influence was expanding beyond the limits of the federation across the Apennines into the valley of the River Po. Marzabotto was a new foundation which was planned according to the principles of orthogonal grid-planning which was becoming common in the Greek world, and which was to be refined during the 5th century by the architect and political philosopher Hippodamus of Miletus. Part of the site of Marzabotto has been eroded away by the action of the River Reno which flows along its southwestern side, but it is still possible to reconstruct the overall plan of a principal main street running from north to south crossed at intervals of 165 meters by three east-west streets. Within this scheme are the housing blocks which vary in width from 35 to 68 meters.

The stone foundations of some of the houses survive, or rather, the footings of the walls of partly fired bricks that supported a roof of wooden beams covered with broad terracotta tiles. The plans of the houses vary a good deal, but a regular feature is a long corridor beneath which was a drain leading out to the street. Many houses had a central courtyard, and in some of them evidence for iron working (in the form of lumps of iron slag) was found. The products were sold in shops along the main street. On a height to the northwest of the residential quarter in the plain there was a religious center with temples and altars. This sacred area is aligned with the rest of the city and was probably planned at the same time. There were also cemeteries to the north and east of the town. Apart from the fact that they mostly held cremation burials, they contained objects which recall Chiusi. Stone *cippi* were erected over the graves and a bucchero head of a man similar to Chiusine products was found. A Gallic cemetery containing iron swords and other La Tène grave-goods found nearby revealed the fate of Marzabotto. The site was clearly overrun by Gauls from across the Alps in one of the frequent invasions that occurred during the 5th and 4th centuries BC, and which involved the sack of Rome in 390 BC. Marzabotto and nearby Felsina (Bologna) probably held out until c. 350 BC. By then the Po valley was gradually transformed into Gallia Cisalpina, as the Romans called it, and the Etruscan element was submerged.

The Etruscan Tombs of Cerveteri

Cerveteri (Etruscan *Chaire*, Latin *Caere*) is situated about 30 miles northwest of Rome and about four miles from the sea. The town itself stood on a plateau, but the necropoleis were situated on low hills to the northwest (the Banditaccia cemetery), to the southeast (the Monte Abatone cemetery) and on a plain to the southwest (the Sorbo cemetery). The Sorbo cemetery was the earliest and contained many Villanovan period *pozza* and *fossa* burials. It slowly fell into disuse in the 7th century, and while it does contain a few early chamber tombs (including the Regolini-Galassi Tomb) most burials were now made in the other two cemeteries.

The tombs at Cerveteri are of interest for two reasons: the interiors of many of them give us a good idea of how Caeretan domestic architecture evolved between the 7th and 5th centuries B.C., and their furnishings provide an index to the relative prosperity of the city's inhabitants at different periods. Thus, the finds made in the Regolini-Galassi Tomb attest the wealth of the Caeretan aristocracy in the Orientalizing period during the 7th century when luxury goods in gold, silver and ivory were imported from the eastern Mediterranean, or made by local and immigrant craftsmen.

The earlier chamber tombs of the 6th and 5th centuries were cut into circular tumuli which consisted of rock beneath and rubble above. Later on, rectangular tombs were built in a more regularly planned manner along "funerary avenues."

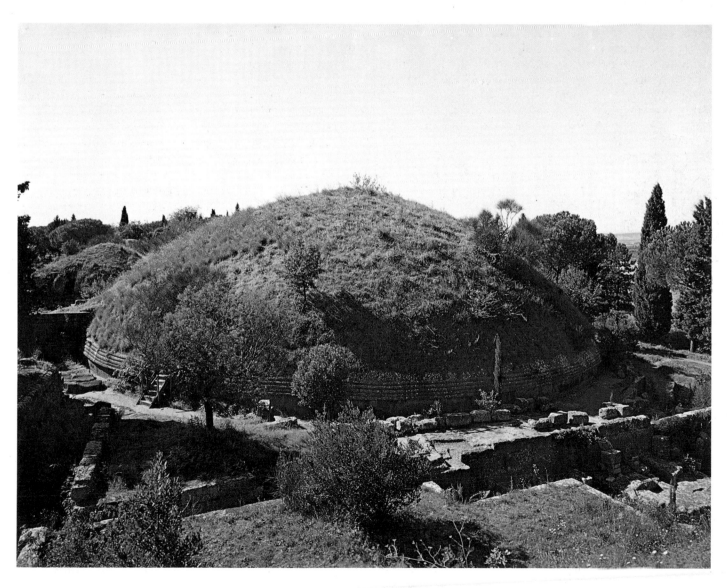

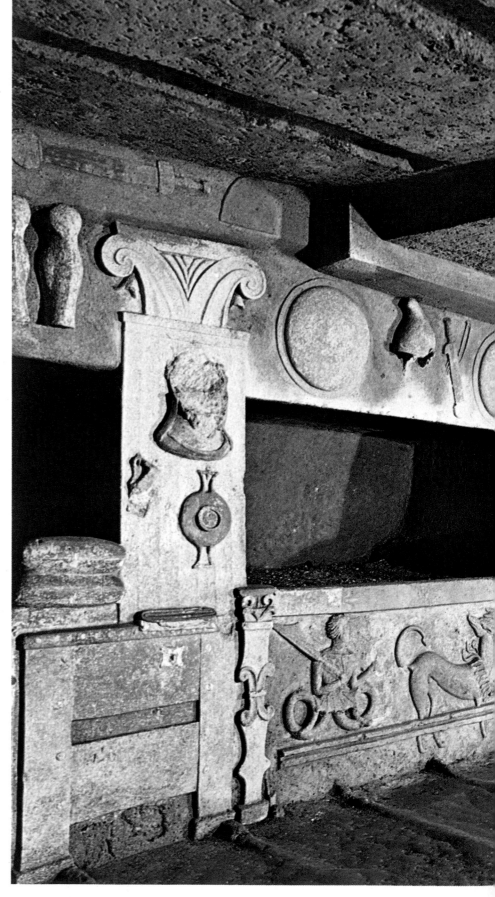

It used to be thought that the Banditaccia cemetery was so called on account of the number of bandits who might be thought to lurk in its "caverns and holes." G. T. Dennis writing in 1848 provided the real answer: "The name is simply indicative of the proprietorship of the land, which once belonging to the *comune*, or corporation of Cerveteri, was *terra bandita* – 'set apart'; and as it was uncultivated and broken ground, the termination descriptive of ugliness was added – *banditaccia*." The cemetery grew around the nucleus of a small Villanovan cemetery which lay across the River Manganello from the city. Some of the large tumuli are up to 40 meters in diameter and contain three or four chamber tombs each.

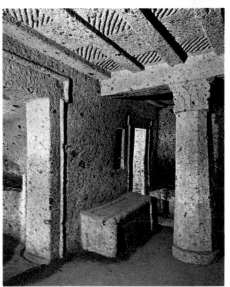

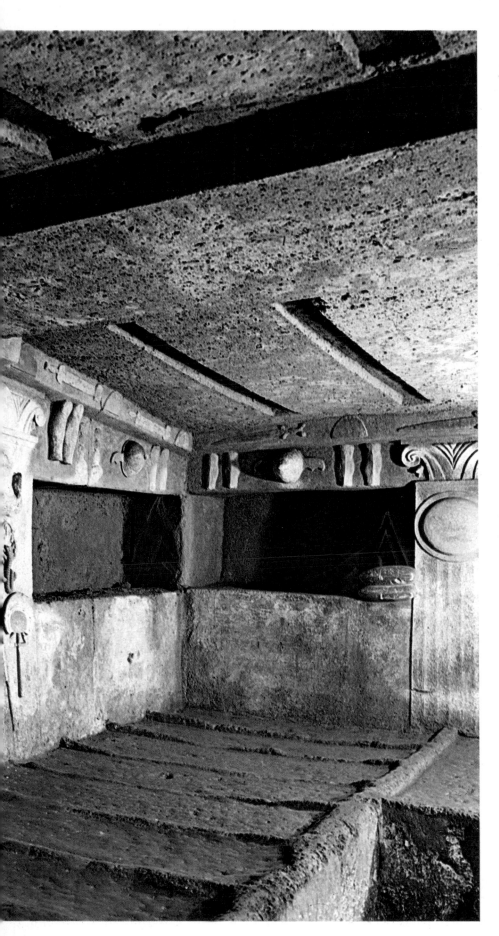

The Tomba dei Capitelli (or "Tomb of the Capitals") (*above*) dates from the beginning of the 6th century BC and is thus among the earliest chamber tombs in the Banditaccia cemetery. It lies beneath a small tumulus and is approached along a short corridor. The principal room has a coffered roof supported by two octagonal columns with capitals of an Oriental type. Both this room and three smaller ones behind have rock-cut funerary couches on which the bodies of the deceased would have been laid.

The Tomba dei Rilievi (or "Tomb of the Reliefs") (*left*) dates from the 4th century BC and consists of a single rectangular room at the end of a flight of steps. Burial niches line the walls and a broad bench in front contained no fewer than 32 separate burials. Painted inscriptions inside the tomb indicate that it belonged to a single family named Matuna. The walls are decorated with stucco reliefs of weapons – mainly swords – and armor – helmets, greaves and shields – as well as household objects such as vases and drinking cups. The principal niche had two places for the persons whose defaced effigies once adorned the pillars to either side. Realistic stucco pillars lie in the niche, and below there is in relief the front of a couch with ornamental legs. On a low footstool can be seen the front of a pair of slippers. The Underworld is evoked by means of reliefs of Typhon (whose legs are shown in the form of snakes) and Cerberus (the three-headed guard dog of Hades).

The Regolini-Galassi tomb lies in the Sorbo cemetery to the southwest of the city and is one of the earliest Caeretan chamber tombs. It is also one of the relatively few Etruscan tombs found with its contents intact (all of them now in the Vatican Museums). There were three burials in all: a cremation in a side chamber and an inhumation in each of the main chambers. The inner chamber (*above*) held the burial of a woman named Larthia. Her name is written in retrograde letters on some of the vessels in the tomb (*above right*). A huge (42 centimeters high) gold breastplate (*right*) was originally sewn upon the garment in which the lady was buried. A copper backing provided stiffening and shape. The surface is decorated with numerous stamped friezes of palmettes, ibexes, griffins, chimaeras and the like. But perhaps the most precious object from the inner chamber was a large gold fibula ("safety pin") (*opposite*). A hinge in the middle gave extra flexibility, which indicates that the fibula was intended to be worn in life and was not merely a grave offering. Rows of small ducks decorated with extremely fine granulation occupy the lower plate, with embossed and granulated winged animals between. Five lions occupy the center of the upper plate. The whole object is 31·5 centimeters long.

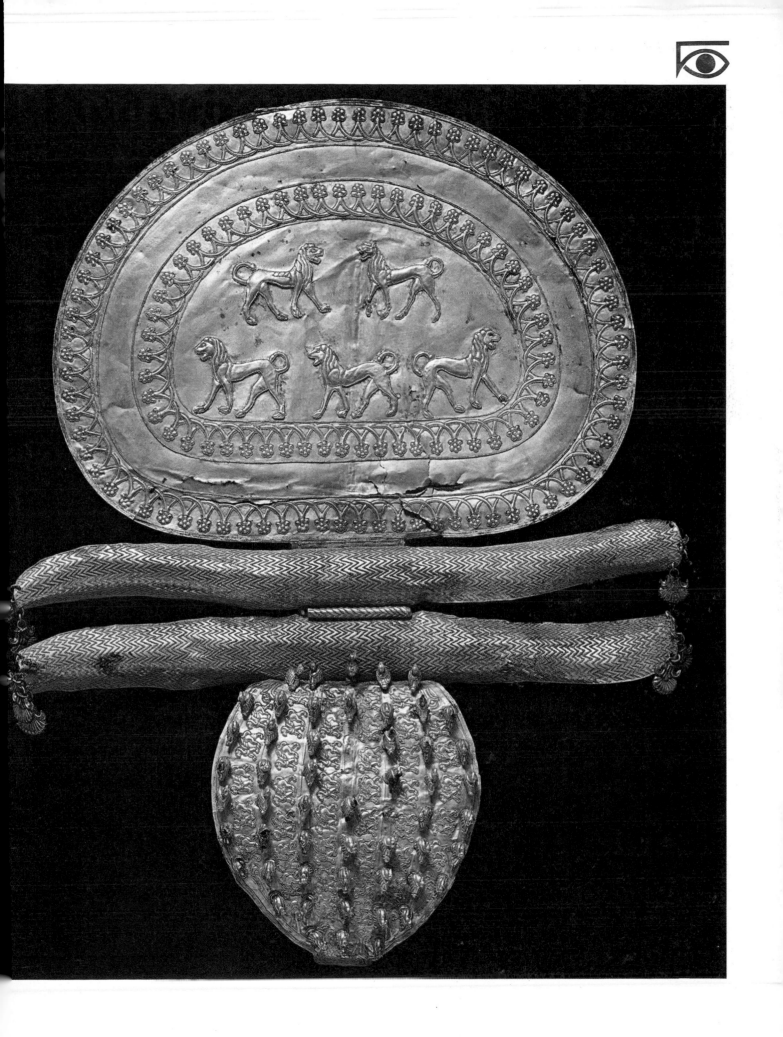

Seventeen biconical and twelve spherical gold beads (*left*) were found with Larthia, but their original arrangement is uncertain and it is more than likely that some are missing. All the heads are decorated with incised and hatched designs.

In a side chamber between the inner and outer parts of the Regolini–Galassi Tomb were the cremated remains of a warrior. He was buried together with this chariot (*below*) of which enough fragments have survived to enable an approximate reconstruction to be made. The original wooden core would have been covered all over with bronze plaques decorated with rosettes and Orientalizing palmettes.

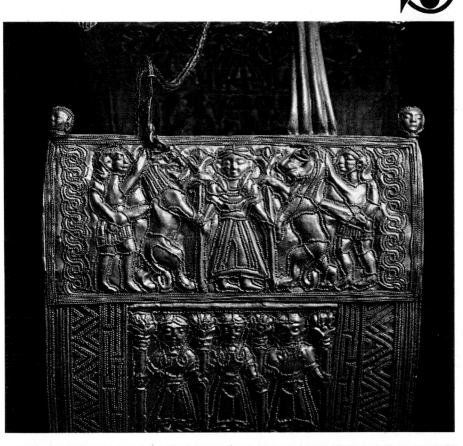

Larthia had a pair of gold bracelets (*right*) decorated with repoussé relief panels of three women standing between stylized palm trees. The panels are divided one from the other by means of Greek key patterns, and all details are defined by means of added granulation. Near the clasps are wider panels showing a woman standing between palm trees and a pair of lions, each of which is being speared from behind by a man. There is a very similar pair of bracelets in the British Museum which probably also came from the Regolini-Galassi Tomb.

The outer chamber contained the remains of a four-wheeled cart (*below*) which it has been possible to reconstruct after a fashion. Small nail holes in the surviving palmette ornament indicate that the cart was originally wooden. The bronze bed on which the body of the deceased once rested was not found with the cart, but this is probably how it was conveyed to the tomb.

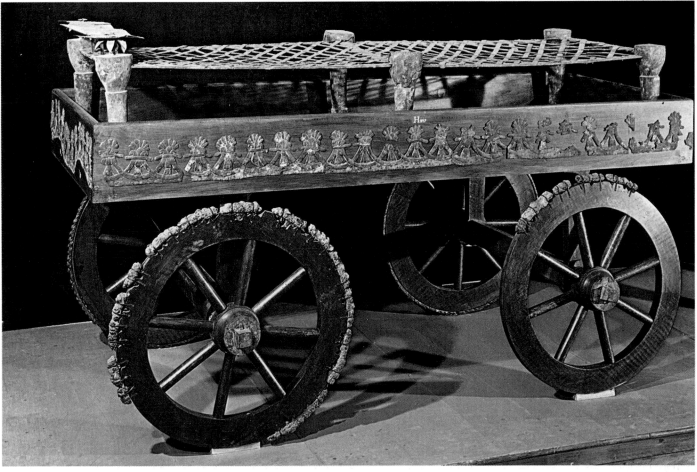

Only one of the three occupants of the Regolini-Galassi Tomb was cremated. His ashes were contained in this two-handled fluted urn (*right*) the lid of which is decorated with a horse in imitation of some Greek geometric pottery.

A bucchero chalice with *à jour* supports (*below right*) can be dated to around 600 BC and is thus rather later than the other contents of the Regolini-Galassi Tomb. It is consequently thought to belong to a later, intrusive, burial.

Around the foot of a bucchero flask (*below*) from the Regolini-Galassi Tomb is a 26-letter early Greek alphabet. On the body are inscribed Etruscan characters consisting of letters combined in 13 syllables. Both alphabet and syllabary are written from left to right. This flask is an important document for our knowledge of early Etruscan script.

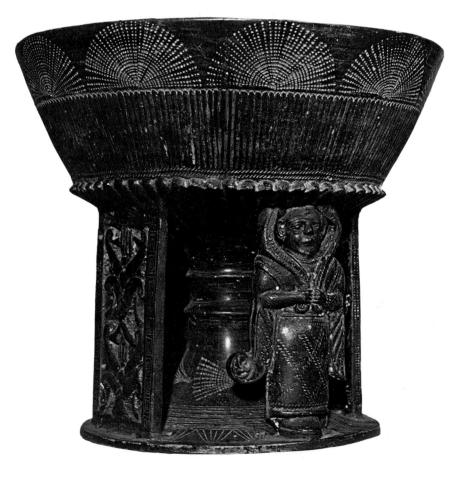

5. Rome and Italy

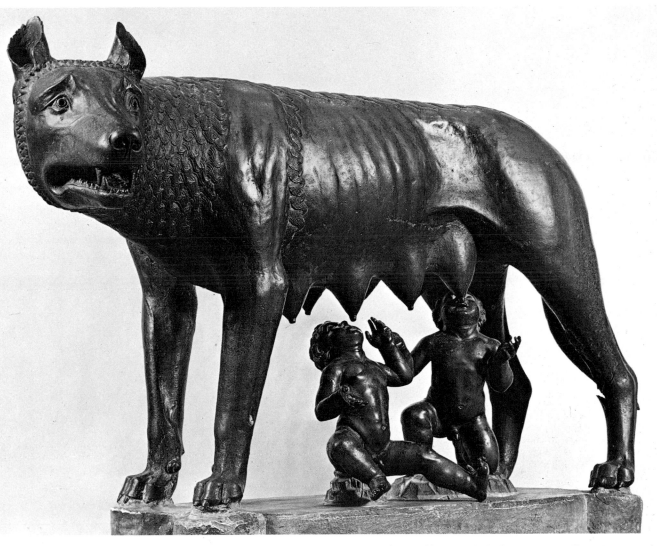

It is often said that Roman archaeology is text-aided archaeology – i.e. that the historical framework is already known from literary or epigraphical sources and the field archaeologist merely fills the gaps. But while it is true that the literary evidence for the history of Rome and its empire is substantial, there are some areas where archaeology could be claimed even to supply the framework of history. This would be the case, for example, with a subject like Roman Wales, concerning which we hear next to nothing in the Roman historians apart from a purple passage in Tacitus, but which archaeological research has elevated into a minor industry. But even when we have ample text-derived information, we can learn from archaeology a good deal about the way that people lived – about the towns and homes they occupied, the objects they used, even the food they ate – subjects on which the literary sources are often silent. Thus, for example, knowledge of the destruction of Pompeii was never lost,

The Capitoline wolf, the symbol of Rome *par excellence*. It was made by an Italian craftsman in the early 5th century BC, and the twins were added after 1471. Capitoline Museum, Rome.

but consider how much more information we have concerning life in a Campanian town in the 1st century AD as a result of the excavations that have been conducted there.

Early Rome – the traditional account. There is no agreement among historians of early Rome as to which category its study should belong to, for the legends surrounding it have been dismissed by some as later inventions, leaving archaeology as the sole source of reliable information. Most, however, try to rationalize the legends in the light of the archaeological evidence, but even this course is beset with pitfalls, for there is no consensus as to what the archaeological evidence actually means. The reason why the history of early Rome is so

obscure is that it was not until the late 3rd century BC that a history of Rome was written. This was a period when the Romans felt that they should be seen to have a past as glorious as that of some of their eastern Mediterranean contemporaries. The material available to the historian at that time consisted of a few recorded facts and many traditional stories concerning Rome's past. The facts might be in the form of lists of magistrates with but a brief indication of their achievements, the traditions in the form of folk memory preserved in religious customs and myths or in national legends.

At the end of the 3rd century BC the Romans had just lived through the wars against Hannibal which had had a devastating effect on Italian life and landscape. The wars against Pyrrhus earlier in the century were just about within living memory. Also familiar would have been the distorted outlines of the "Struggle of the Orders" that had occurred in the 5th and 4th centuries and had resulted in the improvement of the social and civil status of the underprivileged plebeians. The foundation of Roman law had been laid in the mid-5th century with the publication of the Twelve Tables. Two events of the early 4th century had left their mark in the tradition of Rome: the sack of Etruscan Veii by the Romans in 396, and the similar fate of Rome itself at the hands of marauding Gauls in 390. There were also tales told of the expulsion of the last of the kings of Rome and the removal of official Etruscan influence in the person of Tarquinius Superbus more than a century earlier. This was the time when the Roman Republic was created with its chief magistrates, two annually elected consuls, advised by the Senate. Previously, there had been nearly two and a half centuries of monarchy – including a century of Etruscan control. King Numa had established the official cults of the Roman state religion and Servius Tullius had, according to tradition, fortified the city and given it a popular assembly. The first king and legendary founder of Rome had been Romulus who, with his twin brother Remus with whom he eventually quarreled, had been suckled by a she-wolf when they had been exposed in infancy by Amulius, their mother's wicked uncle. Another tradition was rather clumsily cobbled onto this: centuries earlier Aeneas, fleeing from Troy with his father Anchises on his shoulders, and his son Ascanius, had founded the dynasty of Latium from which Rhea Silvia, the twins' mother, was descended.

The evidence of archaeology. While archaeology cannot throw much light on the details of the traditional account, it can certainly supply evidence for the physical environment within which the events preserved in the tradition (albeit in garbled form) took place. It can, for example, disprove the continuity of settlement in Latium from the late Bronze Age that is suggested by the legend of Aeneas and the dynasty he founded. The Latins from whom the Romans were to emerge were immigrants who only arrived in their eponymous homeland from southern

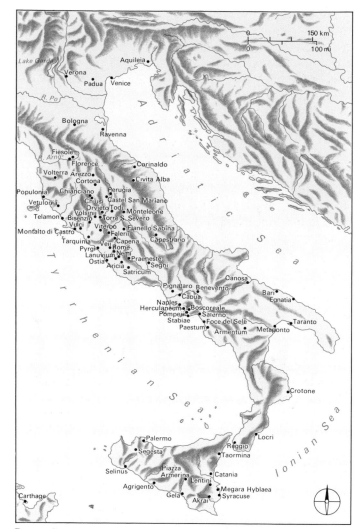

Roman Italy.

Plan of Classical Rome.

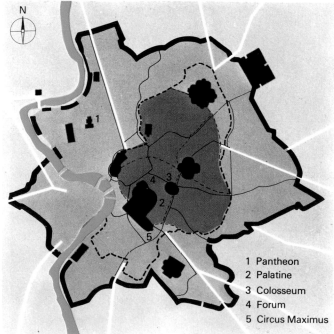

1 Pantheon
2 Palatine
3 Colosseum
4 Forum
5 Circus Maximus

Italy in around 800 BC. This does not mean to say, however, that the legend of Aeneas was a *very* late invention: it was certainly well known in Etruria during the 6th century BC. It was depicted on Greek vases of that period found at Vulci, and on an Etruscan gem, and the theme recurs in some 5th-century BC terracottas from Veii. There are in fact three such terracotta statuettes known, all made from the same mold. On the best-preserved piece the warrior is shown armed with a round shield, greaves and a helmet surmounted by a long plume. On his left shoulder he carries the aged Anchises who clings tightly to his son's neck. It would be interesting to know how the Etruscans learned of the story, but since there is an awkward gap of half a millennium between the artifacts and the presumed date of the event they depict (c. 1250 BC) it would be foolhardy to regard them as evidence for a historical tradition that had lasted that long.

Apart from some traces of Neolithic settlement on the Aventine the earliest dwellings at Rome are to be found on the Palatine, which was the most easily defensible of the larger hills, though other hills were soon occupied as well. All the hills of Rome, apart from the Janiculum, lie on the Tiber's eastern bank. From a plateau to the north there projects a series of spurs: the Quirinal, Viminal and the Esquiline, the last having three more projections called Cispius, Fagutal and Oppius. To the south lies the Caelius, and between it and the river the Aventine. Within the semicircle formed by these hills lie two more: the Capitoline and Palatine. The last mentioned is well defended with steep cliffs on three sides, and was also the nearest hill to a ford across the Tiber which existed just below the Tiber island. Just as this group of hills dominated this part of the Latin plain and the Tiber valley, the Palatine commanded the important river crossing.

It is possible to detect, by means of the pottery (which was often imported from Greece), the main phases in the Iron Age occupation of the hills of pre-urban Rome. The first phase began around 800 BC when habitation was restricted to only some of the hills: the Palatine, Fagutal, Oppius, Cispius, Viminal and Quirinal. The dwellings on the Palatine are marginally earlier than those on the other hills. The valleys between the hills were uninhabited and both they and the hillsides were frequently used as burial places. During this phase the settlements on the hills formed separate small villages divided by the ravines and wildernesses between them. The watercourses and marshes in some of the valleys had the effect of increasing the divisions between the settlements. We know that the villages must have been cut off from one another at this period for their handicrafts display features peculiar to each other. Thus some forms of pottery are common on the Palatine but are missing on the Esquiline or occur only sporadically there, while other forms are frequent on the Esquiline but are absent or rare on the Palatine. The bronze fibulae from these hills differ too: on the Palatine they can occur with a semicircular twisted bow, or in a serpentine form with a spiral disk as a catch-plate, whereas serpentine fibulae with flat bows and plain disk-shaped catch-plates are found on the Esquiline. All these indications suggest that the inhabitants of these two hills had related but different origins.

The burial customs on the two hills also differed. Two standard forms of tomb were found on the Palatine: the *pozzo* ("well") tombs which were invariably associated with cremation burials, and the *fossa* ("ditch") tombs usually with inhumation burials. The latter type varied between only 33 and 40 per cent of the total with cremation dominating. The picture on the Esquiline was rather different. Only two cremations have so far been discovered; all the rest of the burials are inhumations. Even the Palatine graves differ among themselves. During the earlier 8th century BC there were two varieties of *pozzo* tomb: in both cases a cylindrical shaft was sunk into the ground but in one variety the urn was placed in a niche opening out horizontally from the bottom of the shaft; in the other it was contained in a smaller secondary shaft (*pozzetto*) dug in the center of the floor of the main shaft. This variety was to be the only one found during the second half of the 8th century. The *pozzetto* might be covered over by means of stones arranged in the form of a small corbeled roof, or else by means of a single stone slab. We know that the *pozzo* was filled in immediately after cremation, for fragments of the carbonized remains of the pyre have sometimes been found in the *dolium*, the large pot containing the ossuary and grave-goods that was placed in the *pozzetto*. It is interesting to note that the ossuaries were often hut-urns of the kind we have already seen in use in Etruria. Since the use of hut-urns appears

The Palatine hill, one of the first parts of Rome to be settled.

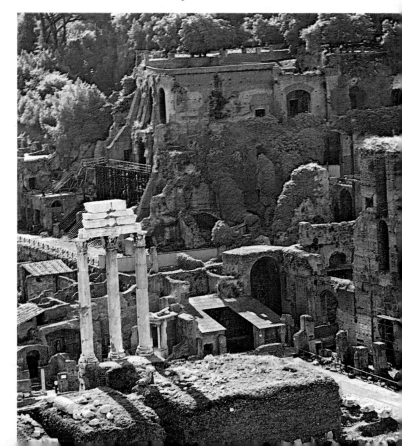

earlier in Latium than in Etruria, it is reasonable to assume that they were introduced into Villanovan Etruria from the south, and it has even been suggested that this occurred as a result of the immigration of Latins into Etruria.

The first villages. According to Roman tradition, Romulus laid out the earliest settlement on the Palatine which in later centuries was known as Roma Quadrata. It is sometimes mistakenly supposed that Etruscan methods of town-planning were employed, but it is now fairly certain that the Etruscans derived their knowledge of regularly planned cities much later than the 8th century BC and that the inspiration for them came from Greece. And so, whatever Roma Quadrata may have meant, it does not imply grid-planning on the Palatine. The fact, though, that the remains on the Palatine are slightly earlier than those on the other hills does give credence to the tradition that the Palatine was the first part of Rome to be occupied.

The hilltop villages clearly became too crowded for comfort, for the next phase, from c. 700 BC onwards, involved the gradual settlement of the valley slopes and huts were built over the earlier tombs. Eventually the areas between the hills came to be occupied, including those which subsequently became the Forum Romanum and the Forum Boarium. Excavations conducted in the former by E. Gjerstad bear out the tradition that it had once been a marsh: alluvial layers of clay and sand mixed with remains of plants and humus were immediately overlain by traces of huts dated to c. 625 BC. It was clear that the area was drained before it was occupied, perhaps following a disastrous inundation that is known to have destroyed huts elsewhere at this time. The brook that ran through the Forum was probably tidied up and cleared of silt so that

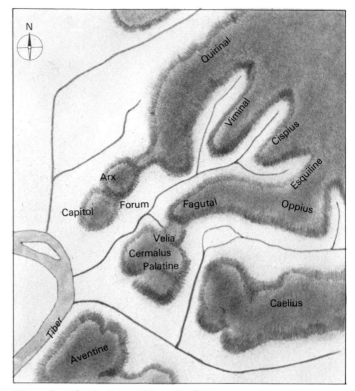

Above: plan of early Rome. After Gjerstad.

Opposite: stratigraphical section of the Forum Romanum descending through Imperial, Republican and earlier levels to virgin soil. Immediately above it were traces of huts dated to the later 7th century BC. After Gjerstad.

Below: nearly two-thirds of the 8th-century burials on the Palatine were cremation burials in well-like *pozzo* tombs. Sometimes the urn was placed in a niche at the bottom of the shaft (*left*), at others in a smaller shaft (*pozzetto*) beneath (*center*). Other burials were inhumations in oblong *fossa* ("ditch") tombs (*right*). After Gjerstad.

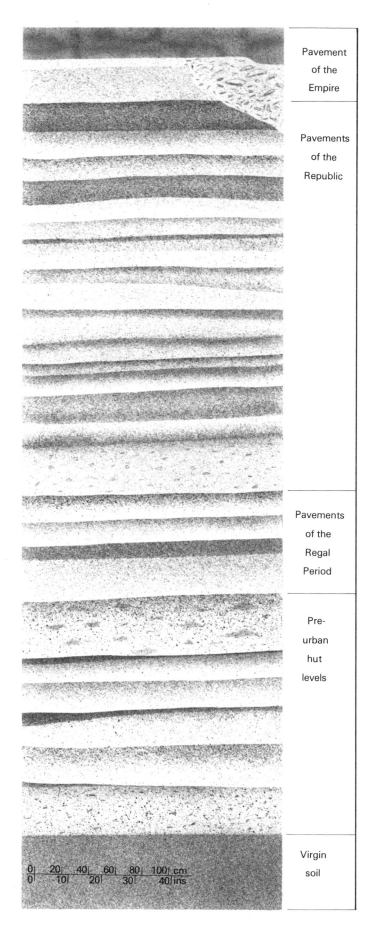

Pavement of the Empire	
Pavements of the Republic	
Pavements of the Regal Period	
Pre-urban hut levels	
Virgin soil	

excess water would run off quickly into the Tiber. Later a great drain, the Cloaca Maxima, would be built to perform this function. Even the lower ground in the Forum Boarium near the Tiber could now be occupied, and huts have been found dating to the first quarter of the 6th century BC. Thus there is a clear picture of the villages running together in a kind of synoccism.

We do not know from archaeology what kind of political organization existed at Rome at this time. We do, however, have a fair idea of what the average dwelling was like. The plans of huts can be reconstructed from holes cut in the rock, and the superstructure with information derived from hut-urns. Traces of huts have been found on the Palatine with their bottoms cut deeply into the rock. Around their edges are holes which once held the posts which supported the wattle-and-daub walls and a roof of thatch. There was probably a central ridge pole inside with several heavy logs laid outside at right angles to hold the thatch in place. Vent-holes at each end would have allowed smoke to escape. The floors were of rammed earth, and there were often small porches supported on poles at the door. The precise dimensions of only one of the Palatine huts are known: 4.90 × 3.60 meters.

Archaeology has also provided us with a little information concerning the diet of the inhabitants of the huts: grape pips are not found before the last quarter of the 7th century BC, which implies that the cultivation of vines was not introduced into Latium until then. Olives seem to have been introduced at the same time, and both may have arrived in Latium as a result of Etruscan influence. The

Traces of the earliest dwellings on the Palatine have been found cut deeply into the rock. Their original appearance can be reconstructed with the aid of hut-urns found in early Iron Age tombs.

Etruscans seem to have been the agents through whom Greek culture was transmitted to pre-urban Rome. Greek pottery and Italian imitations, which are found at Rome in ever increasing quantities in the second half of the 7th century, probably arrived there via southern Etruria. Etruscan bucchero pottery and metalwork from Veii and Cerveteri are also found and indicate the increasing level of material culture of the hut dwellers.

Etruscan influence. The most important contribution that the Etruscans made to Roman culture at this time was the introduction of the alphabet. It has sometimes been argued that the Romans received the alphabet directly from the Greek colony of Cumae, but the consensus now is that the Etruscans acted as intermediaries. This important contribution meant that Rome had the means of efficiently administering an urban community. The earliest Latin inscription is not, however, from Rome, but comes from elsewhere in Latium. It occurs on the famous Praeneste fibula of c. 600 BC and reads *Manios med fhefhaked Numasioi = Manius me fecit Numerio =* "Manius made me for Numerius." The earliest Latin inscription from Rome itself occurs on the "Duenos" vase, so called for the transliteration of one of its more conspicuous words. The vase in fact consists of three conjoined cosmetic jars which are a local imitation of a Corinthian pot of about 525 BC. Around the vase winds a long inscription which reads in English as follows: "He who puts me on the market swears by the gods, 'Your girl will not be friendly with you, will not stand by you, unless you make friends with her by using my help.' Goodman [Duenos] has made me for a good purpose and for the benefit of a good man; may no evil man give me away!" The inscription is in fact the manufacturer's advertisement!

According to the historical tradition Rome came under direct Etruscan rule in 616 BC, when Tarquinius Priscus became king. Whether this event actually took place or not, there is more than a grain of truth in the tradition, for Rome was certainly within the Etruscan sphere of cultural influence at this time. It was to remain under Etruscan rule for much of the 6th century until the last Etruscan king Tarquinius Superbus was finally expelled, traditionally in 510 BC. Evidence exists for direct Etruscan cultural influence as late as the second quarter of the 5th century BC, but it need not be assumed that this necessarily implies political hegemony. The period of Etruscan rule and influence saw Rome change from a cluster of hut settlements into a real city. The huts were replaced with rectangular houses built of stuccoed mud-brick resting on stone foundations. The huts in the Forum were leveled and a pebble pavement laid over their remains. Monumental temples and shrines were built of wood decorated with terracotta revetment reminiscent of the sculptural style found in the part of Etruria near Rome.

These buildings were of modest dimensions at first, but culminated in the temple of Jupiter Optimus Maximus on

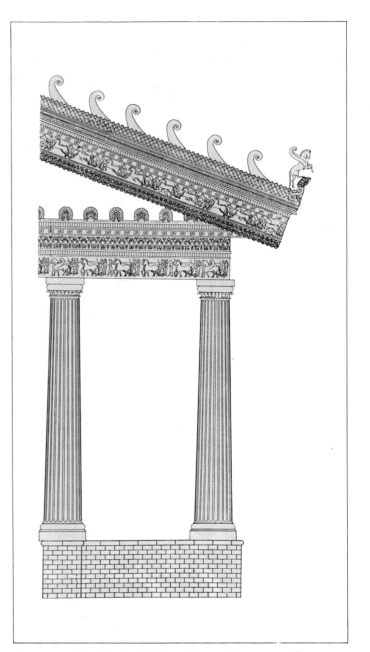

The facade of the Temple of Jupiter Optimus Maximus on the Capitol, decorated with polychrome terracotta plaques made by coroplasts from Veii. Reconstruction after Gjerstad.

The Duenos vase, late 6th century BC, bearing the earliest Latin inscription from Rome. Staatliche Museen, Berlin.

the Capitoline hill. A raised podium supported the whole temple. There were three cult chambers (*cellae*) as was the regular Etruscan fashion: the central one dedicated to Jupiter, and those to right and left to Juno and Minerva. An interesting fact concerning this temple is that it seems to have been built in units of the basic module of 8 feet (2·8 meters). Thus the columns were 8 feet in diameter; the width of the facade between the center of the columns at the corner was 168 feet (8 × 21), and the length of the long sides 192 feet (8 × 24) from the centers of the corner columns to the back wall; the central *cella* was 40 feet wide (8 × 5) and the side *cellae* and porticoes 32 (8 × 4); the length of all the *cellae* was 96 feet (8 × 12); the height of the columns was 56 feet (8 × 7); and the height of the temple from the podium to the apex of the gable 104 feet (8 × 13).

Apart from the massive podium, there is comparatively little of the original temple extant now, but a partially excavated temple in the Forum Boarium, smaller in size but with the same proportional relationship between one part and another, the temple of Fortuna and Mater Matuta which was erected shortly after the Capitoline temple, has provided a large quantity of fictile (terracotta) material that is extremely helpful in reconstructing (on paper) the earlier building. It seems that the architect of the Fortuna and Mater Matuta temple used the Capitoline temple as his model, and a nice parallel has been drawn with the practice of baroque architects in 17th-century Rome who modeled their churches on St Peter's. As we saw in the last chapter, we know from literary sources that terracotta specialists from Veii worked on the revetment of the temple. The much better-preserved terracotta decoration found at the Fortuna-Mater Matuta temple is also in the Veientine style and enables us to reconstruct the Capitoline temple with a frieze of chariots in procession on the entablature and chariots racing up the raking cornice – all in polychrome low relief. It has been suggested that there may be references here on the one hand to triumphal processions, and on the other to the chariot races that were held in the nearby Circus Maximus.

All in all, the archaeological testimony supports the broad outlines of the traditional history of early Rome, though it should be realized that some eminent scholars reject this interpretation of the evidence. A serious stumbling block for them seems to be the fact that there is evidence of strong Etruscan influence for several decades after the supposed expulsion of the last of the Etruscan kings. It has even been proposed that the real period of Etruscan rule was not from c. 616 to 510 BC, but rather 530 to 450. This view, however, creates more problems than it solves. Rome hardly ceased to be in the same cultural area after the expulsion of the kings, and since that area's culture was largely Etruscan, this would explain the continuity of Etruscan influence.

The frugal centuries. Even though the history of Rome becomes progressively better known through the literary sources, there are still facets of Roman life of which details only emerge from the material remains. It has been said that the Romans' strenuous struggles against the Etruscans, Volsci, Aequi, Gauls and Samnites during the 5th to 3rd centuries BC left them no leisure to cultivate the arts. Strabo said of the Romans at this period that they "cared nothing for beauty, for they were too taken up with greater, more necessary things." The archaeological picture tends to reinforce the impression of frugality that we derive from the literary sources. A few concessions were made in the public domain, with the erection of statues to honor great men of the past or distinguished contemporaries, but private individuals courted censure for such a seemingly harmless act as decorating house doors with bronze panels. All the more surprising, then, that there should have been discovered on the Esquiline an exquisitely beautiful terracotta head made in the style of the late 4th or early 3rd century BC.

The Fortnum head, as it is known after the former owner who gave it to the Ashmolean Museum, Oxford, is life-size. It represents a youth pensively resting his chin on his left hand. He gazes into the distance with large deep-set eyes. His mouth is half-open, and his hair rises from his brow in a series of flame-like curls. Typologically the head fits best into the work of Aegean, and especially Athenian, artists of the late 4th century BC. The structure of the face

The expressive Fortnum head, found on the Esquiline, probably made in the late 4th century BC by an immigrant Greek artist. Ashmolean Museum, Oxford.

recalls a head of Alexander in the Acropolis Museum at Athens, and the pathetic expression can be matched on the Demeter of Cnidus in the British Museum. Parallels such as this have given rise to the suggestion that the coroplast who made the head was a Greek artist, perhaps Athenian, working in Italy. We happen to know of a terracotta workshop on the Esquiline from a passing reference in Varro, and it could be that it imported workmen from Magna Graecia (as the part of southern Italy occupied by Greeks was known) or, judging by the Fortnum head, even from Greece itself. There are some tombs of the Republican period on the Esquiline, and it could well be that the Fortnum head belonged to a funerary statue or, more likely, a high relief of the kind that was made at Athens towards the end of the 4th century BC until they were banned as being too luxurious even there. Such a relief would have been set into a *naïskos* surrounded by pilasters and a pediment. The figure would have been represented either as clothed and seated or as standing heroically nude and leaning on a pillar. At all events, the Fortnum head is an unexpected thing in 4th-century Rome, but serves a little to alter the picture of unmitigated frugality that we derive of the period from literary sources.

Burial practices. The usual form of disposal of the dead at Rome was cremation. An exception to this practice is, however, provided by members of the gens Cornelia who were regularly buried in sarcophagi. Thus the family vault of the Scipios, a branch of the Cornelii, which was partly discovered in 1614 and partly in 1780 lying between the Via Appia and the Via Latina about one Roman mile from the city, contains only sarcophagi and no cinerary urns. We know from literary sources that the first member of the gens Cornelia to give up the traditional form of burial was the dictator L. Cornelius Sulla (d. 78 BC) who, having caused the remains of his rival Marius to be exhumed and dishonored, ordered his own body to be cremated for fear of retaliation at the hands of Marian sympathizers. This was a symptom of the troubled state of Roman politics during the last century of the Republic, which culminated in the progressive seizure of power by Augustus in the years after Julius Caesar's death in 44 BC.

The tomb of the Scipios, however, bears witness to the status and prestige of a patrician family during the 3rd century BC when their position in society was virtually unchallenged. The tomb was cut from the tufa rock and now consists of a series of galleries regularly disposed in a more or less regular square (c. 14.5 × 13.5 meters), with four massive rock piers left in the center to support the roof. The tomb appears to have been cut during the first decades of the 3rd century BC, but it is not certain whether it was the work of the first member of the family to be buried there – L. Cornelius Scipio Barbatus (consul in 298 BC) – or that of his sons, L. Cornelius Scipio (consul 259 BC) and L. Cornelius Scipio Asina (consul in 264 and 260 BC). It

would seem, from the prominent position of the sarcophagus of Scipio Barbatus on the axis of the tomb opposite the entrance, that the construction of the tomb in this form was an attempt to heroize a prominent member of the family.

Several sarcophagi were found in the tomb, but that of Scipio Barbatus (now in the Vatican Museum) is the only one to have a rich architectural decoration. It was cut from a rectangular block of pepperino and was decorated on the front and short sides with a Doric frieze of alternating triglyphs and metopes, the latter adorned with rosettes, uncanonically set beneath an Ionic frieze of dentils. Only half the lid is extant, but there is enough of it left to reconstruct a pair of volutes at each end adorned with vegetal ornaments. The end of the name of the occupant remains on the edge of the lid: [. . .] O. CN. F. SCIPIO, which can be reconstructed as L. Cornelius Scipio, son of Gnaeus. On the front beneath the frieze is another inscription written in Saturnian verse, a meter that has been described as "so rough as to be sometimes hardly distinguishable from prose." It can be translated as follows: "Cornelius Lucius Scipio Barbatus, son of his father Gnaeus, a man both clever and brave, whose handsome appearance was equal to his valor, who was consul, censor and aedile amongst you, captured Taurasia Cisaunia in Samnium, conquered Lucania and took hostages." There are certain historical discrepancies between this text and what we actually know to have occurred in the early 3rd century BC (Lucania, for example, did not come under Roman sway until much later), and it is now thought by many that the verse was added out of piety, perhaps around 200, by a descendant who had only a hazy notion of history. But whatever the date of the inscription, there can be little doubt that the monument itself dates to the 3rd century BC. Its form is akin to that of other Italian sarcophagi, but finds some parallels in the Hellenistic world, in which Rome was rapidly becoming a major force. It is interesting, moreover, to note that the second verse of the inscription ("whose handsome appearance was equal to his valor") was the first time that physical beauty was equated with moral qualities. This shows that by c. 200 BC Hellenic artistic notions were gaining ground, and it can be no accident that not long afterwards the practice of realistic portraiture, already common in the Hellenistic world, became widespread at Rome.

A fragment of painted plaster found in a tomb on the Esquiline in 1875 reveals another facet of 3rd-century BC Rome – the custom of preserving a visual image of actual historical events. This was to become one of the hallmarks of later Roman art, and it is interesting to see evidence for it at such an early date. The fragment is 87.5 centimeters high and 45 centimeters wide and, judging by the proportions of the tomb from which it came, was merely part of a frieze 20 meters long. There is, nevertheless, sufficient information preserved in its four registers for us

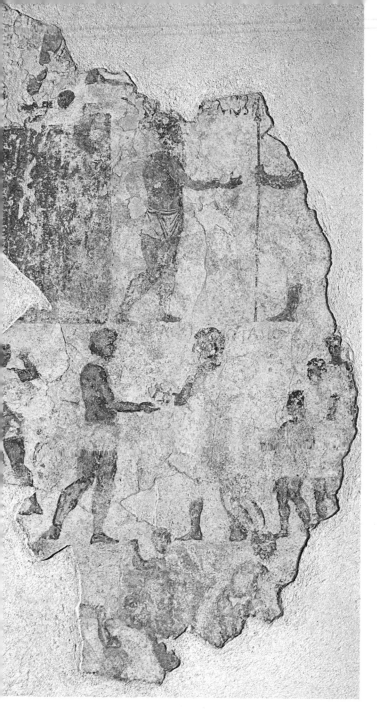

to be able to say which historical events are represented and from which family's tomb it comes. The top register has little of interest, but the second shows in the center a helmeted figure wearing a short kilt (or *subligaculum*) and gilded greaves. He extends his hand in a gesture of friendship towards a partly preserved togate figure who stands holding a spear. The scene is watched by two citizens of the battlemented town in the background. There is part of an inscription just visible between the main figures, but it is not very informative – in contrast with the panel below where a similar scene is being enacted between a fighting warrior holding a gilded shield and with his back to the proceedings on the left, and ranks of spectators on the right. One of the inscriptions here can be read *Q. Fabio*. In the register below is a battle scene, which includes on the right a warrior wearing a helmet with a pair of projecting "bunnies'" ears, which find parallels in other 4th- and 3rd-century BC paintings. The use of gilt (and silvered) armor is known to have been customary among the Samnites, a people of central Italy with whom (as we saw from the sarcophagus of Scipio Barbatus) Rome was at war during the 4th and earlier 3rd centuries. It is likely that the scenes on the Esquiline painting represent battles and parleys that occurred during the hostilities. The name of Quintus Fabius is even more helpful, for we know from other sources of a Q. Fabius Rullianus who was five times consul and who probably died some time after 280 BC. It is more than likely that the fresco came from his tomb. It has also been suggested that the artist concerned was another Fabius – Fabius Pictor, whom we know to have been active as a painter in the last years of the 4th century BC, and to have decorated a temple commemorating a victory over the Samnites. It is possible that he may have decorated the family vault as well.

The Carthaginian menace. With the collapse of the Samnites, Rome suddenly became the most powerful force in Italy. At the same time the North African city of Carthage was expanding her influence in Sicily. Abortive attempts were made by Pyrrhus, king of Epirus in northwestern Greece, to unite the Greeks of the west against the two new powers. Rome's success was largely due to her practice of bestowing on her allies political rewards, notably the privileges – and duties – of her own citizenship. This ensured widespread support during the long and destructive wars against the Carthaginians which occupied most of the rest of the century down to 202 BC. These were years which saw the presence on Italian soil of a marauding Carthaginian army under Hannibal.

Some coins found in recent excavations at Morgantina in Sicily, conducted by Princeton University, both give us an insight into the conditions prevailing in the town before and during a Roman attack in 211 BC (Morgantina had rebelled from an alliance with Rome in 214), and also throw light on an important change that had recently occurred in the Roman monetary system. The

A 3rd-century BC fresco from a tomb on the Esquiline showing actual historical events, probably incidents in the Samnite wars of the 4th and 3rd centuries. Palazzo dei Conservatori, Rome.

Obverse and reverse of the earliest type of *denarius*, the silver coin introduced c. 211 BC. Ashmolean Museum, Oxford.

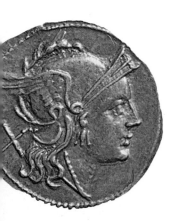

owner of the coins, which included among others a silver *denarius* of the earliest known type, together with three *quinarii* (silver half-pieces) and one *sestertius* (silver quarter-piece), had hidden them away in a jug in a temple in the hope that he might recover them when the danger had passed. The temple caught fire, however, during the assault on the city and its roof fell in, sealing the hoard beneath the debris. The presence of a very early *denarius* together with its fraction in such a closely dated deposit is of great interest for we can now date the introduction of the coin to 211 BC or perhaps the year before. Hitherto, it had on occasion been placed as early as 269 BC or as late as 187 or even 169. With a firm date now for the earliest type, it has been possible to rearrange the later *denarii* into a more meaningful chronological framework. The earliest *denarius* bore on the obverse a head of Roma, the personification of the city, or maybe Roma conflated with the goddess Bellona. The reverse bears a reference to the legendary help that the Romans received from the Dioscuri in their victory over the Etruscans at Lake Regillus in 496 BC. Their help was presumably felt to be equally necessary in 211. The reform of the coinage was in fact a reflection of the dire financial straits in which Rome had found herself in the years immediately preceding 212. In the early years of the Hannibalic war metal for coinage had been plentiful enough and in 216 BC Hiero king of Syracuse made a loan, but then sources dried up. The loan could not be repaid and there was soon no money available with which to supply the Roman army serving in Spain. A novel means of financing the war was adopted: the use of credit. Contractors were engaged on condition that payment would be made later. It even came to pass that sailors were paid by wealthy individuals, not by the state. But between 212 and 206 booty was coming in almost every year, including, it would seem, a fair amount of silver. The new coinage could be considered a device on the part of the state to make it as widely available as possible. The outcome of the Punic wars was that Rome and not Carthage should rule the western world and that in Rome itself the Senate should hold the reins of power.

The fall of the Republic. A series of foreign wars had meant that Rome's usual source of fighting men – the citizen yeomanry – had been weakened. The rural peasantry was gradually (and methodically) bought out by aristocratic landowners who worked the land by means of slave gangs. With the introduction of payment for military service a new problem arose: generals were forced to find the means of paying their troops and to settle them in colonies on retirement from service. There was a good deal of political unrest which was only temporarily halted by the intervention of a powerful military leader, by one such as Marius, Sulla, Pompey or Caesar. L. Cornelius Sulla's victory over Marius in 80 BC marks an important stage in both Roman history and art, for with his rule there began a new, imperial, Roman style

of architecture. Several public buildings on a monumental scale were erected in Rome and its environs for Sulla or members of his circle.

Around 80 BC Sulla settled his partisans at Praeneste, now a charming town (the birthplace of Palestrina), situated some 30 miles east of Rome on the southern side of a steep limestone ridge. Here was built the temple complex dedicated to Fortuna Primigenia which now underlies the whole of the old town. An American air raid during World War II has revealed a large part of the upper temple area. Terraces ran along the bottom of the upper sanctuary and the visitor would make his way upwards towards the central staircase by means of a pair of covered ramps. Only on emerging would he see the splendid view

The temple complex dedicated to Fortuna Primigenia at Praeneste built in the early 1st century BC. Reconstruction after Fasolo and Gullini.

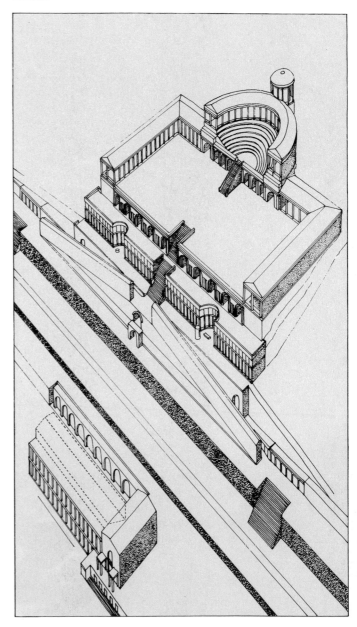

over the plain below. The facade of the next terrace was arranged in two stories with a pair of semicircular recesses disposed symmetrically on either side of the staircase. Above that was a large colonnaded court, dominated by its centerpiece, an elaborate hemicycle supported on a vaulted substructure. The facades on each end were decorated with applied Classical orders. Above yet another colonnade there stood the culminating feature of the sanctuary, the elegant circular temple dedicated to Fortuna. Nearly all the walls and all the numerous vaults at Praeneste were of concrete faced in brick which was to be the commonest building material at Rome during the following centuries.

Below this complex was a lower court where, in the apse of the eastern hall, was found in the early 17th century a very fine mosaic representing the Nile in flood. This is very probably the mosaic referred to by the encyclopedist Pliny when he said that Sulla introduced floor mosaics to Italy and "had one made of small *tesserae* at Praeneste." It has suffered numerous vicissitudes over the centuries and has been restored and relaid on several occasions, but even though perhaps only half of the mosaic is preserved as it originally appeared, enough survives to give us an idea of the taste for exoticism that existed in late Republican Rome. The scene is enlivened by the presence of various animals, many of which are labeled in Greek. There are wild boar, lion, lynx, rhinoceros (referred to in an inscription as *choiropithekos* – "monkey-pig") as well as hippo and crocodiles. Farmhouses with towers appear as well as a farmworkers' hut. We see soldiers gathering for a banquet beneath an awning and a picnic party beneath a rustic arbor. A pleasure barge with a cabin carries along a group of hippo-hunters and behind it can be seen a Greco-Egyptian temple with a rounded pediment. In front are two tall obelisks of the kind that soon were to be imported from Egypt to Rome to adorn public squares and circuses. Priests and devotees dressed in white stand outside the shrine. To the left is a well, the details of which are shown in a curious kind of perspective. We can see the masonry of both the inside and outside of the shaft, as well as the water at the bottom. Ibises fly around and a domestic cow is being driven to the water's edge to drink. The presence of such a scene in 1st-century BC Italy might be thought of as being akin to the similar interest in the Near East which we find among some Italian Renaissance humanists.

Roman society in the 1st century BC was in a state of disunity. A vain attempt to preserve civilized and moderate values was made by Cicero and his sympathizers in the middle decade of the 1st century BC but they were not strong enough to withstand the forces of militarism, personified in Julius Caesar. He combined the traditional Roman "virtues" (he was a soldier from an old family) with a concrete achievement, the conquest of Gaul between 58 and 52 BC. This was but one of the new territorial acquisitions that Rome was to make before 14 AD, which included Spain, Illyricum and Greece, the Rhineland, most of Asia Minor and large parts of North Africa. Since only an army under a strong central government could control these lands, then a military empire became a necessity. The threat to freedom in Italy was postponed by the assassination of Caesar in 44 BC, but was realized by the establishment of a regular empire in 31 BC by his adoptive son, Augustus.

Greek taste in imperial art. Roman art at the time of Augustus was eclectic. The main sources in sculpture were Greek, and the presence of many immigrant Greek sculptors at Rome gave impetus to this artistic movement. The Romans not only continued to develop the trends of the latest Greek art, that is the Hellenistic art of the last three centuries BC, but they also went back to Classical or even Archaic Greek art. It was Augustus who made the final conquests of Greek, or rather Hellenized, lands when he took Egypt in 30 BC; but the process whereby Rome and Italy had become subject to Greek artistic influence had begun centuries earlier, as we have seen. There had been resistance to this influence on the part of Romans of traditional views, but with Augustus Greek art became the vehicle for official propaganda and hence became "respectable." The conqueror Augustus was captivated by things Greek, as the poet Horace tells us in an epistle written to the emperor in 15–14 BC: "conquered Greece took her rude captor captive and brought the arts to rustic Latium."

In the past it had been a relatively easy matter for those with Hellenized tastes to buy or steal earlier works of art, but the supply of originals was running low and so Greek artists from Athens and southern Italy were commissioned to give their Roman masters copies and adaptations of Greek masterpieces of different periods. We are told of Augustus that he liked Archaic Greek sculpture, and accordingly we have a large group of neo-Attic reliefs, sometimes archaizing in the manner of the 6th century BC, sometimes classicizing in the style of the 5th and 4th centuries BC, or sometimes even combining one or both of these styles with a contemporary late Hellenistic style. There is a very good example of the last-mentioned variety in the Cleveland Museum of Art, carved in Pentelic marble from Attica and said to have been found in the theater of Capua, near Naples. It represents Apollo Citharoedus of Delphi, playing his cithara and singing. He receives an offering of wine which a winged Nike or goddess of Victory pours from an oinochoe into a patera which Apollo holds in his extended right hand. Between the two stands the omphalos, the navel or center of the world, which was believed to be in the sanctuary at Delphi. The artist has tried to imitate Archaic Greek sculpture by carving the edges of Apollo's mantle and the overfold of the Nike's dress in regular zigzag folds. But the softness of the faces, the slender proportions of the bodies and the realistic rendering of the Nike's wings betray the late Hellenistic or early Roman period of the 1st century BC.

Other aspects of Greek sculpture were enthusiastically taken up at Rome. One was the practice of making portraits of individuals. The skill of artists trained in the Hellenistic tradition supplied the needs of Roman patrician families who for centuries had made a cult of their dead ancestors, preserving wax images of them in their homes. The Roman love of preserving visual records of actual historical events was also catered for by Greek sculptors. A monument which incorporates all these trends is the Ara Pacis which was set up by Augustus in the Campus Martius at Rome in order to commemorate the peace he had imposed on the Mediterranean world. It was consecrated in 9 BC, having been four years in the building. It consisted of an altar within an enclosure wall representing in ideal terms the procession which occurred on the day that the altar was founded, 4 July 13 BC. The reliefs are carved in a Classical style recalling Attic reliefs of the 5th century BC (though some of the subsidiary decoration on the backs of the walls is archaizing). There are recognizable portraits of members of the imperial family on the south part of the precinct wall. In front can be seen the flamens with their distinctive headdress, and the bearer of the ceremonial axe. Then comes Agrippa with his head veiled, followed by his son Lucius Caesar, aged 4 in 13 BC. The next figure is probably Julia, Agrippa's wife and Augustus' daughter. Apart from the individual characteris-

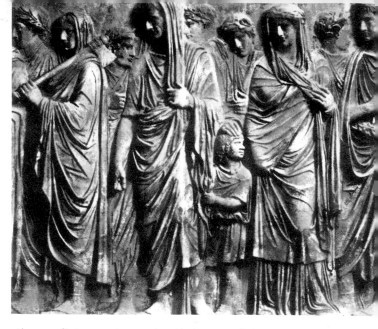

Above: realistic portraiture and an idealization of a historical event occur on the reliefs on the south side of the Ara Pacis at Rome.

Opposite: the courtyard within the "House of the Paintings" at Ostia closely resembles that of any small town Italian apartment block today. Reconstruction after Gismondi.

Below left: Imperial art: portrait in sardonyx of Augustus' sister Octavia as Artemis. British Museum.

Below: Republican art: head of an old man, 1st century BC. Ny Carlsberg Glyptotek, Copenhagen.

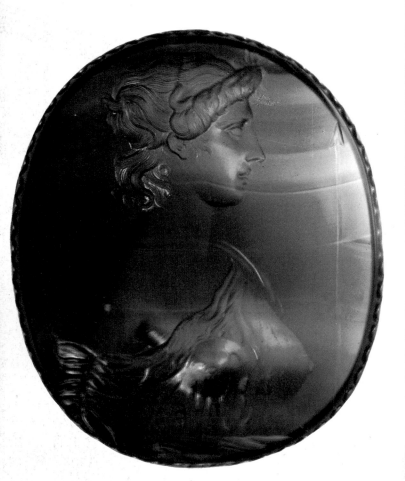

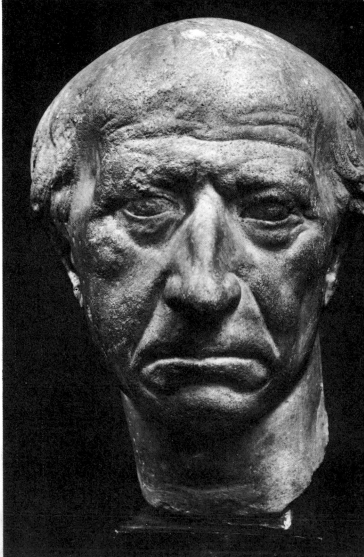

tics portrayed, the relief is very close in formal terms to the Parthenon frieze of the 5th century BC. A departure from tradition, however, was the use of Luna marble (from the quarries at Carrara) for the monument. This was a new source of marble, which was presumably more economic to exploit than the traditional sources in Greece. The development of the Luna quarries can hardly be unconnected with Augustus' claim that he had found Rome a city of brick and left it a city of marble.

Country life at Pompeii. Official art, however, tells us little more than what those who commissioned it wish us to know. For a real insight into Roman life, we should look at a town which has been preserved for us, rather as a laboratory specimen, beneath layers of ash and pumice which archaeologists are still in the process of removing. We saw in Chapter 3 how Pompeii was extinguished by an eruption of nearby Vesuvius in 79 AD. By that time it had become completely Roman, having been for centuries a Samnite town until it was conquered by the Romans and refounded as Colonia Veneria Cornelia Pompeianorum in 80 BC.

Techniques of excavation are now being developed to detect and record information that was often passed over and ignored in the past. Thanks to painstaking work by a team from the University of Maryland, a vineyard has been discovered during the past few years in a corner of Pompeii which had hitherto been thought to have been a cattle market. It occupied an *insula* measuring about 85×75 meters situated just to the north of the amphitheater. In land that was under cultivation at the time of the eruption it is sometimes possible to find evidence of ancient roots, for trees and plants decayed and volcanic dust gradually filled the cavities that remained. One of the first cavities to be discovered in 1966 was also one of the largest. In the words of the excavator, Wilhelmina Jashemski: "We . . . found a tree cavity which when emptied proved to be the largest one yet found; its longest dimension at ground level was 38 cm long and the root was deep. We filled the cavity with cement and it took seven large bucketfuls. After the cement had stood for three days, the soil was pulled away from the cast, and the shape of a root that was growing when Vesuvius erupted was revealed." The smaller cavities were much more frequent and were split into four plots divided by intersecting paths. At each location there were two small cavities but it was not certain whether the second cavity was that of a stake or of another root.

"The local growers," wrote Professor Jashemski in 1973, "who were much interested in the discovery of an ancient vineyard, unanimously insisted that the vines had been staked in antiquity, just as they stake them today.

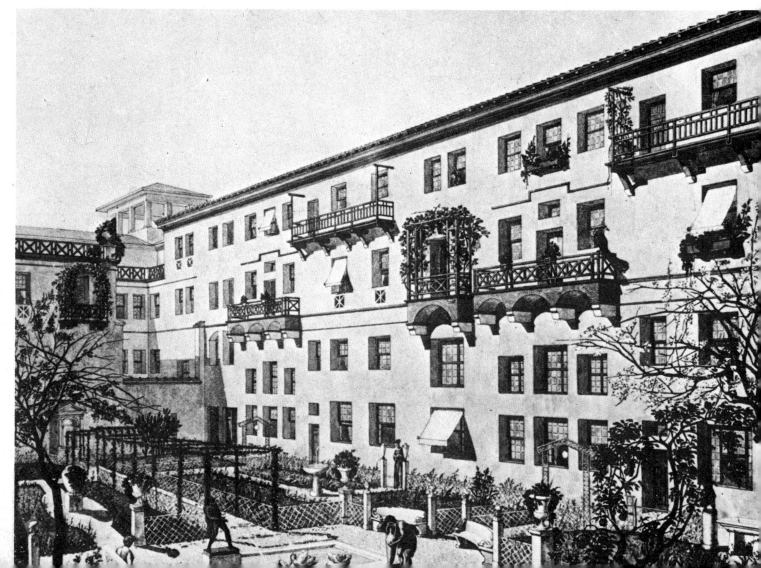

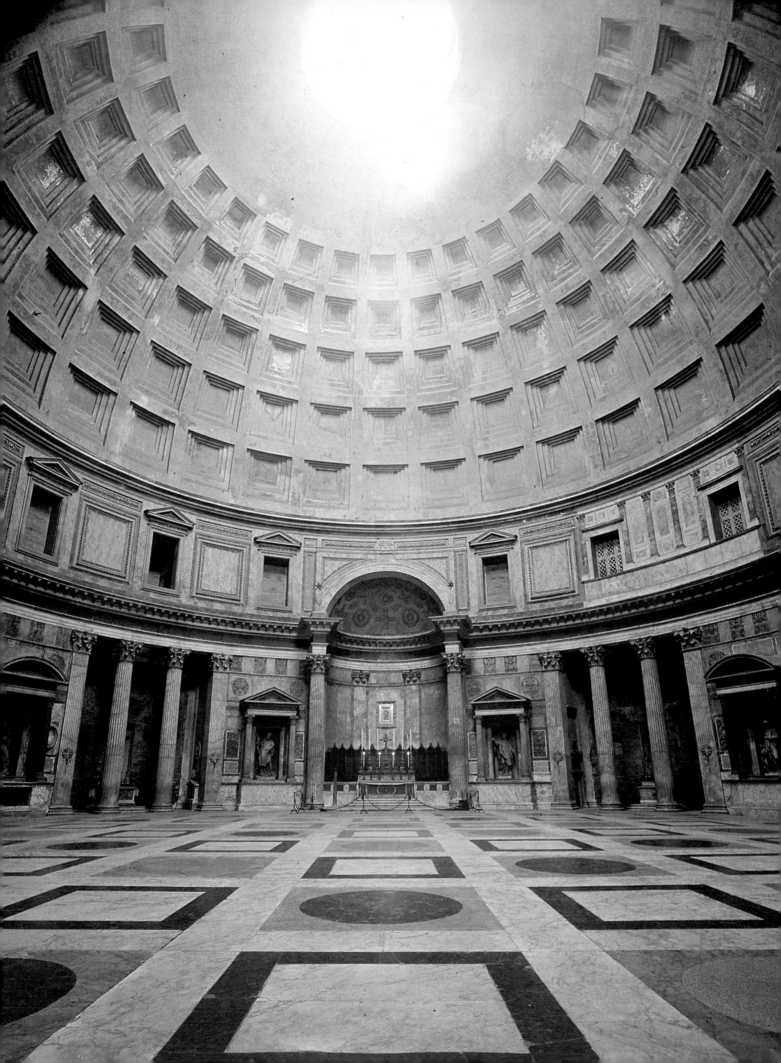

They were sure that the Pompeians had always done it that way. The fruit experts at the University of Naples, on the other hand, believed that the second cavity found in many locations was that of another root, and that the vines had been pruned low, and left unstaked, as is done in Sicily today. With great excitement we began to empty the cavities. We found them perfectly preserved, and it was obvious that, with few exceptions, one was always that of a vine root, easily identified by its shape and small lateral roots. The second cavity was always that of a stake. After the cavities had been cleaned, measured and studied, they were filled with cement and casts made. After three days when the surrounding soil was pulled away, at almost every location the cast of a stake and a root was revealed. The local vine growers were not surprised."

Opposite: the interior of the Pantheon at Rome. The polychrome marble floor harmonizes with the coffering of the ceiling.

Below: one of the earliest reconstructions of the Pantheon as it originally appeared in the 2nd century AD made by Nicholas van Aelst in the 16th century. Private collection.

City life at Ostia and Rome. Pompeii never grew beyond being a country town. For an impression of how Rome itself appeared with its 45,000 or so tall tenement blocks which the poet Martial (who lived in one on the third floor) criticized so bitterly for their dirt and noise, their heat and cold, we must turn to Ostia, the port of Rome. Here, during the late 1st and early 2nd centuries AD, a rapid increase in population had led to the town being transformed from a city of single-family dwellings into a city of almost 20th-century-looking apartment blocks. The site of Ostia was a malarial swamp from the end of antiquity until comparatively recent times, but one of the by-products of land reclamation in the 1920s and 1930s was the uncovering of the ancient city by the Italian archaeological authorities. Their methods of excavation were hardly of the best, which makes for difficulties in closely dating some of the monuments they found, and such details as the plant remains of the courtyards were overlooked.

We can, however, on the analogy of Pompeii and

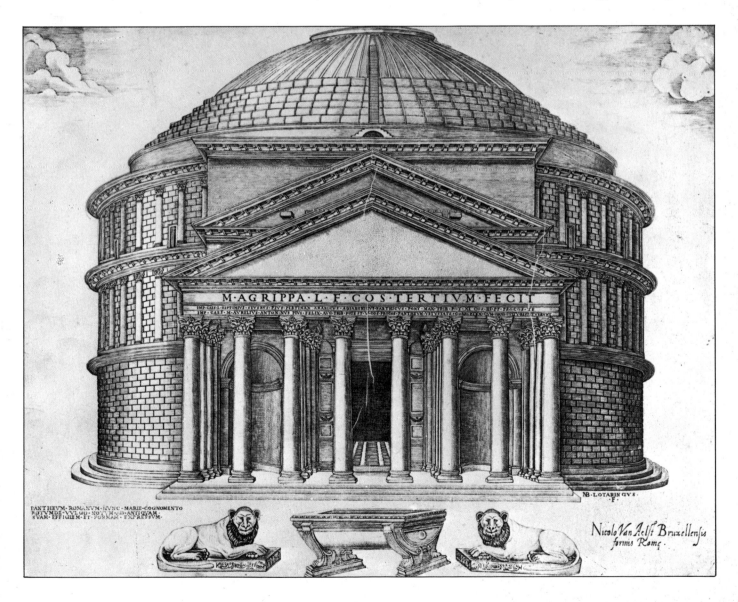

Herculaneum, assume that Ostian courts were landscaped. A typical apartment would have been quite a spacious affair. The "House of the Paintings" had suites consisting of 12 rooms arranged on two floors. The living and dining rooms occupied the height of two stories, some 18 or 20 feet, while the smaller rooms were linked by means of an internal staircase, though each apartment was normally approached by its own individual staircase. The floors would have been decorated with mosaics, and the walls with frescoes. Most dwellings in Rome too would have been of this kind, though only a few have been preserved. There were laws which attempted to restrict the height of some of the blocks which must often have reached unwieldy proportions. Nero tried to limit them to 70, and Trajan to 60 feet in height.

Towering above its neighboring buildings in the earlier 2nd century AD was the Pantheon, one of the grandest of all Roman monuments and one which will serve to illustrate the abilities of Roman architects in the Imperial period. It was built as a temple of all the gods by Hadrian on the site of an earlier temple built by Augustus' minister, Agrippa, in the late 1st century BC. Despite the grandeur of its traditional facade (which, owing to the difference in ground levels, would have appeared even loftier in antiquity than it does today) the real interest of the Pantheon lies in its interior. In Greek temples and earlier Roman ones it had been usual to stress the adornment of the exterior of a building, but with the Pantheon "architectural thinking had been turned inside out," and it is the interior which is given the major emphasis.

The proportions of the interior are extremely simple and satisfying, for it consists of a drum half as high as it is wide (43·20 meters), surmounted by a dome whose height is the same as that of the drum. The dome was the biggest to be constructed until modern times: even those of St Peter's and St Sophia are smaller. The exterior was left plain, but the interior was splendidly decorated. The lower part of the drum was relieved by means of a series of niches and recesses fronted with tall (12 meters high) columns of Egyptian granite. The upper portion of the drum had 16 smaller recesses which originally contained marble sculpture. Although the arrangement of the upper story was altered in the 17th century, the Pantheon provides us with one of the few preserved examples of what was in fact a standard feature of Roman public buildings of the Empire: the use of variegated marbles for the wall revetment.

The crowning glory of the Pantheon, however, was the deeply coffered concrete dome broken at the top by an *oculus* open to the sky. The 140 coffers of the roof, which were probably originally gilded, diminish in size towards the top and make an interesting play of light and shade on the surface of the dome. They have the no less important function of actually lessening its weight. The Pantheon was but one of the magnificent buildings erected in Italy during the early Empire. There were yet others built in the provinces, some of which will be discussed in the next chapter.

The Aurelian walls of Rome, 3rd century AD.

Spectator Sports in the Roman World

By far the most popular sporting activities in Rome were chariot racing and gladiatorial and animal combats. So popular were they that special buildings were erected to accommodate the crowds, often numbering tens of thousands, that flocked to the spectacles. Rich magistrates and, subsequently, emperors used the circus and amphitheater as a political device: they were not merely a means to keep the populace happy ("bread and circuses"), but also provided occasions on which a ruler could accurately gauge the feelings and opinions of the populace.

Where funds allowed, stone-built circuses and amphitheaters were constructed. Wooden structures were notoriously dangerous: Tacitus records how 50,000 people were mutilated or crushed to death when a wooden amphitheater collapsed at Fidenae in 27 AD. Circuses and amphitheaters are among the biggest and most spectacular monuments that have been preserved from Roman times.

Popular interest in chariot racing was fostered by the existence of factions – teams with their supporters' clubs – that existed at Rome and elsewhere: the Blues, Greens, Reds and Whites. Victorious charioteers are often shown bearing palms and laurel crowns as symbols of victory, but their real prizes would have been financial and social. With prizes for a big race as high as 50,000 or 60,000 sesterces, a successful charioteer could amass a huge fortune. The social rewards would include the adulation of fans and the production of souvenirs and mosaics bearing his name. Racehorses too could become famous,

and the names of hundreds have come down to us in inscriptions or on the curse tablets with which keen fans hoped to spoil the chances of horses of rival factions.

The games of the amphitheater attracted much the same audience as the circus. At Lepcis Magna indeed the two buildings were side by side so that spectators could move from one to the other within a matter of minutes. Each of the three classes of gladiators had their supporters: there was the heavily armed "Samnite" gladiator who carried an oblong shield, a visored helmet and a short sword, the lighter-armed "Thracian" with a small circular shield, and the *retiarius* or net-fighter who simply carried a net and a dagger in one hand and a trident in the other. The fact that the combatants were fighting for their lives must have given the proceedings an excitement that we today find difficult to appreciate.

Animal shows took several forms: exotic animals might be exhibited, as in our zoological gardens; trained animals might perform tricks, as in our circuses; or most frequently wild beasts might be set against men, both armed and unarmed, or else featured in large-scale hunts (*venationes*) where they might be slaughtered. The bigger the better so far as the Roman public was concerned: in 26 *venationes* sponsored by Augustus 3,500 animals died. Trajan exceeded all the other emperors by slaughtering 11,000 beasts at the celebrations for his Dacian victory.

Below: a 4th-century AD mosaic in the Villa Borghese, Rome, showing the *retiarii* clearly getting the better of their "Samnite" opponents.

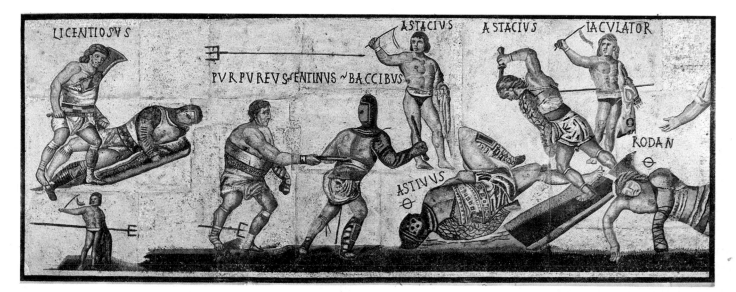

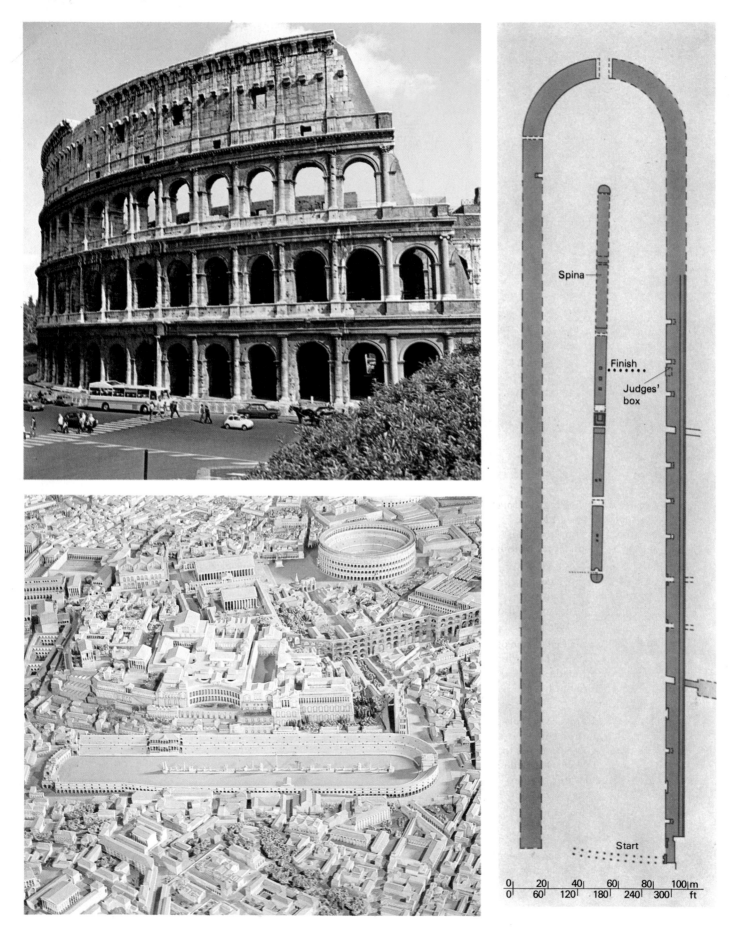

Spina

Finish

Judges'
box

Start

| 0 | 20 | 40 | 60 | 80 | 100 m |
| 0 | 60 | 120 | 180 | 240 | 300 ft |

The starting gates at Lepcis Magna (*above*) are rather less than 3 meters wide: the standard dimension. The implication is that Roman chariot horses harnessed four-abreast would have been very small.

The gates themselves were made of wood; some can be seen on a mosaic (*right*) from Dougga, Tunisia, which also shows the victorious charioteer Eros.

The circus at Lepcis Magna (*left*) is one of the best-preserved examples. The chariots left the starting gates and made seven circuits of the *spina* before finishing opposite the judges' box.

The Colosseum at Rome (*opposite, above left*) was opened in 80 AD and could accommodate up to 50,000 spectators for gladiatorial and animal shows. It owed its (later) name to a colossal statue of Nero which stood nearby.

The largest circus in the Roman world (*opposite, below left*) was the Circus Maximus which lay to the south of the Palatine at Rome. Very little now remains and this model was reconstructed largely with the aid of literary sources. Museo Civiltà Romana.

ANNIAE
ARESCVSA

A lead curse tablet (*left*) found in 1974 beneath the starting gates at Lepcis Magna bears the footprint of a diminutive horse Unrolled, it read (in Greek): "May Strabay, Alōthi, Taxa, Ōnnythēr, Achouēr, Dazar, Achaō, Iaōy, Aōyōi, Aeoiai, Yoiiaōo, Iayōo curse [the horses] Venticula ['Little Breeze'], Gametes ['Husband'], Victor and Populator ['Ravager'], as well as Eventius their charioteer."

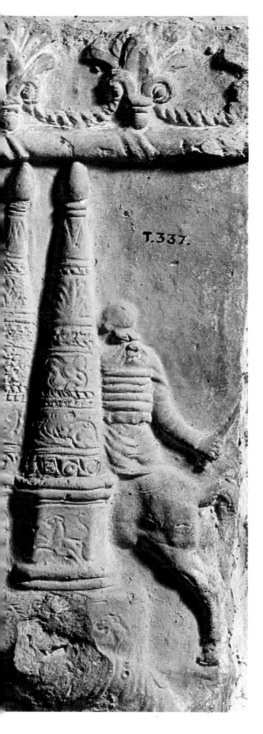

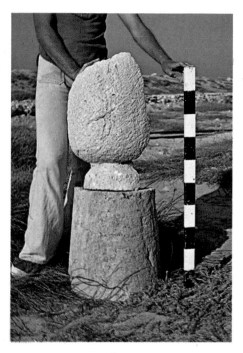

Three cones regularly stood on each of the *metae* and served to give the charioteers an approximate idea of how far they had to go before a turn. The only extant fragments of *meta* cones are at Lepcis Magna (*above*) where it was possible to reconstruct a cone 4·75 meters high (*right*).

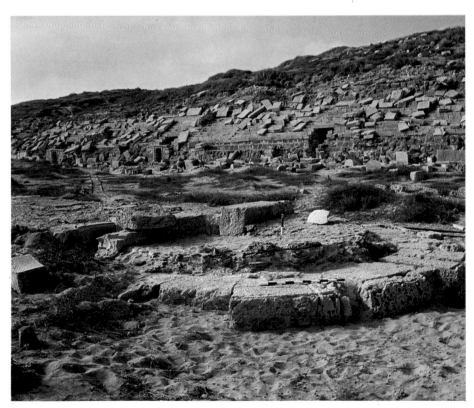

A plaque (*above*) in the British Museum shows a team about to turn at the *meta* at the end of the *spina*. This was the most exciting part of a race, for *naufragia* ("shipwrecks") often occurred here.

Right: the foundations of one of the *metae* at Lepcis Magna.

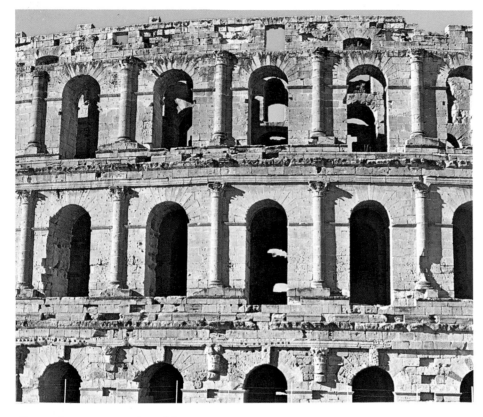

Above: the ornate exterior of the amphitheater at El Djem in Tunisia. The Colosseum at Rome (*below*) and the amphitheater at Mérida in Spain (*right*) have been excavated to reveal the subterranean accommodation for animals and prisoners beneath the arena.

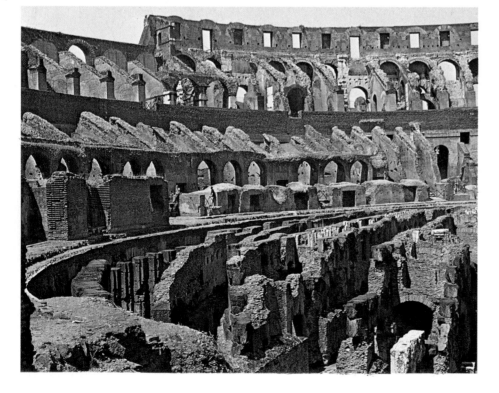

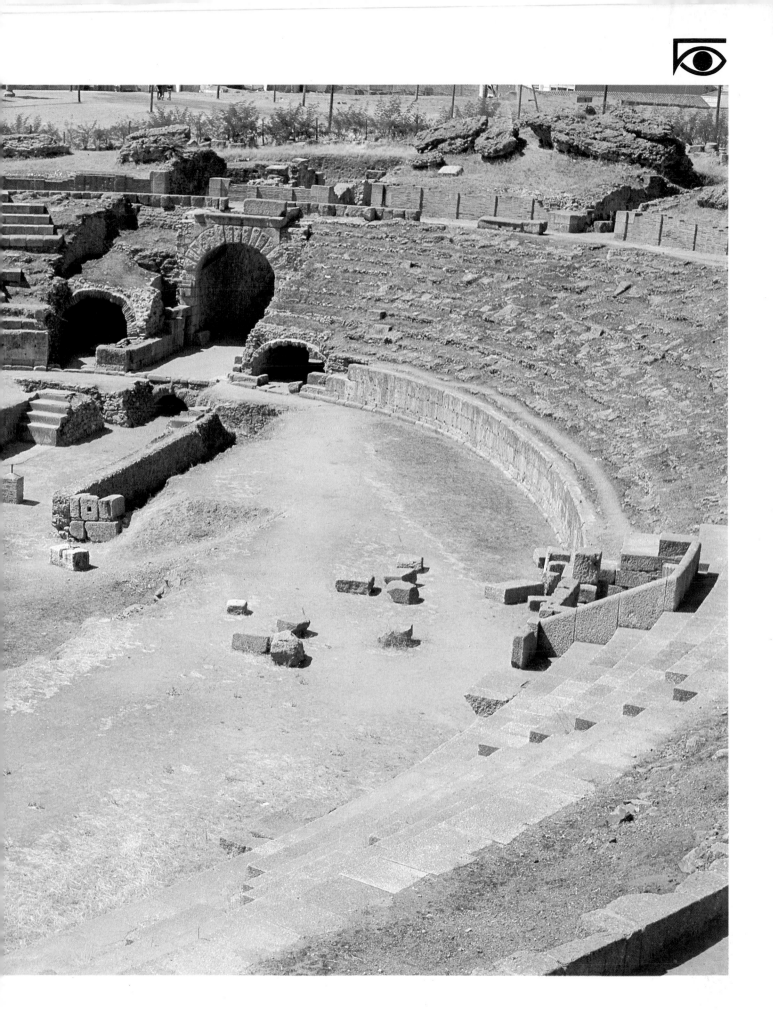

Above: the tombstone of the gladiator Martiales now in Oxford shows him as a *retiarius*, with a trident in his right hand, a dagger in his left, and an arm shield on his left shoulder, and wearing a leather cap and drawers. This stone has a curious history: found in 1774 in the ruins of a house in Islington, London, it was later lost, and then rediscovered in 1879 buried in the Tottenham Court Road. It was almost certainly part of the Arundel collection and probably came from Smyrna in the 17th century.

Above left: a late 3rd-century AD mosaic at Hippo Regius in Algeria shows wild animals – lions, leopards, ostriches and antelopes – being trapped by hunters before being shipped off to amuse a Roman audience. Many North African cities owed their prosperity to the animal trade. Not surprisingly many animals became extinct after four or five centuries of exploitation.

Left: the existence of amphitheaters in so many towns in Spain helped to preserve bullfighting there during the Middle Ages. The Roman *venatio* must have been a sordid affair compared with the elegance of a good *corrida*.

6. The Romans outside Italy

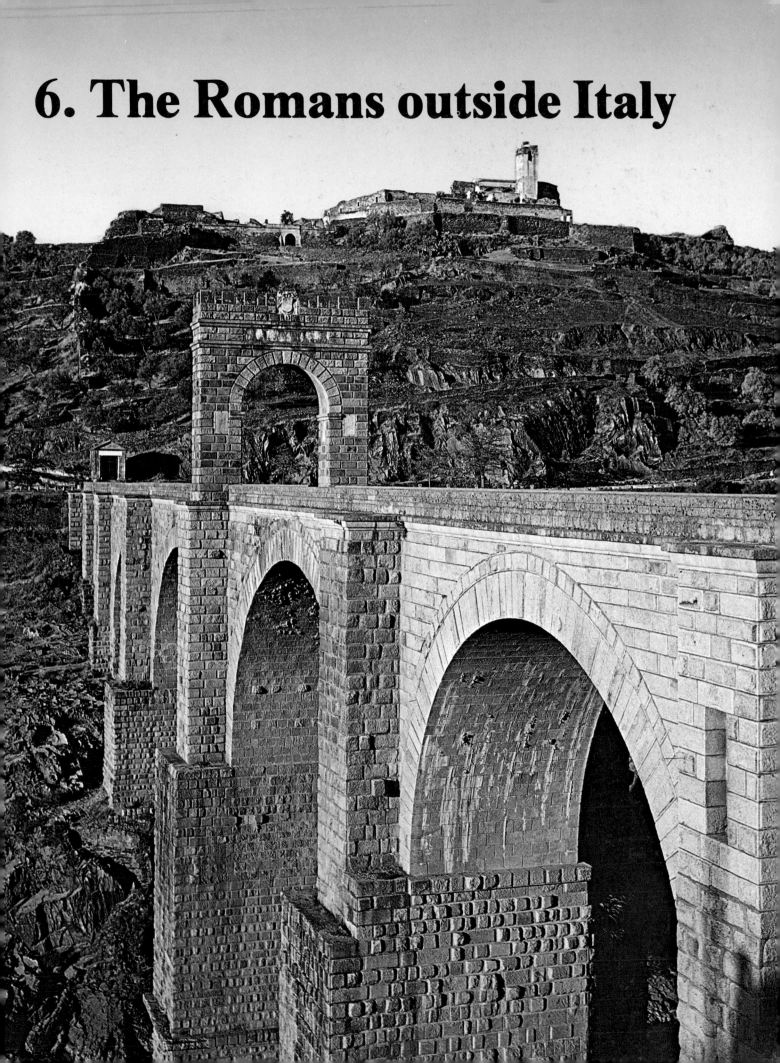

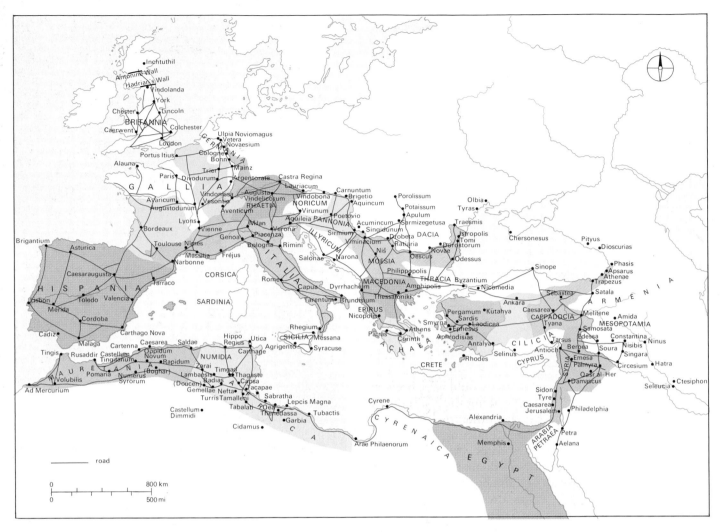

Previous page: the Roman bridge at Alcantara in Spain.

The Roman Empire and its roads.

The growth of empire. At its widest extent, under the Emperor Trajan, the Roman Empire extended from Morocco in the west to Armenia in the east and from Britain in the north to Upper Egypt in the south. The whole Mediterranean coast was under Rome's control, as were all the lands to the north as far as the Rhine and the Danube (the Dacian wars of 101–02 and 105 AD had in fact enabled Trajan to carve out a large enclave to the north of the Danube as well). How was it that this vast area had become subject to a single city? It had been a gradual process, begun when Rome gained control of Latium, continued when first Italy and Sicily and then parts of Spain, Gaul and North Africa succumbed during the Punic wars, and essentially completed when the Hellenistic kingdoms of the eastern Mediterranean crumbled before Rome's military power in the 2nd and 1st centuries BC. The Empire grew partly through the need to counter threats to Rome's existing power (which led to the fortification of the frontier areas), and partly through a desire for military success and booty.

Macedonia, to its surprise and chagrin, was the first eastern power to fall, and in its wake Greece itself came under Roman rule. We have a precious visual record of the victory of the Roman general Lucius Aemilius Paullus at the battle of Pydna in 168 BC. A victory monument set up at Delphi shows a specific event in the battle: a runaway horse caused havoc among the Macedonian lines and helped the Romans to victory. Other military details are accurately depicted: the tall oval shields of the Romans are contrasted with the elaborately decorated round bronze shields of the Macedonians, one of whom can be seen wearing a typical Hellenistic helmet and another a bronze cuirass with leather trimmings. The visitor to Delphi is unfortunately unable to see this important work of art, for it is kept locked away in a museum storeroom. It merits exhibition, however, for it is one of the earliest representations in European art of a historical event that occurred on a specific day.

Roman roads. One of the ways in which Rome was able to achieve military success and, having once achieved it, to maintain it, was through superior communications. Road builders would accompany her armies, and surveyors and engineers would quickly lay roads to enable supplies and

CC↓X
CN·EGNATI·C·F
ΓRO·COS
ΓΝΑΙΟΣ ΕΓΝΑΤΙΟΣΓΑΙΟΥ
ΑΝΟΥΠΑΤΟΣΡΩ ΜΑΙΩΝ
ΣΞ

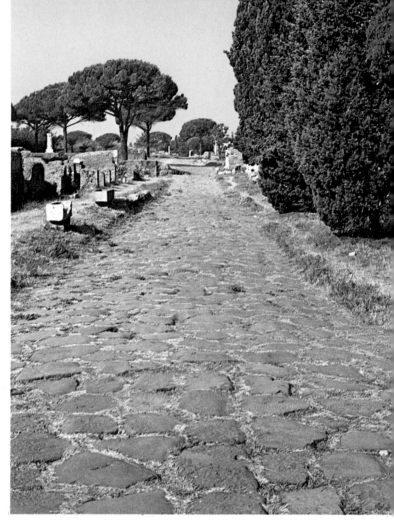

reinforcements to come up. The roads, once laid, gained added economic importance. One of the most important roads in the Eastern Empire was the Via Egnatia which ran from Dyrrhachium on the Adriatic to Byzantium on the Bosphorus. The reason for its name had long been a puzzle to scholars, until the discovery in 1973 of a milestone during the construction of a factory near Thessaloniki in northern Greece. The bilingual inscription on the 1·3-meter-high stone (one of a series that would have been set up at intervals of one Roman mile along the road) shows that it had been erected by the otherwise unknown proconsul of Macedonia Gnaeus Egnatius, the son of Caius. We can pinpoint Egnatius' dates with a fair degree of certainty. The province of Macedonia had been set up in 146 BC (after two decades of an abortive Macedonian federal republic), which gives us a *terminus post quem* for the stone; and the geographer Strabo, in describing the Via Egnatia, relies on an account made by the historian Polybius, who died around 120–119 BC. At some time, then, between these dates, and earlier rather than later, the road had been laid out. We also derive another useful piece of information from the new milestone: independent

Above: a stretch of Roman road at Ostia.

Above left: bilingual inscription in Latin and Greek giving the name of the Roman magistrate who first built the Via Egnatia which ran from Dyrrhachium on the Adriatic to Byzantium on the Bosphorus. Thessaloniki Museum.

Below: detail of a relief from the monument erected by Lucius Acmilius Paullus to commemorate his victory over the Macedonians at Pydna in 168 BC. Delphi Museum.

evidence for the distance from the Gallikos (which is where the stone was found) to Dyrrachium, which was 260 Roman miles. Many of the figures which have come down to us in the literary accounts have become garbled in transmission, but it is now clear that the figure of 267 Roman miles which Polybius gave for the distance from Dyrrachium to Thessaloniki is the correct one.

Romans in the Greek world. The positive and negative sides of the impact that Rome and the Greek world had on each other have been succinctly summarized by Arnold J. Toynbee. After describing how Latin literature came to be based on Greek models, he says: "The impact of Greek literature on Roman life, like the impact on it of Greek philosophy and Greek religion, was part of the cultural counter-offensive by which the Greeks captivated their Roman conquerors. This was a riposte to an impact on the Greek world that was not cultural but was military, political and psychological. The Roman nobility were dazzled by Hellenism at their first encounter with it, before a longer and closer acquaintance with their Greek contemporaries had given them a disillusioning experience of the Hellenic civilization's seamy side – above all, the factiousness of Greek politics and the dishonesty of Greek private life. The Greeks, on their side, were impressed by the quality of Rome's military and political institutions, before a longer and closer acquaintance with their Roman contemporaries had given them, for their part, a disillusioning experience of the dark side of the Roman national ethos – its ferocity, rapacity, ruthlessness, vindictiveness, and duplicity."

There was in fact a deep cultural gulf between the average Greek and the Roman man in the street. This can be illustrated by a story told by the Greek historian Polybius who lived for many years in Rome as a political exile. When in 167 BC L. Anicius Gallus celebrated his triumph over Macedon's Illyrian allies, he brought to Rome for the occasion some of the most eminent Greek flautists. When the Greek artists started to perform, the Roman audience began to get up and leave. Anicius saved the situation by making the artists stop playing classical music and start a sham fight among themselves instead. The Roman audience streamed back; this was more like what they were used to.

The Romans could deal savagely with their Greek allies, especially when they were recalcitrant. In 146 BC the powers of central Greece tried to throw off the Roman yoke. Acting on instructions from the Roman government, the Roman commander L. Mummius made an example of Corinth, one of the most famous cities in Greece. The Corinthians must have been aware of their impending fate, for excavations conducted by the American School of Classical Studies at Athens have revealed the point where they made their last stand. The discovery of about 30 catapult balls of four or five different calibers in a stoa near the Archaic Greek temple which displayed signs of having been demolished in a singularly ferocious manner implies that some Corinthians held out in their arsenal. Broken roof tiles, building debris, quantities of ash and burned wood, and the presence of sling bullets and spearheads indicate that the building was destroyed by violence and fire. The victorious Roman army, we are told, massacred every adult male citizen found within the walls and the women and children were sold into slavery. The city itself was looted, and the manner in which this was done also tells us something about the Romans. Polybius describes soldiers so ignorant of the value of pictures painted by Greek old masters that they used them as draught-boards. Their commander Mummius, however, who was more cultured, succeeded in looting many other masterpieces which he then used in a conscious effort to encourage Greek taste in Italy, an action which perhaps reveals the application of a curious double standard.

The sack of Corinth was very much an exceptional event, and most of Rome's dealings with Greece were tinged with respect for an older and more sophisticated culture. Hellenistic kings had made a practice of bestowing public buildings on Greek cities and shrines and the Romans continued this tradition. Athens was frequently a recipient of Roman architectural largesse, and one of the most original and important monuments to be erected there in the early Empire was the Odeion built on the south side of the Agora (the "civic center" of ancient Athens) by Augustus' friend, collaborator and son-in-law M. Vipsanius Agrippa, who visited Athens in about 15 BC. The Odeion was a covered theater or lecture hall which seated about 1,000 spectators. It was almost exactly square in plan and consisted of a high gabled hall in the center which housed a vestibule and the seating, stage and orchestra, surrounded by a much lower outer structure which included a green room and a broad passageway on three sides which would have commanded excellent views to east and west. The details of the architecture were Attic, and included Corinthian capitals of great delicacy. Another type of capital consisting of acanthus leaves combined with lotus leaves provided a touch of variety. Sculptured herms stood along the front of the stage, and bronze statues of heroic size stood in niches around the walls. An interesting feature was the roof which had a span of 25 meters and was covered with terracotta tiles. No traces of internal supports have been found and it has rightly been described as "one of the most daring achievements in roofing known in Greek lands in any period." The Roman element was the sheer scale of the building, which can hardly have blended with the other earlier and rather smaller buildings of the Agora, and its scale was eventually its undoing, for at some time in the 2nd century AD the roof collapsed causing serious damage to the variegated marble floor of the orchestra, marble benches and sculpture (we do not hear of any *people* being hurt). When it was subsequently rebuilt, the area to be spanned was greatly reduced.

Local customs and religious belief. Whenever possible, the Romans preferred to allow the Greek cities of the eastern Mediterranean to continue with their own system of government and their own local customs. Thus an important shrine such as the Asclepieion at Pergamum might be modernized in the contemporary Roman manner in the 2nd century AD. The cult had begun on the site in the early 4th century BC when a Pergamene gentleman named Archias had had a hunting accident and went to the shrine of Asclepius at Epidaurus in Greece for a cure. The treatment was successful and Archias decided to found a similar institution in his home town. An Asclepieion was a mixture of a spa, a health farm and Lourdes. The invalid pilgrim would fast, bathe, be applied with mud-packs, and sleep in a special dormitory where he would receive guidance and healing from the god in his dreams. The Asclepieion at Pergamum had gone public in the early 2nd century BC when it had probably ceased to be the private property of the founder's family; and when it was redeveloped in the mid-2nd century AD, it took the form of a large square surrounded by colonnades on three sides. Leading off these were a theater and rest rooms (one a splendid 32-seater), while on the fourth side lay a large circular temple of Asclepius, similar in form to the Pantheon at Rome, and in the southeast corner an even larger round building with six segmental "side chapels" in which the sick sought their cures. The health center was not run on wholly quack lines and was in fact at the forefront of contemporary medical research. Galen was resident physician there in the 2nd century AD, and the library must have been exceptionally rich in medical

The Odeion, a large public hall, erected on the south side of the Agora at Athens by M. Vipsanius Agrippa c. 15 BC. After Izenour.

literature. We happen to possess an inscription, carved in crisp Greek letters, connected with the building of the library. The "Council and people" expressed their gratitude to a certain Flavia Melitina, a rich widow with political connections, who had paid for the library's construction.

Inscriptions are among the most important sources that we possess for information concerning administration, religious beliefs and everyday life in the Roman world, and their number increases year by year as new discoveries are made. The erection of inscriptions, especially those of a private nature, implies that the ability to read and write was widespread, and occasionally we find explicit claims to literacy. Thus several tomb stones from the environs of Kütahya, the ancient Cotiaeum, on the northwestern fringe of the highlands of Phrygia in central Asia Minor, have as part of their decoration a writing tablet and a set of pens and a portable ink well. This area had gone into a steady decline during the 1st century BC, but experienced a resurgence under the Flavian and Antonine emperors, when it lay in the eastern part of the province of Asia. It was in fact only with the spread of Roman authority into the Anatolian hinterland that this part of the world became Hellenized. The tomb stones are written in Greek and one in the Kütahya Museum has an extra inscription, added almost as a footnote, containing the warning that "whoever lays evil-doing hands on this, may he fall into a heap of premature disasters." The lower part of the stone is carved in the form of a door – a reference to the far more expensive form of burial in a tomb chamber which would have been closed with a stone door. The deceased is shown with his wife whose hand mirror and comb are in evidence above, while a plow, a

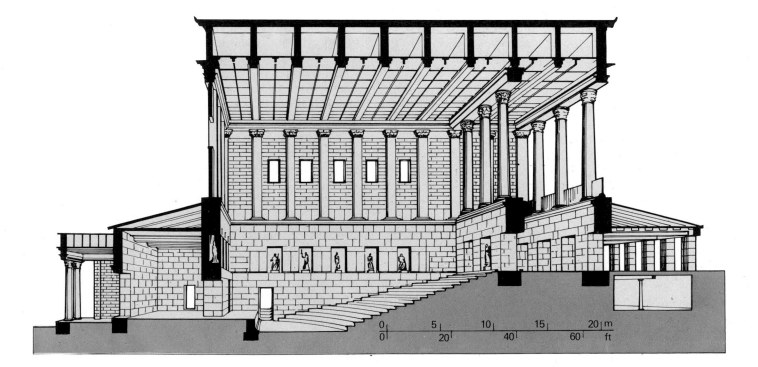

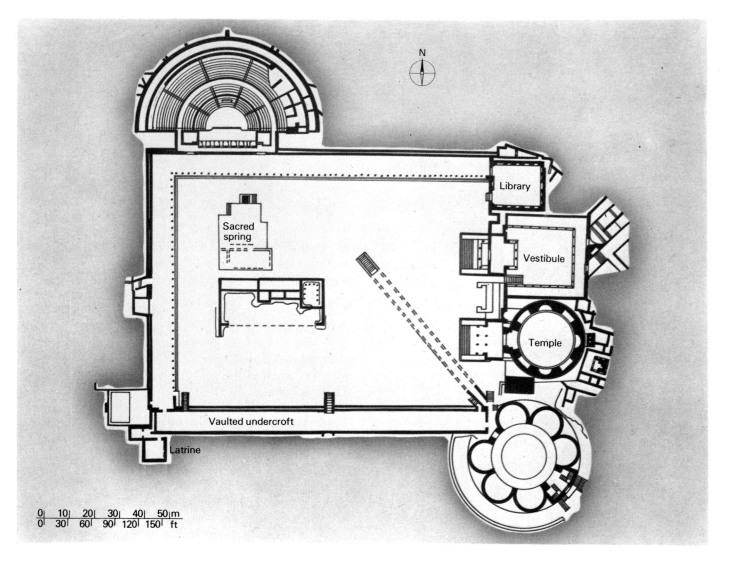

Library

Vestibule

Sacred
spring

Temple

Vaulted undercroft

Latrine

N

0 10 20 30 40 50 m
0 30 60 90 120 150 ft

Plan of the Asclepieion at Pergamum, built between 140 and 175 AD.

The exterior of the hall in the Asclepieion at Pergamum where the sick sought their cures.

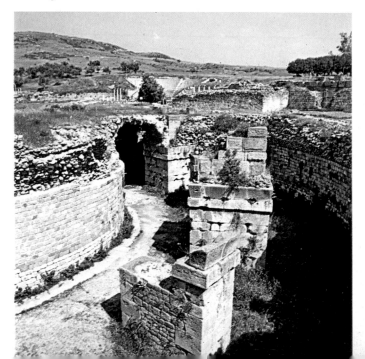

reference to the source of their livelihood, is carved below. In relatively modern times the stone was reused by an Armenian, perhaps one of the potters for which Kütahya was famous, in the 17th and 18th centuries.

Another inscription in the Kütahya Museum provides evidence for a Jewish community in Roman Cotiaeum. The tomb stone of Podara, daughter of Domos, bears an inscribed *menorah* (the seven-branched candlestick), as well as the *lubal* (palm branch) and *ethrog* (citrus fruit) that are carried in the Jewish Feast of the Tabernacles. On the far right is carved a *shofar*, the ram's horn that is sounded at the New Year and Yom Kippur. Unlike most of the religions that the Romans encountered in their conquest of their empire, Judaism, and to a certain extent Christianity, were not prepared to compromise with the official state religion of Rome. We have a poignant reminder of the strength of the convictions of the Jews who opposed Roman rule in Judaea in the recently excavated fortress at Masada in Israel. The Zealots – the remnants of the Jews who had revolted in 66 AD and who had escaped the cruel Roman sack of Jerusalem in 69 – held out in their almost unassailable fortress until 73. The main structures and

fortifications had been the work of King Herod and were built as a royal citadel in the later 1st century BC at a time when Herod feared attack from Cleopatra of Egypt. Israeli archaeologists found that Herod had built himself a luxurious establishment on a scale of grandeur that was probably more appropriate to his normal way of life than to a state of siege which, however, he never had to endure. The residential apartments at the northern tip were laid out like a villa and there were huge storehouses for provisions, a synagogue and even a large bath-house. Between the period of Herod and the Jewish revolt Masada was occupied by Roman legionaries, but the most impressive finds were those connected with the Zealots' last stand: the chambers in which they lived, the lamps they used, silver shekels, parchment scrolls and, most touching of all, the potsherds on which were inscribed names which, it has been suggested, were those of the Zealots chosen to slay the defenders so that the Romans found next to no one alive when they finally broke through.

The splendors of Roman Africa. Another area of the Greek world that became Roman after a period as part of a Hellenistic kingdom was Cyrenaica in North Africa. The principal city, Cyrene, was one whose population at its height could probably have been counted in hundreds of thousands. It also had a sizable Hellenized Jewish minority and was the center of another Jewish revolt against the Romans in the reign of Trajan in 115 AD. The revolt spread to Egypt, Cyprus, Syria and other places in the Levant before it could be brought under control. The rebellion in Cyrene was led by a person whose name is given as either Luke or Andrew, and many public buildings were

Above: tomb stone from the Anatolian hinterland carved with rough portraits of a countryman and his wife. Reliefs of writing equipment show that he, at least, was literate. Kütahya Museum.
Below right: the camp of Masada, where the besieged Zealots held out for four years.
Below: the 2nd-century AD theater at Aspendos, southern Turkey.

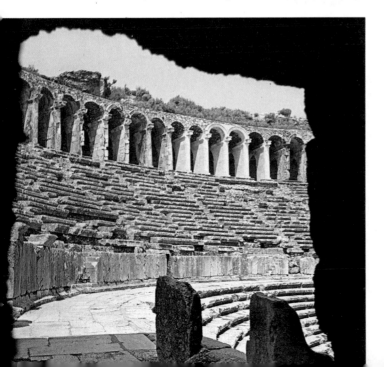

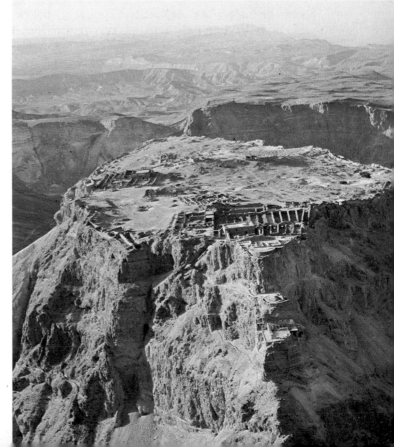

destroyed including porticoes around the Agora and various temples and baths. The Romans met force with force and sent infantry and cavalry by sea to deal with the situation. A late source says that 220,000 were killed in the fighting, but such a large figure is probably to be regarded with suspicion. But whatever the figure, the upshot was that the revolt was put down and Roman military veterans were settled in Cyrenaica to make good the loss of manpower. A program of rebuilding was started and most of the destroyed buildings were quickly put back into operation. A Latin inscription found in the baths informs us that in 119 AD the Emperor Hadrian ordered to be restored "the baths" in the sanctuary of Apollo at Cyrene, "together with their porticoes and ball courts as well as the surrounding buildings that were destroyed and burned in the Jewish revolt."

Far more splendid were the Hadrianic baths at Lepcis Magna in Tripolitania. The bath-house was a natural social center at Rome and the introduction of bath buildings to Roman Africa must have played an important role in the dissemination of Italian social – and architectural – ideas. Lepcis Magna had been a city of Phoenician origin in the Carthaginian Empire, but after the defeat of Carthage in the Punic wars was for a time subject to local Numidian kings. In the late 2nd century BC she became a "friend and ally" of Rome, and never looked back. She flourished under Roman protection, specializing in the wild animal trade, and could afford to build on a lavish scale. It is hardly surprising that the first known example in Africa of a public bath built on the pattern of the great imperial bath buildings of Rome was to be found in Lepcis.

In front of the baths to the north was a *palaestra* or sports ground which was basically a large open space surrounded by a colonnade straight on the sides and curved at the ends. The first component of the baths proper was the *natatio* or open-air swimming pool. It too was surrounded by a covered portico. In wings on each side beyond the changing rooms were large rest rooms with the usual conjoined marble seats and a deep flushing channel beneath. The *frigidarium*, or cold room, must have been the most splendid room in the baths, paved and revetted with marble slabs and roofed with three concrete cross vaults springing from massive *cipollino* columns. Cold plunge baths were situated to east and west. Further south lay the *tepidarium* or warm room with a single central bath, while on the south side lay the *caldarium*, or hot room, and the famous *laconica* or sweat rooms which were heated by means of hot air emanating from furnaces and boiler rooms placed along the south wall. The dismally cramped passageway in which the stokers worked is still preserved in the Hunting Baths at Lepcis, where there can also be seen some of the chimneys in which small fires would be lit to make the furnaces "draw" when they were started up. The fire in the furnaces would heat up large metal plates which would act as elements to heat the water in neighboring pools. This is why there are furnaces close to all the hot rooms in the Hadrianic baths. Hot air would also circulate beneath the floors of the sweat rooms and up the tiles which lined the walls. Large amounts of water would be necessary for such large baths and a special supply had to be found. An inscription dated to 119–20 AD (which is when the baths were built) records how a certain Q. Servilius Candidus "found water, raised it and brought it into the colony at his own expense." The implication is that Candidus had to build an aqueduct, and he was probably responsible too for the water storage tanks that have been found just to the south of the Hadrianic baths.

It was the normal thing in the Roman world for a rich private citizen to contribute towards the construction of public buildings, and Lepcis was particularly fortunate in the architectural gifts bestowed on it by patriotic citizens. An inscription in beautifully cut Roman and Punic letters in the theater at Lepcis informs us that the latter had been built by a certain Annobal Rufus, a person of Carthaginian extraction, as his name and that of his father Himilcho Tapapus denote. He describes himself as an "adorner of his native land" – with justice, for the theater at Lepcis is one of the finest anywhere in the Roman world – and as a "lover of concord," being presumably conscious of the need to encourage good relations between the Punic and

An inscription in the theater at Lepcis Magna in Latin and Punic tells us that it was built by a certain Annobal Rufus, a native of the city.

Roman elements of the citizenry.

But the most remarkable contribution made by a native son to Lepcis Magna was the whole new quarter that was added by the Emperor Septimius Severus after his visit to his native land in 203–04 AD. Only part of the Severan quarter at Lepcis has been cleared, but buildings of almost unparalleled magnificence have been revealed. A huge forum (c. 140 × 80 meters), surrounded by a columnar arcade, way ahead of its time in the way the arches spring directly from the capitals, was dominated at one end by a lofty temple on a high podium in the Italian manner. The architectural details, however, of the Severan scheme are distinctly Greek in style and indicate that immigrant workmen from Asia Minor (perhaps, it is thought, from Aphrodisias) had been employed. Even some of the marble came from that area: huge pieces of Proconnesian marble from the Sea of Marmora were used in a basilica – an immense covered hall – which stood along the northeast side of the forum. It measured some 85 meters from the apse at one end to that at the other. Apart from the marble – there were two stories of pink Egyptian granite columns a good deal of wood would have been necessary to support the roof and the galleries. An indication of how much wood could be used in the construction of a basilica is provided by an inscription from Thessaloniki in Macedonia, where a local citizen presented 10,000 cubits of wood for such a purpose. The most striking feature in the Lepcis basilica was the presence of four large marble pilasters decorated with mythological scenes attached to each end wall.

The defense of Africa. Septimius Severus' visit to Lepcis in 203 AD was not a purely social one. The coastal areas had recently come under attack by various tribes of the interior who we can guess were the Garamantes of the Fezzan and the Nasamones of eastern Tripolitania, who lived in the area known as the "pre-desert" on the northern fringes of the Sahara. This had always been a troublesome frontier area as long as the Romans had had dealings with it. The *Legio III Augusta* saw service there in 21 BC and their commander Sempronius Atratinus was granted a triumphal procession at Rome in recognition of his exploits. Soon afterwards an expedition was made under L. Cornelius Balbus against the Garamantes, and though their capital Garama in the Wadi el-Agial was captured, we hear of yet another expedition against them in 15 BC. The trouble seems only to have come to an end in 6 AD when the western tribes were defeated by Lentulus Cossus. Apart from a rising of the Nasamones which was harshly dealt with in 85–86 AD, the desert was peaceful until the time of Septimius. He and his son Caracalla set about a radical reorganization of the desert defenses by creating a system of static defense – the *Limes Tripolitanus* as it was called – consisting of outlying forts situated on the main lines of communication between the interior and the coast. Behind, a buffer zone was soon established, occupied by

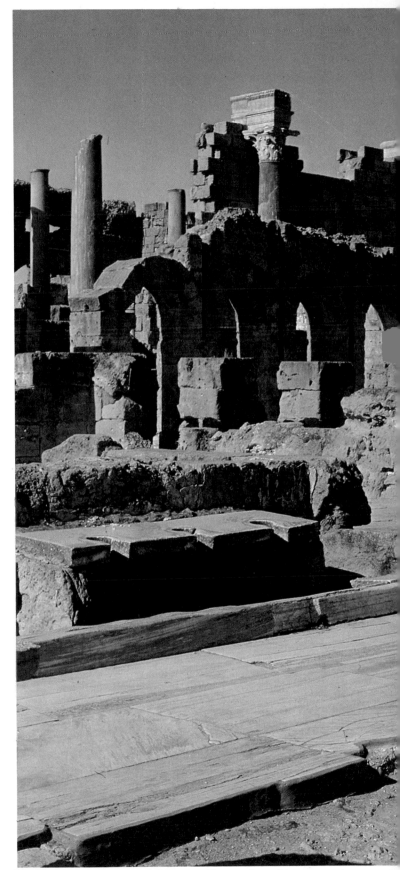

The Hadrianic baths at Lepcis Magna, with part of a multi-seater latrine in the foreground.

soldier-farmers living in fortified farmhouses on land that they were granted in return for an undertaking that they would act in defense of their territory against invasion from the south.

The Garamantes have recently been a focus of archaeological interest. For the past few years a British team from the University of Newcastle-upon-Tyne has carried out surveys and excavations in several places along a 100-mile stretch of the Wadi el-Agial – the *Garamanticae Fauces* of Pliny – not least at Garama, the Garamantes' capital, and found that they regularly occupied promontory spurs projecting from the face of the escarpment on the southern side of the wadi. The upper surfaces of these promontories were often found to be covered with the remains of dry-stone-wall huts and small scooped shelters. Their flanks were terraces and also showed signs of habitation. Cemeteries around them contained pottery of Roman date. That at Saniat ben Howedi proved to be particularly fruitful: 43 tombs were of 3rd-century AD date or later – the period when the Garamantes were threatening the Roman coast land. Most had been robbed, but a number of complete plates, flagons and lamps were recovered.

At a lower level several larger square tombs were isolated. Two had been damaged in antiquity, but never robbed. They were painstakingly and laboriously excavated so that all the fragments of the highly interesting pottery they contained could be rescued and recorded. The first tomb produced three wine amphoras, a two-handled flagon, an incense bowl, a lamp, eight fine red-ware bowls of Italian origin, a quern and some dark blue beads. The second was even more productive and illustrated the comparative wealth of a Garamantian lady newly acquainted with Roman goods at some time towards the end of the 1st century BC. Again, there were a quern and an incense bowl, but eleven amphoras, five glass bowls, nine small Egyptian faience bowls and no fewer than 31 fine-ware bowls from Italy, including several Arretine ware pieces. This suggests that Italian merchants were close at hand when the early Roman military expeditions visited Garama.

The site of Carthage. Carthage had been Rome's enemy for much of the 3rd century BC. The third and last Punic war brought the Romans to its very walls. The siege lasted for three years before Carthage fell in 202 BC. Fear of a Carthaginian revival was a constant worry at Rome. Cato made persistent demands in the Senate that Carthage be destroyed: "delenda est Carthago." In 146 BC ten officials were sent from Rome to preside over the city's complete destruction; its inhabitants were put to the sword or sold into slavery and the buildings razed to the ground. An international rescue project currently being conducted under the auspices of UNESCO will, it is hoped, provide us with a good deal of information concerning the Punic city.

The site of Carthage, however, with its fabulous harbor and rich hinterland, could not remain deserted for very long. The Romans were eventually forced to redevelop it, though anti-Carthaginian prejudice died hard. Caius Gracchus was the first to have understood the situation and

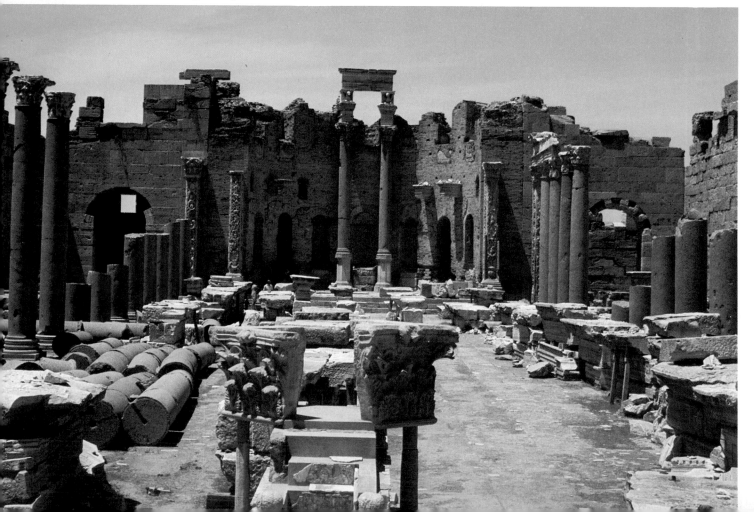

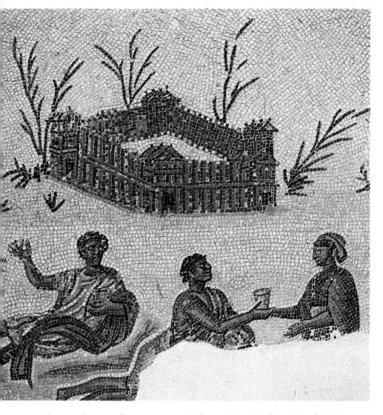

Above: a Roman fort on a mosaic from North Africa. Bardo Museum, Tunis.

Opposite: the Basilica at Lepcis Magna is one of the most impressive Roman monuments anywhere. It was built by the Emperor Septimius Severus who was born at Lepcis.

in 122 BC organized a colony of Roman settlers; but city life did not properly begin until Julius Caesar settled some of his veterans there. Augustus completed his predecessors' work by establishing at Carthage Roman citizens already living in nearby cities. It can hardly be a coincidence that about this time Virgil composed the *Aeneid* – the epic poem containing the famous love story of Dido, queen of Carthage, and Aeneas. Thenceforward a new life started for Carthage, and by the 2nd century AD it was filled with sumptuous buildings.

Unlike Lepcis, which had the advantage of being fairly well supplied with water, Carthage was always short. There was no river, and springs were extremely rare in the neighborhood. In an attempt to overcome this lack, cisterns were built, one to a house, in which rainwater was collected and stored. This clearly was insufficient for the needs of an ever-growing city, and so immense reservoirs were constructed, again for rainwater. But even this proved not to be enough for the city's requirements, and so under Hadrian the still impressive Zaghouan aqueduct was built to carry water from a mountain spring some 60 miles away. Even today this spring produces water at a rate of 200 liters per second, or 17 million cubic meters in 24 hours. In the Roman period, though, it has been calculated that it produced 32 million cubic meters per day. A huge basin was constructed at the spring at Zaghouan in which the water was gathered before beginning its long cross-country journey. The aqueduct was constructed of stone, and sometimes progressed at ground level, sometimes underground, and sometimes for miles at a time on picturesque arches.

Carthage, of course, lies near modern Tunis, the capital of modern Tunisia, a country whose boundaries approximate to the Roman province of Africa Proconsularis, and which has proved to be full of impressive Roman remains to fascinate the scholar and beguile the tourist. Africa Proconsularis had not always been Roman, but was deliberately Romanized during the centuries following the fall of Carthage. The coastal cities had been Carthaginian trading centers and were soon occupied by Roman merchants. Inland, though, there were Numidian villages, agricultural centers that were more or less civilized according to where they were situated. As we saw with Lepcis Magna, it was not a particularly difficult matter to Romanize a Carthaginian city, for the infrastructure was already there. The problems of the interior of Africa Proconsularis (as of Numidia and Mauretania to the west) were rather different. The urban model had first to be created in the hope that the local inhabitants would imitate it.

Trajan's colony at Timgad. The legionary fortress at Lambaesis (in modern Algeria) had been built to guard the road against invaders from the Sahara and was laid out in the regular manner usual in Roman military establishments of the 1st century BC. In the year 100 AD Trajan decided to found a Roman colony at Timgad, a short day's march away to the east, and the Third Legion stationed at Lambaesis was put in charge of the operation, under the direction of the legate L. Munatius Gallus. The new inhabitants – military veterans and local population – were all granted Roman citizenship. Little attempt was made to conceal the military origin of the builders, for the city's almost square plan was the nearest thing to that of a fort. It was in fact meant to be defensible in the case of sudden attack. Within, the city was divided into housing blocks on a strict grid pattern. The only exception made was in the center of the south side where, on rising ground, the forum and theater (the latter capable of holding between 3,500 and 4,000 persons) were inserted. Elsewhere there were comfortable-looking single-story houses arranged around courtyards, most of them occupying a single block each. Those on the more important streets – those running from the north gate to the forum (the *cardo*) and between the east and west gates (the *decumanus*) – were fronted with colonnaded porticoes so that the pedestrian would be sheltered from the sun and the rain, rather as in some north Italian cities today.

The policy of Romanization seems to have succeeded, and the surrounding countryside to have become peaceful, for within a comparatively short time temples, baths and

houses sprang up outside the old lines of the walls. An index of the comparative wealth of Timgad in its palmy days is provided by the luxurious decoration of some of its buildings. The "Arch of Trajan," for example, situated at the western gate to the city on the road to Lambaesis, is a most elaborate structure. It was almost certainly not erected under Trajan, for the closest parallels (at Lambaesis and Zana) are probably to be dated to the early 3rd century AD; a late 2nd-century date is more appropriate. It consists in fact of three arches – a tall, wide one over the road, and two shorter, narrower ones over the sidewalks to either side. The openings on each face are surrounded by four fine columns, strangely only fluted in their upper parts (the lower parts of columns were usually only left unfluted when there was a danger of their being knocked by passers-by). There are *aediculae* for statues over each of the side openings, and above them are elegant segmental pediments which rest on the columns. Such grandeur was by no means the exception in the cities of Romanized western North Africa for there are dozens of arches of greater or lesser complexity elsewhere.

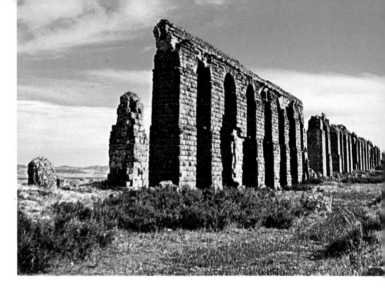

Above: the Zaghouan aqueduct carried water into Carthage from a spring 60 miles away. It was built in the time of the Emperor Hadrian.

Opposite: the site of a Roman villa at Ailly in northern France photographed from the air by R. Agache.

Below: the so-called Arch of Trajan at Timgad, probably built towards the end of the 2nd century AD.

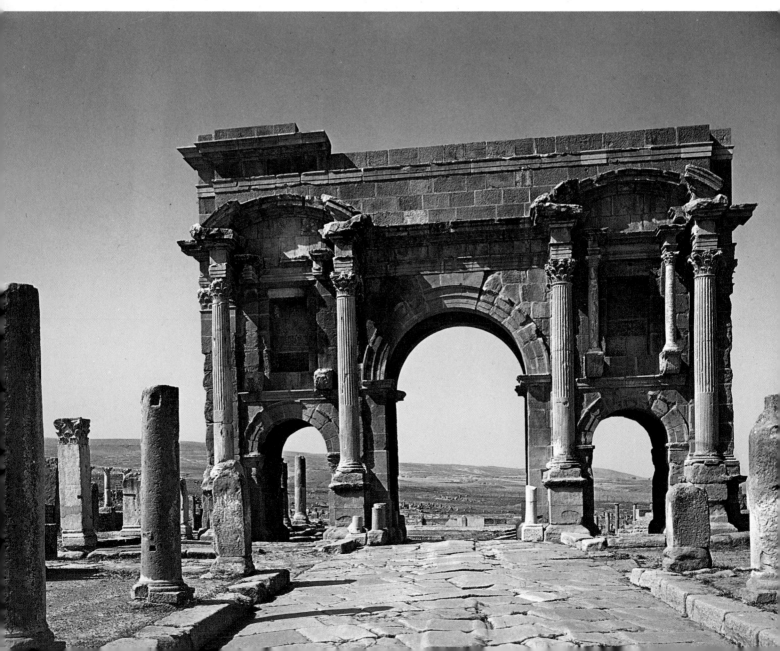

Roman Gaul. Modern France approximates to Roman Gaul which, together with Spain, constituted one of the first non-Italian regions to be Romanized. Defeated by Julius Caesar in the 1st century BC in a series of wars of which he has left vivid descriptions, the Gauls were quick to adopt a peaceful Latin civilization. Their simple tribal capitals became cities with all the trappings of Roman civilization – watered by spectacular aqueducts and linked by an impressive network of roads. The peaceful condition of Gaul was guaranteed by the presence of Roman armies guarding the Rhine frontier against incursions from the north by Germanic tribes. A large part of the population must have remained in the countryside, although until very recently there was very little archaeological evidence for their way of life. During the past few years, however, aerial exploration by R. Agache of the fertile plains of Artois and Picardy in northern France has revealed the presence of more than 1,000 Roman villas. It has thus been possible to obtain some idea of the rural economy of the region in the centuries preceding the catastrophic invasions which occurred in the second half of the 3rd century AD.

The villas are widely spread, occupying choice positions on isolated plateaus, and vary in size from vast establishments measuring some 180 × 300 meters, through medium-sized villas measuring 80 × 180 meters, down to mere houses with a barn. The smaller villas may have been dependent on the larger ones, some of which seem to have been set up as the country residences of local grandees. The rich plains produced corn, and presumably wool – complementary products, for sheep would have fertilized the cornfields, and both were constantly required by the army on the frontier. The larger establishments were as much factories as farms. Slave-run, they appear to have been self-supporting. Excavated villas have produced evidence for the production of pottery, bricks, tiles and ironwork. The economic system has been characterized as one where it was hoped to "produce everything, to buy nothing, and to sell if possible." Apart from the isolated villas, small civilian settlements (*vici*) have been observed on the principal highways, and, deep in the country, rural shrines (*fana*) sometimes on a huge scale, with theaters, baths and basilicas. Aerial exploration has truly revolutionized our knowledge of a highly important aspect of Roman Gaul.

Roman Britain. Strictly speaking, so far as the average Roman was concerned, the island of Britain, lying off the coast of the inhabited world in the Ocean itself, should not have been there. This attitude seems to go some way towards explaining why it took so long for the Romans to incorporate Britain in the Empire. Julius Caesar had made what proved to be an abortive attempt at conquest in 55 and 54 BC, and it was not to be until very nearly a century later that the Emperor Claudius, needful of triumphal success in foreign wars, embarked on the invasion of Britain in 43 AD. The south was quickly overcome and the province of Britannia soon established with its capital at Londinium, the remains of which underlie the present City of London. Even the revolt of the Iceni under their queen, Boudicca, did not halt the Romans in their attempts – never wholly successful – to bring the whole island under their control.

Tacitus informs us of the deliberate policy of the Roman governor Agricola (in office 78–84 AD) to Romanize the native population by encouraging settlement in towns and the spread of Roman language and ideas. Agricola also went much further than any other governor of Britain in attempting to defeat and Romanize the tribes of North Britain, the modern Scotland. For a short time he made his frontier the point at which the distance from coast to coast was narrowest (between the Firth of Forth and the Firth of Clyde), which he used as a springboard for further activity up the east coast of Scotland. Here he built several military establishments to watch the exits from the highland glens. The most remarkable of these was the legionary fortress at Inchtuthil in Perthshire, intended for

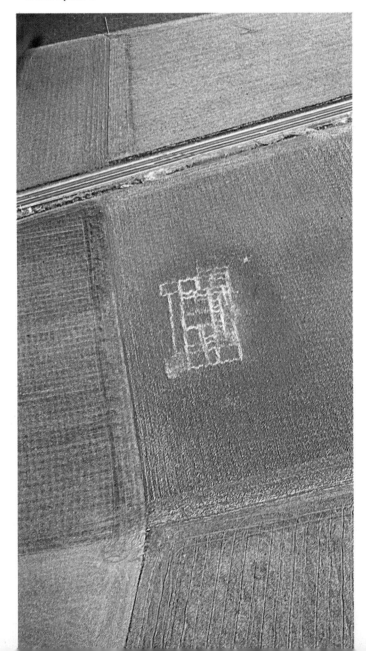

the Twentieth Legion, but evacuated even as they were moving in, probably as the result of pressure on the Danube frontier which necessitated the withdrawal of another legion from Britain. Although the evacuation of Inchtuthil and its dependent forts meant the collapse of Agricola's strategical plan for the northeast, it does mean that we have at Inchtuthil the best-preserved legionary fortress in the Roman Empire.

The site of Inchtuthil lies on a plateau on the north bank of the Tay not far from Perth. The fortress measured overall 480 × 480 meters and excavations in the 1950s and 1960s by the late Sir Ian Richmond and by J. K. St Joseph have shown that it was constructed almost entirely of timber buildings: a headquarters building (*principia*), four tribunes' houses, 64 large barracks, six large granaries and 180 storerooms, as well as a drill hall (*basilica exercitatoria*), a construction shop (*fabrica*) and a hospital designed for a casualty rate of between 2 and 3 per cent. The preliminary

turf-built defenses had been replaced in stone and all seemed to be set for an orderly occupation by the legion. Instead, we have evidence for an evacuation of the site which involved the methodical destruction of all the buildings and the removal or burial of equipment lest it fall into enemy hands. The new installations were uprooted and much timber burned. Pottery and glassware were deliberately pounded into small pieces, and flagstones were stripped and broken. An indication of the speed with which the evacuation was conducted is provided by the presence of a cache of a million nails of all sizes carefully buried beneath the construction shop.

The details of the history of the Roman frontier in Britain are notoriously complex: at times the Hadrianic frontier between the Tyne in the east and the Solway in the west was defended, at others the Antonine frontier built on the line of the temporary Agricolan frontier between the Forth and the Clyde. But at some time after

the first withdrawal from Scotland and before the Hadrianic frontier with its walls and ditches, its forts, mile castles and turrets was constructed, another line of forts was built a little way to the south along a road which in medieval times was known as the Stanegate (the "Stone Road"). The site of one of these forts, Vindolanda at Chesterholm, provides a vivid contrast to Inchtuthil, for apart from a gap between 125 and 160 AD, it was in continuous occupation throughout the Roman period (which came to an end in Britain in 410 AD). But it was not just the fort that was occupied. In common with many other military establishments, a *vicus* had grown up outside its walls which housed a substantial civilian population: the families of the troops, merchants and camp followers in general.

One of the most spectacular monuments of Roman Gaul is the Pont du Gard which was built to carry water to Nîmes.

This aspect of the Roman occupation of Britain had not received much attention in the past, but the excavations conducted in recent years by the Vindolanda Trust have had as one of their principal objectives the elucidation of the civilian town. The name of Vindolanda, however, is now well known for an interesting discovery that was made in 1973 in the hard-packed bracken covering of the floor of a building of the pre-Hadrianic fort, which was found to contain, in addition to cloth from garments, well-preserved leather shoes and a good deal of human excrement, some delicate wooden writing tablets. With the aid of infrared photography, the inscriptions on the tablets can be read and they are at present being studied by philologists. Preliminary findings show that the tablets that have so far been deciphered are either official army records or the private papers of individual soldiers. They include a letter of recommendation and a letter of thanks for clothing (including an unspecified number of woolen

socks – very necessary garments for a Northumbrian winter!), as well as accounts which give us useful information concerning not only the kinds of food and drink commonly in use at Vindolanda, but also the way in which all aspects of Roman military life were closely supervised.

Augustus' frontier policy. The form of the northern frontier of the Roman Empire on the continent was largely the creation of Augustus, although his original project proved to be overambitious. This envisaged the subjugation of all the lands as far north as the Elbe in the west, and the Danube in the east. The areas between the Alps and the Danube, Raetia and Noricum, were the first to be secured, and then Augustus turned his attention to the Balkans. First Agrippa and then Tiberius conducted campaigns which brought Pannonia under Roman rule. Illyricum had been a province since 27 BC, and by 6 AD Moesia, which stretched along the right bank of the Danube from Pannonia and Illyricum as far as the Black Sea, was established as a province. A great Balkan revolt was put down by Tiberius in 7–8 AD, but no sooner were things settled in that quarter than news came of a great disaster that had befallen the Roman army in Germany.

It is not really certain, when Augustus decided in 12 BC to advance the frontier from the Rhine to the Elbe, whether his intention was to find a more rational alternative boundary to the Rhine, or whether it was merely a step to greater things. Whichever it was, he misjudged the magnitude of the task. Although by 5 AD Roman armies controlled much of the territory between the Rhine and the Elbe, the region was far from Romanized. The Celts of Gaul with their existing tribal centers had been easily persuaded to adopt an urban way of life, but there were no such settlements in the country north of the Rhine, and the time was not yet ripe for creating them. The appointment by Augustus of Quinctilius Varus in 9 AD as legate of the Rhine armies can be seen, with hindsight, to have been an unwise move, for in attempting to hasten the pace of Romanization north of the Rhine, Varus gave unwitting encouragement to anti-Roman sentiments. A former Roman auxiliary named Arminius, the chief of the Cherusci, plotted with neighboring tribes to remove the Roman presence once and for all, and achieved this objective by successfully ambushing Varus at the head of three of his legions as he was moving to winter quarters through the Teutoburg Forest. The legions were wiped out and Varus committed suicide. In vain did Augustus cry out, as he often did, "Varus, give me back my legions!"

This loss of military manpower enforced a retrenchment, and the Rhine was adopted as the ultimate boundary in the west. The area to the south of the Rhine continued to be Romanized, and the policy of urbanization was assiduously pursued. At some time during the second half of the 1st century BC the tribe of the Ubii from the northern bank of the Rhine had been resettled on its southern bank in a township known as Oppidum Ubio-

Right: a writing tablet from the fort at Vindolanda.

Below: plan of the legionary fortress at Inchtuthil. After Richmond. . A = Headquarter, B = Tribunes' houses, C = Drill hall, D = Construction shop, E = Hospital, F = Granaries, G = Storerooms.

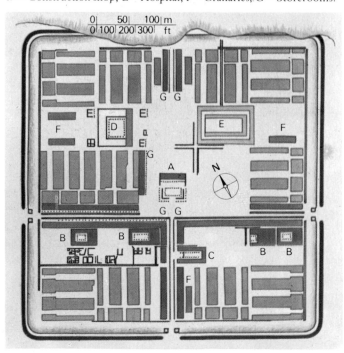

rum. Here Agrippina, the daughter of Germanicus and the future wife of the Emperor Claudius, was born in 15 or 16 AD, and when in 50 AD a Roman colony was founded on the site of the nearby fortress of the First and Twentieth Legions, she prevailed upon her husband to have it named Colonia Claudia Ara Agrippinensis, in her honor as much as his. Today we know the city as Cologne. In addition to the Ubii, the inhabitants of the new colony were to be veterans who had retired from the legions. The grid plan of the original fortress (which must have resembled Inchtuthil) governed the lines of the new city, and can even be detected in parts of Cologne today. Indeed, it has been claimed that the modern Hohe Strasse, which lies over the *cardo maximus*, the principal north-south street of the colony, is probably the oldest street in any German city. At right angles runs the modern Bodengasse, some 9·50 meters below which there runs for a distance of 200 meters a well-preserved stone-built Roman drain, one of several which took the city's sewage down to the river. It was probably also intended to take floodwater in the case of a sudden storm, for near its mouth it is 2·50 meters high internally, and 1·20 meters wide. It was almost certainly laid out at the time of the foundation of the colony, and shows how Roman civil engineers were capable of a standard of planning that was not surpassed until the 19th century.

So long as the tribes to the north of the lower Danube were peaceful and disunited, and the Roman legions stationed there were on the alert, then the northern frontier in that quarter was safe. But when, for example, in the civil wars that followed the death of Nero in 68 AD, the legions stationed in Moesia marched on Italy leaving the area in the not very sure hands of Thracian troops, Moesia was invaded from the north by Roxolani, then by Dacians, and then by Iazyges, who were all beaten off only with difficulty. Under Vespasian the military establishment of Moesia was doubled, and the frontier on the upper Danube strengthened. These measures might have been sufficient if things in Dacia had remained as they had been for the previous century, but the emergence of a formidable military leader in Dacia, in the person of King Decebalus, put paid to any hopes of peace the Romans may have had.

The Dacian wars. Decebalus wished to introduce Greco-Roman civilization into his country (which approximates to the modern Romania), and in order to deal with Rome on equal terms, he set about learning the Roman art of war. Deserters taught him the Roman methods of entrenchment and the construction of siege engines. His plans were far-reaching, and he even entered into negotiations with the Parthians, Rome's long-standing enemy in Asia. In 85 AD, his preparations complete, Decebalus inflicted his first blow on Rome by invading Moesia. Two Roman generals fell fighting the Dacians: Oppius Sabinus, the governor of the province, and Cornelius Fuscus, the

A Roman drain running beneath the modern Bodengasse at Cologne, built to carry sewage and floodwater from the city into the Rhine.

praetorian prefect who had been sent out from Rome by the Emperor Domitian. Fuscus had been foolhardy enough to take his army across the Danube into enemy territory without adequate support. The next general, Julianus, was more successful and dealt a serious blow to the Dacians by slaughtering large numbers of them on his way to victory at the battle of Tapae. A peace of sorts was struck: the Dacians agreed to a token submission to Rome, but in return the Romans had to agree to provide Decebalus with workmen and engineers, as well as gifts of money. These last were regarded in some quarters as a shameful tribute, though with little justification. Despite hostilities with other Danubian tribes, peace was preserved with the Dacians for more than a decade, but in the early 2nd century AD the danger that a great rival power might be consolidated on the Danubian frontier encouraged the Emperor Trajan to try to reduce Dacia to a state of vassaldom.

On 25 March 101 AD sacrifices were offered at Rome for the success of Trajan's first expedition against Dacia, and he set out almost immediately for the Danube, which he crossed at the head of an army of 60,000 men. We have a

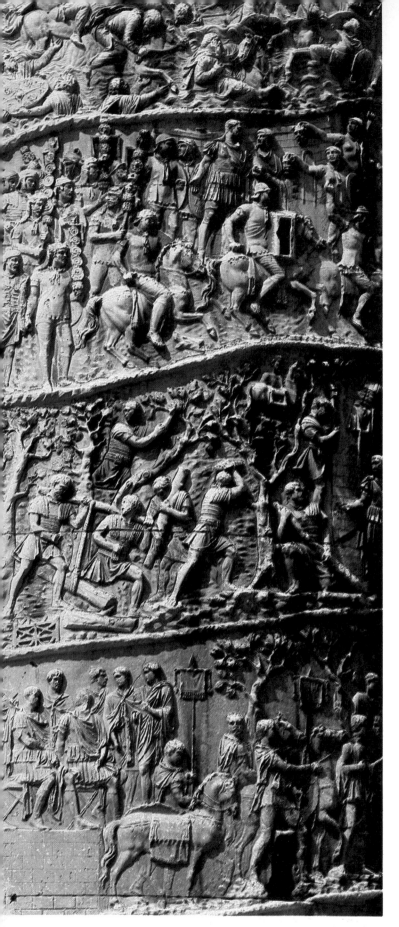

The lower part of Trajan's Column showing the early stages of the first Dacian War (101–02 AD). Ships are loaded, troops harangued and fortresses built.

vivid glimpse of the river crossing at the foot of Trajan's Column in Rome which was set up to commemorate and record the Romans' eventual victory over the Dacians. We see the Roman army leaving Viminiacum across a pontoon bridge made of boats lashed together. Another Roman success at Tapae was the major success of the first season's campaign, and the second season saw the resumption of their march on the Dacian capital Sarmizegethusa, in the face of very strong opposition. The Dacians were reinforced by Sarmatian mounted archers whose mounts, as well as the riders themselves, are shown on Trajan's Column as clad completely in chain mail. Peace talks came to nothing, and it was only when the Romans won a victory at the gates of Sarmizegethusa itself that Decebalus submitted unconditionally. Terms were imposed on him that made him a subject king federated to Rome.

Once the Romans had withdrawn, however, it quickly became apparent that he did not intend to carry out the terms that had been imposed on him, and was once more plotting with his neighbors against Rome. In 104 AD therefore Trajan determined to overthrow Decebalus altogether and to make Dacia a Roman province. In doing this he was going against Augustus' precept that no more provinces should be added to the Empire, but Trajan clearly thought that the Dacian threat warranted this course of action. A sign of his resolve to make a final conquest of Dacia was the building of a permanent bridge (of timber on stone piers) across the Danube at his new crossing point Egeta. The architect was Apollodorus of Damascus, and bricks found in the piers indicate that the work was carried out by soldiers of the Thirteenth Legion. Even more troops were assembled for the second Dacian war than for the first, and slowly but surely they moved across the country, approaching Sarmizegethusa from the east, and eventually laying siege to it, probably in 106 AD. In the final battle the Dacians were hopelessly defeated, but Decebalus escaped. He was cornered and committed suicide, and his head was brought to Trajan and sent to Rome.

Both Dacian wars are represented on the reliefs of Trajan's Column, which help to fill out the meager literary account. But these reliefs are not merely of historical value, for they supply us with a great deal of ethnographical information, and more besides. We learn how the Dacians appeared: long-haired and bearded, wearing trousers and long-sleeved jerkins. We see the Roman army building camps and bridges – and frequently being addressed by the emperor. We are shown the nastier side of war: piles of Dacian heads being presented to Trajan, and Dacian women torturing captive Roman soldiers. A lake-village built on piles is set on fire and women and children appeal for mercy. Such vivid scenes remind Roman archaeologists, whether they be working beneath a Mediterranean sun or in a Northumbrian mist, of the human drama that often lies behind the discoveries that they make.

Further reading

GENERAL

Cornell, T., and **J. Matthews,** *Atlas of the Roman World* (Oxford and New York, 1982).
Cunliffe, B., *Greeks, Romans and Barbarians: Spheres of Interaction* (London, 1988).
Lewis, N., and **M. Reinhold** (eds.), *Roman Civilization Sourcebook i, The Republic; Sourcebook ii, The Empire* (New York 1966).
Millar, F. (ed.), *The Roman Empire and its Neighbours* (London, 1967).
Scullard, H. H., *From the Gracchi to Nero* (3rd ed., London, 1970).
Starr, C. G., *The Roman Empire 27 BC–AD 476: A Study in Survival* (New York and Oxford, 1982).
Stillwell, R., W. L. MacDonald and **M. A. McAllister,** *The Princeton Encyclopedia of Classical Sites* (Princeton, N. J., 1976).
Syme, R., *The Roman Revolution* (Oxford, 1939).
Wells, C., *The Roman Empire* (London, 1984).

HISTORY OF ARCHAEOLOGY

Bradford, J., *Ancient Landscapes* (London, 1957).
Daniel, G., *The Origin and Growth of Archaeology* (Harmondsworth, 1967).
Lanciani, R., *The Ruins and Excavations of Ancient Rome* (London, 1897).
Lehmann, P. W., and **K. Lehmann,** *Samothracian Reflections, aspects of the revival of the antique* (Princeton, N. J., 1973).
Rumpf, A., *Archäologie, i* (Berlin, 1953).
Vickers, M., "The Palazzo Santacroce Sketchbook," *Burlington Magazine*, December 1976.

THE ETRUSCANS

Coarelli, F. (ed.), *Etruscan Cities* (London, 1975).
Cristofani, M., *The Etruscans: A New Investigation* (London, 1979).
Moretti, M., *Nuovi monumenti della pittura etrusca* (Milan, 1966).
Pallottino, M., *The Etruscans* (London, 1975).

ECONOMICS AND SOCIETY

Balsdon, J. P. V. D., *Life and Leisure in Ancient Rome* (New York, 1969).
Connolly, P., *Greece and Rome at War* (London, 1981).
Crook, J. A., *Law and Life of Rome* (London, 1984).
Duncan-Jones, R., *The Economy of the Roman Empire* (Cambridge, 1974).
Garnsey, P., K. Hopkins and **C. R. Whittaker** (eds.), *Trade in the Ancient Economy* (London, 1983).
Grant, M., *The Roman Emperors: A biographical Guide to the Rulers of Imperial Rome* (London, 1985).
Greene, K., *The Archaeology of the Roman Economy* (London, 1986).
Humphrey, J., *Roman Circuses: Arenas for Chariot Racing* (London, 1986).
Keppie, L., *The Making of the Roman Army* (London, 1985).
MacMullen, R., *Roman Social Relations, 50 BC to AD 284* (New Haven, Conn./London, 1974).

Meiggs, R., *Trees and Timber in the Ancient Mediterranean World* (Oxford, 1982).
Rawson, E., *Cicero, a Portrait* (London, 1975).
Rose, A. J., *A Handbook of Latin Literature* (3rd ed., London, 1961).
Rostovtzeff, M., *Social and Economic History of the Roman Empire* (Oxford, 1957).
Sherwin-White, A. N., *The Roman Citizenship* (2nd ed., Oxford, 1973).
Toynbee, A. J., *Hannibal's Legacy* (Oxford, 1965).
Toynbee, J. M. C., *Animals in Roman Life and Art* (London, 1973).
—— *Death and Burial in the Roman World* (London, 1971).
Watson, G. R., *The Roman Soldier* (London, 1969).

REGIONS AND SITES

Brogan, O., *Roman Gaul* (London, 1953).
Coarelli, F., *Roma* (Milan, 1980).
Collingwood, R. G., and **I. A. Richmond,** *The Archaeology of Roman Britain* (2nd ed., London, 1969).
Frere, S., *Britannia* (3rd ed., London, 1987).
Kraus, Th., and **L. von Matt,** *Lebendiges Pompeji* (Cologne, 1973).
Meiggs, R., *Roman Ostia* (2nd ed., Oxford, 1975).
Nash, E., *A Pictorial Dictionary of Ancient Rome* (London, 1961).
Potter, T. W., *Roman Italy* (London, 1987).
Travlos, J., *A Pictorial Dictionary of Ancient Athens* (London, 1971).
von Elbe, J., *Roman Germany: A Guide to Sites and Museums* (Mainz, 1975).
Wilkes, J. J., *Dalmatia* (London, 1969).
Wilson, R. J. A., *A Guide to the Roman Remains in Britain* (London, 1975).

ART AND ARCHITECTURE

Bianchi Bandinelli, R., *Rome the Centre of Power: Roman Art to AD 200* (London, 1970).
—— *Rome, the Late Empire, Roman Art AD 200–400* (London, 1971).
Boëthius, A., and **J. B. Ward-Perkins,** *Etruscan and Roman Architecture* (Harmondsworth, 1970).
Henig, M. (ed), *A Handbook of Roman Art* (Oxford, 1983).
Humphrey, J. H., F. B. Sear, and **M. Vickers,** "The Circus at Lepcis Magna," *Libya Antiqua*, ix–x (1972–74).
Johns, C., and **T. Potter,** *The Thetford Treasure: Roman Jewellery and Silver* (London, 1983).
Kraus, Th., *Das römische Weltreich* (Berlin, 1967).
McKay, A. G., *Houses, Villas and Palaces in the Roman World* (London, 1975).
Plommer, H., *Ancient and Classical Architecture* (London, 1956).
Sear, F., *Roman Architecture* (London, 1982).
Strong, D. E., *Roman Art* (London, 1976).
Sutherland, C. H. V., *Roman Coins* (London, 1974).
Toynbee, J. M. C., *Roman Art* (London, 1965).
Vickers, M., J. Allan and **O. Impey,** *From Silver to Ceramic: The Potter's Debt to Precious Metal in the Greco-Roman, Islamic and Oriental Worlds* (Oxford, 1986).

Acknowledgments

Unless otherwise stated, all the illustrations on a given page are credited to the same source.

R. Agache, Service des Fouilles, Abbeville 131
Architettura e arte decorative, 1923–24; photo J. R. Freeman, London 107
Ashmolean Museum, Oxford, Department of Antiquities 7, 27, top, 55, 101, 118 top right; Department of Western Art 31 bottom, 37 top 47; Heberden Coin Room 103 bottom
Badisches Landesmuseum, Karlsruhe 70 top left
R. Barnard, London 4, 18 top, 60 top, 62 top, 98 top, 98 bottom, 99 left, 104

Bibliotheca Estense, Modena 32 left
Bibliothèque Nationale, Paris 28 bottom
Bodleian Library, Oxford 46 right
British Museum, London, Greek and Roman Department 2, 36 top, 81, 106 bottom left; Department of Coins and Medals, photo R. Gardner 12; Department of Prints and Drawings 52 right; photo J. R. Freeman, London 51
C. Canby, Oxford 23
P. Davis, Oxford 78 top right, 121 top left
G. Dennis, *Tomb of the Tarquins* (1878); photo R. Wilkins, Oxford 73
Deutsches Archäologisches Institut, Rome 27 bottom left
Dorset County Museum 54 bottom
Dutch Institute, Rome 1
Elsevier, Amsterdam 14 right, 106 top, 121 bottom
Firestone Library, Princeton, N. J. 22 bottom, 48 bottom right
Fototeca Unione, Rome 44
J. Paul Getty Museum, Malibu, California 70 bottom
R. Gorringe, London 56, 57 top left, 57 top right, 60 bottom, 86, 88 left, 96 bottom, 100 top, 112 right, 115 top right, 123, 124 top, 134 bottom left
S. Halliday, Weston Turville 9, 16 bottom left, 16 bottom right
R. Harding Associates, London 62 bottom left, 65 top, 127
A. A. M. van der Heyden, Amsterdam 14 left, 15 left, 15 right, 16 top, 22 top, 25, 63 top, 63 bottom, 64, 65 bottom right, 66 top right, 66 bottom, 97, 110, 116 bottom left, 121 top right, 125 bottom right, 128, 136
M. Holford Photographs, Loughton 113 bottom, 114 top, 117, 130 bottom
Institut Français, Beirut 18 bottom
Institute of Archaeology, Oxford 58
Landesbibliothek, Darmstadt 29 bottom
Lovell Johns, Oxford 11, 72 right, 96 top, 120
H. Loxton, London 66 top left
Mansell Collection, London 106 bottom right
D. J. Mattingly, Oxford 6

S. Mitchell, Oxford 125 top
Musée de l'État, Luxemburg 48 top, 48 bottom left
Musées Nationaux, Paris 35 top, 40 top right, 41 top left, 42 top center
Musei Capitolini, Rome; photo O. Savio 103 top
National Gallery, London 31 top
Photographie Giraudon, Paris 39 top
Picturepoint Ltd, London 74 and 75 bottom, 77 top, 77 bottom, 83 right, 112 top left, 116 top left, 125 bottom left
Preussischer Kulturbesitz, Berlin 100 bottom
M. Pucciarelli, Rome 13, 20 right, 57 bottom, 61, 71, 72 left, 76 left, 78 top left, 82, 83 left, 89 bottom right, 90 top left, 90 bottom, 91, 93 top right, 94 bottom right, 99 right, 108, 111, 112 bottom left
M. Pucciarelli, Rome, Time Inc., from Time-Life *Emergence of Man* 90 top right, 92 top, 92 bottom, 93 bottom, 94 top, 94 bottom left
Rheinisches Bildarchiv, Munich 135
Rijksmuseum, Leiden 54 top
Römisch-Germanisch Museum, Cologne 27 bottom right
The Royal Collection, Crown Copyright, Hampton Court Palace, London 33, 38, 40 bottom, 41 bottom, 42 bottom
Scala, Florence 20 left, 29 top, 32 right, 43, 78 bottom, 85, 95, 119
F. B. Sear, Adelaide 113 top, 115 top center, 115 bottom, 130 top
R. Sheridan's Photo Library, London 42 top right
Spanish Tourist Office, London 118 bottom
G. Speake, Oxford 17
Spectrum Colour Library, London 124 bottom
J. Spon, *Miscellaneae Eruditae* (1685); photo R. Wilkins, Oxford 34 and details on 39–42
Staatliche Antikensammlungen und Glyptothek, Munich; photo G. H. Krüger-Moessner 79
Staatliche Graphische Sammlung, Munich 70 top right
Staatliche Münzsammlung, Munich; photo C. Zocher 21
A. Starkey, London 19, 118 top left, 130 bottom, 133
W. Stukeley, *Itinerarium Curiosum* (1724); photo R. Wilkins 49
M. Vickers, Oxford 24, 35 bottom, 36 bottom, 50 bottom, 109, 114 bottom, 126
Vindolanda Trust, Northumberland 134 bottom right
L. von Matt, Buochs 59, 62 bottom right, 65 bottom left, 67, 68 top, 68 bottom, 69, 75 top, 84 left, 84 right, 87, 88 and 89
R. Wilkins, Oxford 28 top, 50 top
R. Woods, *Ruins of Baalbec* (1757); photo R. Wilkins, Oxford frontispiece, 52 left

The Publishers have attempted to observe the legal requirements with respect to the rights of the suppliers of photographic materials. Nevertheless, persons who have claims are invited to apply to the Publishers.

Glossary

Aedicula Small niche surrounded by columns and an **architrave**.

Aedile Roman magistrate charged with a variety of functions including the maintenance of public works, the inspection of buildings, the prosecution of non-political offenses and the provision of an adequate corn supply. Until 22 BC aediles also controlled public games, on which they often spent much of their private wealth.

Aeneas In legend, the son of Anchises and Aphrodite. According to Homer, the chief Trojan warrior after Hector. The hero of **Virgil**'s epic poem the *Aeneid*, in which he wandered around the Mediterranean for seven years after the fall of Troy before founding a kingdom in Latium.

Aequi Warlike people of central Italy occupying the upper valley of the Anio. They were in a perpetual state of hostility to Rome until they were finally subdued in 304 BC.

Agora Central zone of a Greek city, the daily scene of social life, business and politics.

Agricola Gnaeus Julius Agricola (37–93 AD) Born at Fréjus in S Gaul, he served in Britain, Asia and Aquitania before being appointed governor of Britain in 78, a post he held for seven years. Father-in-law to **Tacitus** who wrote a sympathetic biography.

Agrippa M. Vipsanius Agrippa (63–12 BC) Grew up with **Octavian** and became his most trusted minister and son-in-law. He commanded the fleet at Actium in 31 BC, was consul in 37, 28 and 27, and did much to improve Rome by means of public works.

Alaric (d. 410 AD) Ruler of the Visigoths. He besieged Rome three times in the years 408–10.

Alberti, Leon Battista (c. 1404–72) He embodied the Renaissance ideal of the "universal man" having an encyclopedic knowledge of the most varied disciplines. He painted, sculpted, wrote poetry, but is now chiefly remembered as an architect and engineer.

Alexander Romance Myths attached to the name of **Alexander the Great** which are to be found in the languages of nearly all the peoples from the Indian Ocean to the Atlantic, derived ultimately from a book by one "Callisthenes" written in Egypt in the 2nd century AD.

Alexander the Great (356–323 BC) Son of Philip II of Macedon; pupil of **Aristotle**. He succeeded to the Macedonian throne in 336 and immediately began planning an invasion of Asia. In 334–332 he conquered Asia Minor, Syria, Palestine and Egypt; in 331–328 Persia and Bactria. In 328 he married Roxane of Sogdiana; and in 327–325 he conquered the Punjab. The greatest general of antiquity, Alexander died at the age of 33.

Allen, George W. G. Professional engineer who pioneered techniques of aerial photography in England in the 1930s.

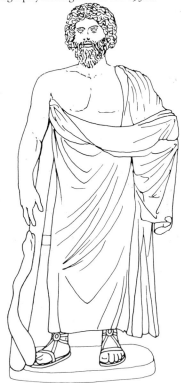

Asclepius

Amphora Two-handled jar used for storing liquids such as wine or oil.

Antenor Trojan who according to legend opened the gates of Troy to the Greeks. The legendary founder of Padua.

Antiochus III of Syria (c. 242–187 BC) Expansionist ruler who failed to take note of the Romans' rising star and was defeated by them at Thermopylae (191 BC) and Magnesia ad Sipylum (190/189 BC) as well as in a naval campaign.

Antonines Roman emperors from Antoninus Pius (138–61 AD) to Commodus (180–92).

Antoninus Pius

Antoninus Pius (86–161 AD) Roman emperor from 138 in succession to **Hadrian**. His long and peaceful reign was marked by energetic reforms and a beneficial domestic policy.

Antony Marcus Antonius (c. 83–30 BC) **Caesar**'s right-hand man who commanded part of his army at Pharsalus in 48. He was consul in 44 and attempted to succeed Caesar after his assassination, but was thwarted by Octavian (**Augustus**). A member of the second triumvirate with Octavian and Lepidus. Went east after the battle of Philippi in 42, where he fell in love with **Cleopatra**. Under the latter's influence he began to assume the pomp of an Oriental despot, but both were brought down by Octavian in 31 at the battle of Actium. Died by his own hand in 30 BC.

Apollo God of light and healing, and of youth and music.

Archaic Period of Greek art which lasted from c. 700 BC to c. 480 BC.

Architrave One or two beams of stone or wood laid between one capital and the next.

Aristotle (384–322 BC) Philosopher; tutor to **Alexander the Great**. He founded the Peripatetic school of philosophy at Athens in 335 BC.

Basilica

Arretine ware Fine mold-made pottery, normally red in color, and decorated in relief, made in the Arezzo area between about 100 BC and 100 AD.

Asclepius God of medicine whose cult was honored in various centers in the Greco-Roman world: e.g. Epidaurus, Pergamum, Balagrae.

Ashmole, Elias (1617–92) English antiquarian, astrologer, historian and exciseman. His "cabinet of curiosities" was presented to Oxford University in 1683 and formed the nucleus of the Ashmolean Museum.

Athena Goddess of enlightenment, reason and thought, and hence of art and science. The patron goddess of Athens.

Atticus Q. Caecilius Pomponianus Atticus (109–32 BC) Confidant of **Cicero** who owed his surname to his long residence in Athens and his acquaintance with Greek literature. Cicero's letters to him written between 68 and 43 BC are still preserved.

Augustus Gaius Julius Caesar Octavianus Augustus (63 BC–14 AD) **Caesar's** heir, and the first Roman emperor. He gained command of the army after Caesar's assassination in 44 BC, returned to Rome and became consul. He formed the second triumvirate, the Roman world being divided between **Antony**, Lepidus and himself. With Antony, he defeated Brutus and Cassius at Philippi in 42 BC. When war broke out in 31 BC with Antony and Cleopatra he won a brilliant victory over them at Actium. He based his rule at Rome on constitutional powers, notably those of the popular tribunes, backed up by his command of the army.

Aventinus (1477–1534) Name taken by Johann Turmair, author of the *Annals of Bavaria*, from Aventinum, the Latin form of his birthplace Abensburg. He was called the "Bavarian Herodotus."

Basilica Originally a large hall used for public business at Rome, but later applied to a characteristic form of early Christian church.

Bellona Roman goddess of war, wife of Mars.

Benjamin of Tudela (*fl.* 12th century AD) Jewish rabbi from Spain who spent 13 years traveling in Italy, Greece and the east as far as the borders of China. He wrote an account of his journey in his *Itinerary*.

Biondo, Flavio (1392–1463) Papal secretary whose works, which dealt with the history and antiquities of Italy from the Roman period to his own day, were extremely influential in awakening local patriotism and interest in antiquity.

Boniface IV Pope from 608 to 615 AD.

Bronze Age Period preceding the **Iron Age** when bronze (an alloy of tin and copper) was the principal material for weapons and tools. It began in Italy c. 1650/1500 BC.

Bucchero Characteristic kind of Etruscan pottery, black or gray in color. The name is derived from the Spanish *bucaro*, which was applied to Central American pottery, imitations of which were being sold in Italy at the time that Etruscan sites were first excavated.

Caesar Gaius Julius Caesar (100–44 BC) He distinguished himself at the siege of Mytilene at the age of 20, and on his return to Rome in 77 BC won fame as an orator. He favored the *populares* in domestic Roman politics. As consul in 60 BC, he formed the first triumvirate (a political alliance) with **Pompey** and Crassus, a move which enabled him to carry all his measures as consul. He campaigned in Gaul 58–50 BC. He refused the Senate's order to disband the army, crossed the Rubicon and marched on Rome in 49 opposed by Pompey, whose forces were defeated in the ensuing civil war. As master of the Roman world he introduced some wise reforms including that of the calendar. He was assassinated in the Senate by upholders of the constitution on the Ides of March 44 BC.

Caldarium Hot room in a Roman bath house.

Cameo

Cameo Stone with two or more layers of color such as onyx or sardonyx decorated in relief.

Capital Crowning member of a column.

Caracalla (188–217 AD) Son of **Septimius Severus**. His real name was M. Aurelius Antonius, "Caracalla" being a nickname derived from a kind of Gaulish coat he favored. All free inhabitants of the Empire were granted Roman citizenship during his otherwise bloody reign.

Carpaccio, Vittore (1460/65 – before 1526) Venetian painter. His most important works were four sets of fresco cycles in Venice.

Caryatid Figure in the form of a woman used in place of a column on a temple or as a support for a mirror.

Casaubon, Meric (1599–1671) Classical scholar, born in Geneva, the son of Isaac Casaubon, and educated in England. He was a Student of Christ Church, Oxford, for 13 years before holding livings in Kent. As a Royalist, he resisted Cromwell's blandishments to write a history of the English Civil War, restricting his literary output to works mostly of a philosophical nature.

Cassiodorus Flavius Magnus Aurelius Cassiodorus (c. 490–583 AD) Roman politician and writer. As Theodoric's chief minister he did much to conserve Roman culture – both literary and monumental – at a time when it was threatened by the barbarian invasion.

Catullus Valerius Catullus (87 – c. 54 BC) Latin poet, born at Verona. Two poems lament the early death of his only brother and others deal with his passion for a society lady whom he calls Lesbia. He was not a politician, but was favorably disposed towards **Caesar** and his party.

Cella Inner sanctum of a Greek or Roman temple.

Celts Name applied by the ancients to a people occupying lands to the north of the Mediterranean, united by a common speech and a common artistic tradition.

Censor Chief registrar and leading financial officer at Rome. He kept the lists which recorded the property and status of citizens, and was ultimately responsible for the collection of revenue. By virtue of their powers censors came to have a moral authority over the whole state.

Centaur Mythical creature, half man and half horse.

Charles IV (1316–78) King of Bohemia (1346–78) and Holy Roman Emperor (1355–78).

Cicero Marcus Tullius Cicero (106–43 BC) Roman politician and philosopher who, through his oratorical and legal skills, rose to high office. As consul, he suppressed the revolutionary conspiracy of Catiline and was forced into exile as a result. He emerged from political eclipse after the death of **Caesar** but his outspoken attacks on **Antony** led to his assassination. He wrote speeches, letters (notably to his friend **Atticus**) and philosophical works.

Cipollino Green and white striated marble from Karystos in Euboea.

Cithara Greek and Roman stringed instrument.

Classical (a) Period of Greek art which lasted from c. 480 BC to the end of the 4th century BC. (b) Expression used to describe the civilizations of Greece and Rome as a whole.

Claudius

Claudius Tiberius Claudius Nero Germanicus (10 BC–54 AD) After 50 years mostly devoted to literary pursuits, he was raised by the army to the imperial throne in 41 AD. He was greatly influenced by his wives (who included the notorious Messalina and Agrippina, the mother of **Nero**) and freedmen. In need of military victory, he invaded Britain in 43 AD.

Cleopatra (68–30 BC) Daughter of Ptolemy Auletes, she was secured on her throne by **Caesar** to whom she bore a son, Caesarion. She captured the heart of **Antony** in 41 and accompanied him in his campaign against Octavian. She was present at Actium where

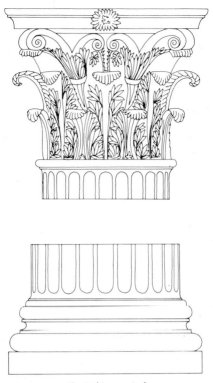

Corinthian capital

the retreat of her ships helped to lose the day. She died from a self-inflicted asp bite.

Client Man who in return for protection would help a powerful patron in both political and private life.

Cloaca Maxima Great drain at Rome which still carries water from the Forum valley to the Tiber.

Coffer Recesses in a ceiling which (a) led to a saving in materials and (b) provided an interesting play of light and shade.

Colt Hoare, Richard (1758–1838) English antiquary. He became interested in Etruscan antiquities when in Italy on the Grand Tour, and on his return to Britain devoted his attention to the antiquities of Wiltshire, from the Bronze Age to the Roman period. He established techniques of archaeological excavation.

Constantine the Great Flavius Valerius Constantinus (272–337 AD) Junior emperor in the west from 306, before defeating Maxentius at the battle of the Milvian bridge in 312. He is said to have owed his victory to a vision of a Christian symbol. After defeating Licinius in the east, he moved the capital from Rome to Byzantium, renaming the latter Constantinopolis (city of Constantine).

Consul One of two annually elected officials: the highest magistracies in the Roman Republic.

Corinthian Order Greek architectural order characterized by a capital decorated with acanthus leaves. The most frequently used architectural order in the Roman period.

Cornice Overhanging eaves of a Roman building.

Coroplast Worker in terracotta.

Crater

Crater Large vessel used by the Greeks for mixing wine with water, a common practice in the ancient world.

Cuirass Bronze breastplate.

Cunnington, William (1754–1810) English excavator and field archaeologist who worked mainly on the antiquities of Salisbury Plain.

Curia Senate house at Rome, situated on the north side of the Forum Romanum.

Cyriac of Ancona (c. 1390–1452) Self-taught merchant scholar who traveled widely and often in the Levant, recording many Classical monuments and inscriptions, some of which have subsequently disappeared.

Daedalic art Style which developed in Greece in the 7th century BC under the influence of Syro-Phoenician art.

Demeter Goddess of corn and plenty.

Dempster, Thomas (fl. 1620) Scottish scholar who lived in Italy. He wrote his *De Etruria regali* between 1616 and 1625, which was not, however, published until 1723–24.

Denarius Principal silver coin of the Romans, first minted c. 211 BC. The issuing magistrates would often place on their coins types referring to their family history or their own exploits.

Dentils Tooth-like decorative features frequently used instead of a frieze on an ancient building.

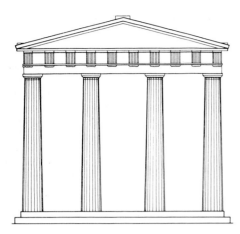

Doric facade

Diana Moon goddess, and goddess of hunting (= Greek Artemis).

Diocletian Valerius Diocletianus (245–313 AD) Roman emperor 284–305. He reorganized the administration of the Empire and retired in 305 to Split on the Adriatic coast where he built a palace.

Dioscuri Castor and Pollux, the "sons of Zeus," the one famous for his horsemanship, the other as a boxer. In Roman legend they are supposed to have provided assistance at the battle of Lake Regillus in 496 BC.

Dirce Mythical daughter of Helios and wife of Lycus. She was punished for her treatment of Antiope by being bound to the horns of a bull.

Domitian

Domitian Titus Flavius Domitianus Augustus (51–96 AD) Younger son of **Vespasian**; succeeded his brother Titus to the throne in 81 AD. He governed well at first, but later became cruel and tyrannical. In 83 he secured the Rhine provinces by an expedition in Germany against the Chatti, but fought an inconclusive campaign in Dacia in the late 80s. He was finally murdered with the connivance of his wife Domitilla.

Doric order Greek architectural order characterized by its relative simplicity, occasionally used in the Roman period.

Dromos Pathway leading up to the entrance of an Etruscan tomb.

Entablature That part of an ancient temple between the capitals and the cornice.

Epicureans School of Greek philosophers called after its founder Epicurus (341–270 BC). He held that pleasure (meaning the tranquil enjoyment of life) was the sole good, pain the sole evil.

Equites Literally "knights," and originally members of the cavalry service of the army, but later an effective political force at Rome, entry to whose ranks was limited by a property qualification.

Faience In an Egyptian context, a mixture of sand and clay fired to a temperature at which the surface fuses to a blue or green glaze.

Feliciano, Felice (1433–after 1479) Born in Verona, he became a professional scribe and was a poet and man of letters in his own right. His scriptorium was the most important center for the dissemination of antiquarian material collected by **Cyriac of Ancona**.

Fibula Ancient equivalent of a safety pin.

Fibula

Flavians Family to which the Emperor **Vespasian** belonged; the dynasty ended with the death of **Domitian** in 96 AD.

Flora Italian goddess of vegetation and fertility.

Fontana, Carlo (1634/8–1714) Roman Baroque architect, engineer and publisher.

Forum Boarium Site of a cattle market at Rome in the area between the Aventine and the Capitol, on the banks of the Tiber.

Forum Romanum Geographical, social and political center of the city of Rome.

Frieze Band of relief decoration on a Roman building.

Frigidarium Large unheated room near the entrance of a Roman bath house.

Galen Claudius Galen (c. 130–c. 200 AD) Born at Pergamum. The most important ancient writer on medicine. Consulting physician to the Emperor **Marcus Aurelius**.

Ghiberti, Lorenzo (c. 1378–1455) Important early Renaissance sculptor at Florence. His works include the bronze doors for the baptistery of the cathedral at Florence and treatises on art history and theory.

Glyptic art Art of gem engraving.

Goths Germanic people originating in Scandinavia who migrated to the frontiers of the Roman Empire which they periodically raided. The Ostrogoths lived in the Balkans before moving to Italy under **Theodoric** in 489; the Visigoths under **Alaric** devastated Greece and much of Italy in the early 5th century AD and eventually retreated to Spain.

Hadrian

Hadrian Publius Aelius Hadrianus (76–138 AD) He succeeded **Trajan** in 117 AD and spent the greater part of his peaceful and prosperous reign traveling in the provinces. He built the Pantheon and a luxurious villa near Tivoli.

Hannibal (247/6–183 BC) Carthaginian general who precipitated the Second Punic War in 220/19. He invaded Italy, crossing the Alps with many losses in 218, and won several victories in pitched battles (Trebia, 218; Lake Trasimene, 217; Cannae, 216), but failed to dislodge the north Italian cities from loyalty to Rome. He remained unconquered in S Italy and withdrew to defend Carthage in 203 BC, finally being defeated at Zama in 202. He fled east in the 190s and fought for **Antiochus of Syria**. He committed suicide in 183 or 182 BC.

Heemskerck, Maarten van (1498–1574). Dutch artist. He lived in Rome from 1532 to 1538, where he made numerous drawings of Roman antiquities visible in his day which, now that many monuments have been moved or lost, are of the greatest documentary value.

Hellenistic Conventionally, an adjective describing the period between the death of Alexander the Great (323 BC) and the battle of Actium (31 BC).

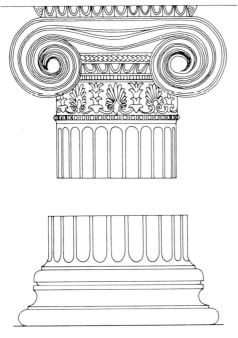

Ionic capital

Heraclius (575–641 A D) Emperor at Constantinople from 610. He defeated the Persians (622–27) but failed to hold back the Arabs (636). He instituted administrative and military reforms which were the basis of the medieval Byzantine state.

Hercules Italian deity identified with the Greek Heracles. Both represented deities who gave strength and fought against the powers of evil, characteristics epitomized in the famous 12 labors.

Herm Terminal figure consisting of a head (usually of Hermes) on a pillar.

Hermaphrodite Person possessing both male and female physical attributes.

Herod the Great King of the Jews, from 40 to 4 BC. The friend of Augustus and Agrippa, but a cruel and tyrannical ruler.

Hildebert of Tours (1055–1133) French writer and ecclesiastic. His *Letters* enjoyed great popularity in 12th- and 13th-century France and Italy, and were frequently used as classics in schools.

Honorius Flavius Honorius (384–423 A D) Emperor in the west 393–423 A D. A weak emperor who withdrew Roman forces from Britain in 410.

Horace Quintus Horatius Flaccus (65–8 BC) Son of an ex-slave, he was introduced by **Virgil** into the court circle and composed poetry on a variety of themes: the *Satires* and *Epodes*, *Odes*, *Epistles* and the *Secular Hymn* in praise of the Augustan regime.

Hydria Water jar.

Insula "Block" in a Roman city.

Intaglio Gemstone cut in relief and used as a seal.

Ionic order Greek architectural order characterized by a spreading capital ending in a pair of volutes, not infrequently used in the Roman period, especially in the eastern Mediterranean.

Iron Age Period when the use of iron overtook that of bronze for the manufacture of everyday tools. It began in Italy in about the 9th century BC.

Jupiter Top god in the Roman pantheon (= Greek Zeus).

Justinian Flavius Petrus Justinianus (483–565 A D) Born near Niš in modern Yugoslavia, but raised in court circles at Constantinople; sole emperor from 527. He was responsible for the construction of many outstanding buildings, notably St Sophia, and codified Roman law in his *Codex Justinianus* (534), which included the *Digest* (533), the *Institutes* (533) and the later *Novels* (565).

Juvenal Decimus Junius Juvenalis (c. 60–140 A D) Roman poet. His 16 *Satires* provide a cynical picture of the degeneracy of the Roman upper classes of his day, but also provide realistic details of everyday life.

Laconicum Room in a Roman bath house which was heated to an extremely high temperature so that the bathers would perspire.

Laetus, Pomponius (1425–98) Italian humanist who founded an academy at Rome whose members adopted Greek and Roman names.

Lares Tutelary deities of a particular spot.

Limes Military frontier of the Roman Empire, marking it off from barbarian tribes.

Livy Titus Livius (59 BC–17 A D) Historian who wrote a history of Rome in 142 books. His narrative skill has been compared to that of Sir Walter Scott.

Lucretius Titus Lucretius Carus (94–55 BC) Latin poet, author the poem *On the Nature of Things*, the object of which was to convince the reader of the doctrines of Epicureanism. See also **Epicureans**.

Maecenas Caius Cilnius Maecenas. Roman knight from Arezzo, for many years the chief friend and confidant of **Augustus**. A patron of the arts. Died in 8 BC.

Majorian Julius Majorianus, emperor in the west 457–61 AD.

Mantegna, Andrea (c. 1431–1506) Italian painter. He spent his formative years in Padua, apprenticed to Francesco Squarcione. He became painter at the Gonzaga court at Mantua in 1460 where he remained almost continuously until his death.

Marcus Aurelius (121–80 A D) Adopted by **Antoninus Pius** in 138, becoming emperor in 161. He campaigned against the Marcomanni and Quadi and other tribes in the Danube area. He wrote the *Meditations*, a work imbued with **Stoic** philosophy.

Marcus Aurelius

Marius Gaius Marius (157–87 BC) Coming from an obscure background, he was a "new man" in Roman public life. He won distinction in military service in Spain and then rapidly became a leader of the popular party at Rome. He reorganized the army on a voluntary basis. He was elected consul on several occasions; he saved Italy from a German invasion in 104–101 BC, but in 87 was responsible for a wholesale massacre of members of the aristocratic party.

Martial Marcus Valerius Martialis (38/41 – c. 100 A D) Born in Spain, he lived in Rome as a man of letters and wrote 15 books of verse *Epigrams*.

Maximian Marcus Aurelius Valerius Maximianus (c. 240–310 A D) Roman emperor 286–305 AD. He was **Diocletian**'s colleague, but retired with him in 305. He was forced by **Constantine** to take his own life in 310.

Meleager Son of Oeneus, king of Calydon. One of the Argonauts, and later leader of the heroes who slew the monstrous boar which had devastated the country around Calydon.

Metope Square slab, often decorated with relief sculpture, in the frieze of a Doric temple.

Mycenaean Term applied to the late Bronze Age in Greece: c. 1500–1100 BC.

Naïskos Literally "a little temple," used to describe the appearance of 5th- or 4th-century BC Greek tombstones which regularly had a **pediment** supported on columns.

Natatio Swimming pool in a Roman bath house.

Necropolis Cemetery situated outside the walls of an ancient city.

Neolithic Term used to describe an agricultural way of life involving permanent settlement in one spot at a time before the use of metal became widespread.

Nero

Nero Nero Claudius Caesar Drusus Germanicus (37–68 AD) His reign (begun in 54) was remarkable for licentiousness and cruelty. He murdered his step-brother Britannicus, his mother Agrippina and his wife Octavia. He put the blame for the great fire at Rome of 64 on the Christians, many of whom he put to death by burning. He built an enormous palace (his "Golden House") on the Esquiline. Died by his own hand.

Numa Pompilius According to legend, the second king of Rome, renowned for his wisdom and piety.

Obelisk Pointed four-sided pillar of granite or porphyry. Many were exported from Egypt and set up in Rome. The name (= "little meat-spits") was invented by Greek soldiers serving in Egypt in the 6th century BC.

Octavian See **Augustus**.

Oculus Hole in the center of a dome to admit light.

Oinochoe Jug for pouring wine.

Omphalos Stone at Delphi considered by the ancients to be the navel of the universe.

Ossuary Vessel containing unburned human bones.

Ovid Publius Ovidius Naso (43 BC–18 AD) Writer of erotic and mythological poetry. He was exiled by Augustus for moral reasons to Tomi on the Black Sea, whence he wrote poems contrasting his miserable lot with the cosmopolitan atmosphere of Rome.

Palladio, Andrea (1508–80) Italian architect who worked mainly in Vicenza and Venice. He adopted the forms of Roman architecture, but reinterpreted them in a Mannerist fashion. His treatise, *Four Books on Architecture* (1570), was very influential.

Pallas Poetical name for **Athena**.

Patera Dish used for pouring libations (offerings) to the gods.

Parthia Region of Asia to the southeast of the Caspian Sea occupied by a warlike people famous as mounted archers. They inflicted huge losses on the Romans at Carrhae in 53 BC, were temporarily subjected to Rome under **Trajan**, and became part of the Sasanian empire in 226 AD.

Patricians Most privileged class of the Roman citizenry, which in the early Republic monopolized the most important magistracies and religious offices, but whose influence was gradually diminished with the admission to high office of **plebeians**.

Pediment Triangular gable end of a Greek, Etruscan or Roman temple.

Petrarch Francesco Petrarca (1304–74) Humanist poet and scholar who traveled widely in search of Classical manuscripts, and who was one of the most influential figures of the age leading up to the Italian Renaissance.

Peutinger, Conrad (1465–1547). German humanist and antiquarian. He was educated in Italy, and by 1497 was town clerk of his native Augsburg. He was one of the first to publish Roman inscriptions.

Philip V of Macedon (238–179 BC) King of Macedon who led resistance to the Romans in Greece in 214–205, 200–197 and 185–179 BC.

Phocas East Roman emperor 602–10 AD Deposed by **Heraclius**.

Pisano, Nicola (c. 1220–78/84) Sculptor at Pisa. He helped to create a new sculptural style for the late 13th and 14th centuries in Italy.

Pitt Rivers, General Augustus (1827–1900) English soldier and archaeologist. He applied the evolutionary theory to artifacts and assembled an ethnographic collection (which can still be seen in Oxford as originally laid out), arranged according to the use to which articles were put. In 1880 he inherited a large part of Cranbourne Chase in Wiltshire and conducted excavations with a thoroughness and attention to detail which were uncharacteristic of his day.

Plebeians General body of Roman citizens who were at first excluded from high offices but achieved political equality with the **patricians** as a result of the "Conflict of the Orders" during the 5th to 3rd centuries BC.

Polybius (c. 200–c. 117 BC) Greek historian from Megalopolis, Greece. He wrote his *Histories*, dealing with the years 220–146 BC, a political exile in Rome.

Pompey Gnaeus Pompeius Magnus (106–48 BC) Roman general. Military successes in the east gave him an influential position in Roman politics in the mid-1st century BC. He led the Republican army against **Caesar** losing at Pharsalus in 48. He fled to Egypt where he was killed.

Porphyry Dark red volcanic rock quarried in Egypt much used by the Romans for ornamental purposes.

Priapus Ithyphallic deity of fertility whose image was often set up in gardens to protect them.

Propertius Sextus Propertius (c. 50–15 BC) Latin elegiac poet, attached to the literary circle of **Maecenas**.

Proton magnetometer Instrument for determining the intensity of the earth's magnetic field with a view to indicating the presence of subterranean features.

Province Under the late Republic, an area outside Italy considered to belong to the Roman people, governed directly by a Roman magistrate, with fixed geographical limits and subject to Roman taxation. Under the Empire there were two kinds of provinces: senatorial, governed by ex-magistrates under the supervision of the Senate; and imperial, directly under the emperor's control.

Ptolemies Macedonian dynasty which ruled in Egypt from after the death of Alexander the Great in 323 BC to the death of Cleopatra in 30 BC.

Punic Carthaginian

Pyrrhus (318–272 BC) King of Epirus who brought a large army to Italy in 280 BC, and despite a series of victories in battle failed to win the war; hence the term "Pyrrhic victory."

Quern Stone for grinding corn.

Quinarius Half a **denarius**.

Reliquary Container, usually fashioned in precious metal, for the display of a relic of a saint.

Resistivity survey Method of surveying an archaeological site without actually digging. The underlying principle employed is that of different materials offering different kinds of resistance to the passage of electric current through the earth.

Reuvens, Caspar Jacob Christiaan (1793–1835) Dutch scholar. From 1818 he was Professor of "Egyptology, numismatics, architectural history, Classical and non-Classical archaeology" at the University of Leiden. He created very high standards of excavation and recording.

Revetment Thin marble slabs with which the Romans decorated the walls of public buildings and the more luxurious private houses.

Revett, Nicholas (1720–1804) Architect and draughtsman who studied in Rome from 1742, where he met **James Stuart** whom he accompanied on a journey to Greece to gather material for their *Antiquities of Athens* (1762).

Riegl, Alois (1858–1905) Austrian art historian, belonging to the "Vienna School." In his *Spätrömische Kunstindustrie* (1901) he rejected **Winckelmann**'s assertion that Classical Greek art represented artistic perfection and that all other art should be judged in comparison with it.

Rienzo, Cola di (1313–54) Popular leader at Rome who, inspired by his reading of the classics, tried to restore the city's former greatness.

Romulus and Remus Legendary founder of Rome and his twin brother, sons of Rhea Silvia by the god Mars. Ordered to be drowned in the Tiber, they were stranded and saved by a she-wolf. When they grew up, they killed their wicked great uncle Amulius and replaced their grandfather Numitor on the throne of Alba Longa. They then resolved to found a new city by the Tiber, but could not agree as to its position, Romulus favoring the Palatine, and Remus the Aventine. Even when the question was settled by means of augury, the brothers could not agree, and Romulus slew Remus in his anger. The new city was populated in an interesting manner: the Capitoline was declared a sanctuary for homicides and runaway slaves, and Sabine women were taken by force during an athletic meeting as wives for them.

Samian ware Misnomer, now hallowed by frequent usage, for Gaulish tableware (*terra sigillata*), usually red in color and often decorated in relief.

Samnites People of central southern Italy whose efforts to conquer Latium and Campania brought them into conflict with

Rome in the 4th century BC. They submitted to Rome in 290, but made a final attempt for freedom in the 80s BC and were defeated by Sulla in 82.

Sphendone

Sarcophagus Marble casket, often decorated in relief.

Senate Consultative body which by the late Republic consisted of ex-magistrates whose advice to the serving magistrates was *de facto* binding. The Senate was largely responsible for directing the Roman state during the last centuries of the Republic, but its failure to control military leaders led to its eclipse.

Seneca Lucius Annaeus Seneca (c. 4 BC–65 AD) Born in Cordoba, Spain. Tutor and adviser to **Nero**. Stoic philosopher and tragedian. He committed suicide on being implicated in an anti-Neronian plot.

Septimius Severus

Septimius Severus (146–211 AD) Born near Lepcis Magna in Africa. Commander-in-chief of Roman forces in Illyria when, in 193, he was proclaimed emperor. He had to defeat two other claimants before he was securely in power. He spent three years successfully campaigning in Parthia, and from 208 was in Britain, where he died.

Servius Tullius Legendary sixth king of Rome, supposed to have been responsible for three important measures: a new constitution for the Roman state, an extension of the city boundaries and the erection of a city wall.

Sestertius Quarter of a **denarius**, silver under the Republic, but brass under the Empire.

Shekel Chief silver coin of Judea.

Sphendone Word used to describe the curved end of the Hippodrome (circus) at Constantinople.

Spinario Statue of a boy pulling a thorn from his foot. One of the few large bronze statues to survive in medieval Rome.

Stoa Covered portico.

Stoics School of Greek philosophers founded at the end of the 4th century BC by Zeno, who taught in the Painted Stoa at Athens, hence their name.

Strabo (c. 64 BC–21 AD) Greek historian and geographer. Only his *Geography* is extant.

Stuart, James (1713–88) Painter and architect of Scottish extraction. He was in Rome in 1741 and traveled in Greece between 1751 and 1755 with **Nicholas Revett** collecting material for their *Antiquities of Athens*, published in 1762. This publication made Stuart famous and he was henceforth known as "Athenian" Stuart.

Stukeley, William (1687–1765) Distinguished English antiquarian and field archaeologist, influential in the foundation of the London Society of Antiquaries. Wrote *Itinerarium Curiosum* (1724 and 1776). He was overinclined to see the hand of the Druids at work.

Stylite Type of Christian hermit who escaped from the world by perching on a column.

Sulla Lucius Cornelius Sulla (c. 138–78 BC) Roman politician. He was the first to use large-scale violence at Rome for political ends. As dictator in 81 he enacted a short-lived legislative program, the seeds of whose failure he had sown himself.

Sylloge Collection, or corpus, of inscriptions.

Tacitus Publius Cornelius Tacitus (55–120 AD) Roman historian. Among his earliest works were the *Agricola*, a biography of his father-in-law, and the *Germania*, an ethnographic survey of the Germanic tribes at the end of the 1st century AD. His most important works are the *Annals*, dealing with the history of the years 14–68 AD, and the *Histories*, covering 69–96 AD.

Tepidarium Warm room in a Roman bath house.

Tessera Small cube of stone used in making mosaics.

Theodoric Ostrogothic king of Italy 493–526 AD, nominally subject to the eastern Roman emperors.

Theodosius II (401–450 A D) Emperor who came to the throne in 408 and was always a weak ruler, being much influenced by his sister Pulcheria, his wife Eudoxia and various officials of the court.

Terracotta Baked clay, used for statuettes, decorative plaques and large-scale sculpture.

Tiberius

Tiberius Tiberius Claudius Nero Caesar (42 B C–37 A D) Consul in 13 B C and commander against the Pannonians and Dalmatians in 11 B C. In the same year he was forced to marry **Augustus'** unpleasant daughter Julia. Adopted as Augustus' heir in 4 A D, he was mostly away on campaigns until his accession in 14 A D. He confided overmuch in the praetorian prefect Sejanus whom he eventually put to death. From 26 A D he lived in seclusion in Capri and was smothered in 37.

Toga Flowing, woolen garment worn by Roman citizens.

Toga

Trajan Marcus Ulpius Traianus (52–117 AD) Born at Italica in Spain, he served in the army

Trajan

in the east and in Germany. In 97 he was adopted by Nerva and succeeded him in the following year with the title of Imperator Caesar Nerva Traianus Augustus. He fought and defeated Decebalus of Dacia in two campaigns (101–03 and 104–06) and invaded Parthia in 114 and reached the Arabian Gulf. He died in Cilicia on his way back to Italy.

Transhumance Practice of grazing animals in widely separated pastures at different times of the year.

Tribune of the People Officer who defended the rights of the **plebeians**, who had the right of veto and whose inviolability from prosecution was guaranteed.

Triglyph Feature which alternates with the **metopes** in the frieze of a Doric temple.

Urban VIII (1568–1644). Born Maffeo Barberini; elected pope in 1623.

Vandals Germanic people originating in Scandinavia who moved south, and from beyond the Danube made raids on Roman provinces during the 2nd and 3rd centuries AD. In 406–09 they devastated much of Gaul before crossing into Spain. In 429 they occupied parts of North Africa.

Varro Marcus Terentius Varro (116–27 BC) "The most erudite of the Romans," he wrote 74 works in 620 books on all manner of subjects.

Vasari, Giorgio (1511–74) Italian painter, born in Arezzo, but active in Florence. He was more famous, though, for his *Lives of the Artists* (1550).

Venus Goddess of love (= Greek Aphrodite).

Verres Caius Verres. Proconsul in Sicily from 73 to 71 BC. He practically desolated the island and the Sicilians decided to impeach him, despite his powerful aristocratic friends. **Cicero** undertook the prosecution; the weight of evidence proved so overwhelming that Verres left Rome in despair and was condemned in his absence.

Vespasian Titus Flavius Sabinus Vespasianus (9–79 AD) He served as a legionary commander in Britain in 43 AD and conducted the war against the Jews in 66. Proclaimed emperor by his troops in Alexandria in 69, he celebrated a triumph for the Jewish war jointly with his son Titus at Rome in 70. He restored order at Rome, and lived simply and frugally.

Vespasian

Vicus Civil settlement which grew up outside a military establishment.

Virgil Publius Vergilius Maro (70–19 BC) Born near Mantua, he became a member of the literary circle at the Augustan court, writing pastoral poems (the *Eclogues*), four books in praise of Italy and agriculture (the *Georgics*), and the national epic the *Aeneid* in 12 books.

Volsci Non-Latin people who lived in Latium beside the river Liris. Continually hostile to Rome, they were only finally subdued in 338 B C.

Waywode Turkish governor.

Wickhoff, Franz (1853–1909) Austrian art historian, founder of the "Vienna School" of art history. He believed, in contrast to **Winckelmann**, that Roman art was not a degeneration of Greek art, but that it had created new and original values.

Winckelmann, Johann Joachim (1717–68) German archaeologist and art historian, who worked for most of his life in Rome as Cardinal Albani's librarian. His writings directed a popular taste towards Greek and Roman art, and were influential in creating the modern study of art history and archaeology.

Wood, Robert (1717?–71). English scholar who traveled in the Levant with James Dawkins between 1749 and 1751, visiting Palmyra and Baalbek, their engravings and description of which were published in *The Ruins of Palmyra* (1753) and *The Ruins of Baalbec* (1757). Wood went on to have a political career in England.

Zealot Member of a Jewish sect which resisted Roman rule in Judea between 66 and 73 AD.

Index